Imagined Battles

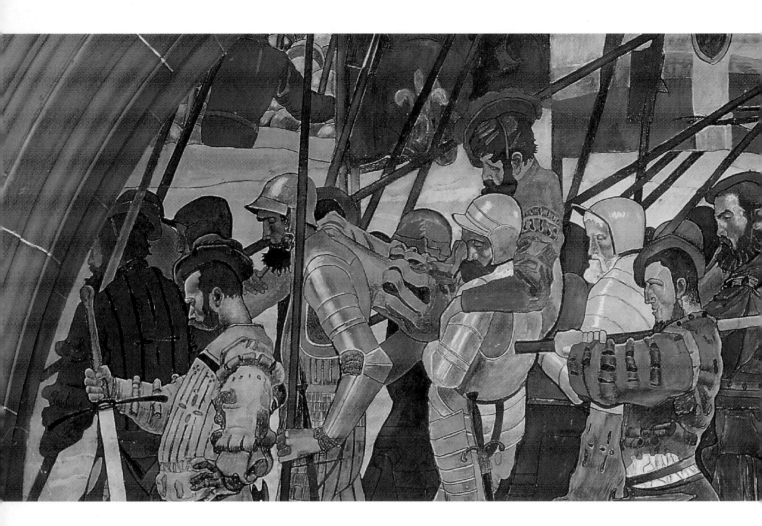

Imagined

Reflections of War in European Art

Peter Paret

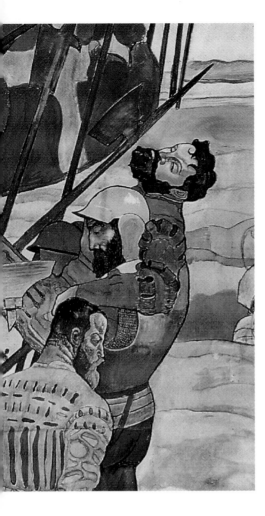

Battles

The University of North Carolina Press

Chapel Hill & London

The paper in this book meets the guidelines for
permanence and durability of the Committee on
Production Guidelines for Book Longevity of the
Council on Library Resources.

Library of Congress Cataloging-in-Publication Data

Paret, Peter.

Imagined battles: reflections of war in European art /
Peter Paret.

p. cm.

Includes bibliographical references and index.

ISBN 0-8078-2356-2 (cloth: alk. paper)

1. Battles in art. 2. War in art. 3. Art, European.
I. Title.

N8260.P27 1997

758'.93554'0903 — dc21 96-52518

CIP

01 00 99 98 97 5 4 3 2 1

Publication of this volume has been aided
by a generous grant from the L. J. Skaggs and
Mary C. Skaggs Foundation.

Contents

Acknowledgments

A paper I heard John Hale give at a conference on "Art and History" at the Rockefeller Center in Bellagio, and subsequent conversations with him at the Institute for Advanced Study, first encouraged me to develop some of my thoughts on the relationship of art and war into a short book. My indebtedness to Professor Hale increased with the appearance of his splendid study *Artists and Warfare in the Renaissance* some years later. I outlined the main themes of what I intended to write in the fifth Reckford Lecture in the Humanities, which I gave at the University of North Carolina at Chapel Hill in the spring of 1994. It is a pleasant duty once again to thank my hosts on that occasion.

Early versions of parts of several chapters were presented at the session "War and Culture" of the eighteenth International Congress of Historical Sciences at Montreal; in a lecture at the Institute for Advanced Study, published as a brochure, *Witnesses to Life: Women and Infants in Some Images of War, 1789–1830*, Institute for Advanced Study, Princeton, New Jersey, 1996; in a lecture at the conference, "Die Wiedererweckung des Krieges aus dem Geist der Revolution," in the Berlin-Brandenburgische Akademie der Wissenschaften; and at meetings of the Seminar on Force in History at the Institute for Advanced Study. The seminar is funded in part by the Harry Frank Guggenheim Foundation and by J. Richardson Dilworth, Trustee Emeritus of the Institute. I am grateful to Mr. Dilworth and to James Hester and Karen Colvard of the Guggenheim Foundation for the interest they have shown in the work of the seminar, and to the participants of the meetings for their comments.

Four scholars with different perspectives on the methodologies of history and art history—my colleague Irving Lavin, Beth Irwin Lewis, William J. Pressly, and my son Paul Paret—read sections or all of the manuscript, and I thank them for their criticism, questions, and suggestions. Professor Lewis also interrupted her own research and writing to take charge of the ever more demanding process of gathering the illustrations, which often entailed rephotographing the originals, and of arranging for the permissions. I cannot thank her enough for her kindness. I am grateful to John Blazejewski of Princeton University for the good humor and efficiency with which he responded to our repeated requests for photographing yet one more woodcut or etching. Finally, it was a pleasure to work with the editorial staff of the University of North Carolina Press—in particular Lewis Bateman, who expressed an interest in the project when it consisted only of a few lecture notes; Stevie Champion, who copyedited the manuscript; and Pamela Upton, who saw to it that the various segments of the enterprise fit smoothly together.

In several ways, personal experience has motivated my interest—now of long standing—in the place war occupies in history and in the role it has played for my own generation. Responding to one's experiences by studying matters they have evoked directly and indirectly is an attempt to repay a debt to one's past. The pages that follow are dedicated to the memory of the men with whom I served, and against whom I served, in New Guinea and the Philippines during the Second World War.

I

The Siege of Castellazzo

As a significant historical force and to those who encounter it a singular personal experience, war occurs often enough to be a common subject in art. Artists depict war as they know it, as they imagine it, or as their patrons want it to appear. They interpret as well the reactions of their environment to war—reactions and interpretations that often shape the representation of the thing itself. In the following pages a number of paintings and prints from the Renaissance to the twentieth century are discussed as examples of the coming together of art and war, which reveals something about each and about the societies and cultures that gave rise to both.

In 1507 or soon afterward the young Niklaus Manuel made a pen-and-ink drawing of a subject of importance to his native town, Bern, and to himself (Fig. 1.1). The drawing—the assumption that it was a design for a commemorative window is now questioned—shows a young, armed man standing under a broad arch. His left hand grasps a halberd, his right hand is partly extended in a gesture that is difficult to interpret. Is he emphasizing what is being said in the drawing, or is he asking for money, which, as will be seen, would accord with his occupation? The figure has a touch of elegance to it, reminiscent of the Roman statues of a god or young warrior that were being rediscovered and inspired painters and sculptors at the time, and yet the pose is slightly awkward. The man's placement on the curved ground, the indeterminate gesture of his right hand, the folds made by his cloak hanging over the sheath of his sword all betray the artist's

inexperience. But he has observed his subject closely. The figure is a generic image, a common social type representing qualities that Bern valued. But Manuel also introduced references to himself.

The young man's doublet and striped hose, decoratively slashed to allow the differently colored lining to show through, and his beret embellished with five ostrich feathers are the dress of a fighting man, whom the crosses on his chest and thighs mark as Swiss. The motif of the cross is repeated and thrust to the foreground of the drawing by the intersecting vertical halberd and horizontal sword, which points to what may be the precinct of a church. The halberd identifies the man as a light foot soldier, the type that at the beginning of the sixteenth century made up more than half of the Swiss Confederacy's armed forces and of the units and individual mercenaries hired out to fight for or against the French king, the emperor, the pope, and the Italian city-states in their recurring wars for the control of northern and central Italy.

In the space above the arch, its curve just touched by the point of the halberd, Manuel drew the scene of a battle in which this man had presumably taken part and from which he has returned (Fig. 1.2). On the left of the drawing the walls of a town or castle are under assault; on the right rise the tents of the besieging army with two cannons before them, which are surrounded by men loading and firing their heavy handguns. At the far right, at the top of one of the columns that support the arch, soldiers watch the carnage, ready to intervene if they are needed.

The outcome of the struggle, at the stage shown in the drawing, is in the balance. Men with shields raised to protect themselves are climbing ladders that have been placed against the walls. The defenders are opposing them with lances and swords; one man wields a long-handled club; in the rear, near the top of the second ladder, another appears to be firing a handgun. The most effective weapons, however, are not devices constructed according to the increasingly complex designs of Renaissance military technology, but stones thrown or rolled at the attackers on the ladders and at the base of the walls. The ground is covered with these primeval objects and with the men felled by them. In the far distance, between tents and massed lances, which suggest troops approaching in close formation, a banner with three fleurs-de-lis identifies the scene: it is an episode in the French campaign against Genoa in the spring of 1507, in which the army of Louis XII, reinforced by thousands of Swiss mercenaries, destroyed the city-republic. The drawing shows the attack on the city, or perhaps the assault on the fortress of Castellazzo. The two cannons on the right side of the drawing may refer to the feat, singled out in contemporary accounts, of the Swiss dragging two heavy guns up a slope to smash the walls of the fortress.

The fleurs-de-lis are also a reference to the person of the artist. Little is known of Manuel's early life, and although surviving documents indicate that his future brother-in-law served in the campaign against Genoa, it is not certain that Manuel did. But after the campaign, in an assertive social gesture not uncommon at the time, Manuel assumed a coat of arms or possibly adapted the design of an escutcheon that his ancestors had claimed. Perhaps in allusion to the Swiss participation in the campaign against Genoa and to the honors Louis XII had paid the Swiss contingent, Manuel chose three fleurs-de-lis, placed horizontally above vertical bars, the

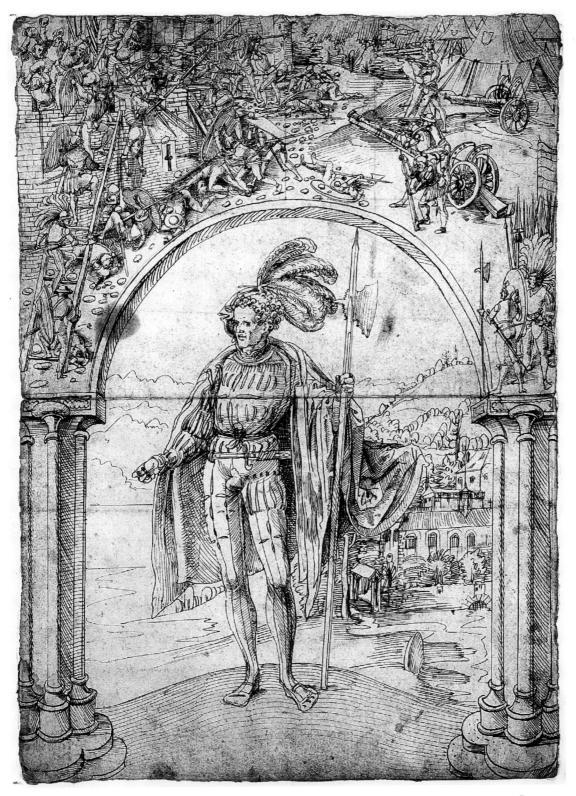

FIGURE 1.1. *Niklaus Manuel*, Swiss Man-at-Arms under an Architectural Arch, *1507. Kupferstichkabinett, Öffentliche Kunstsammlung Basel.*

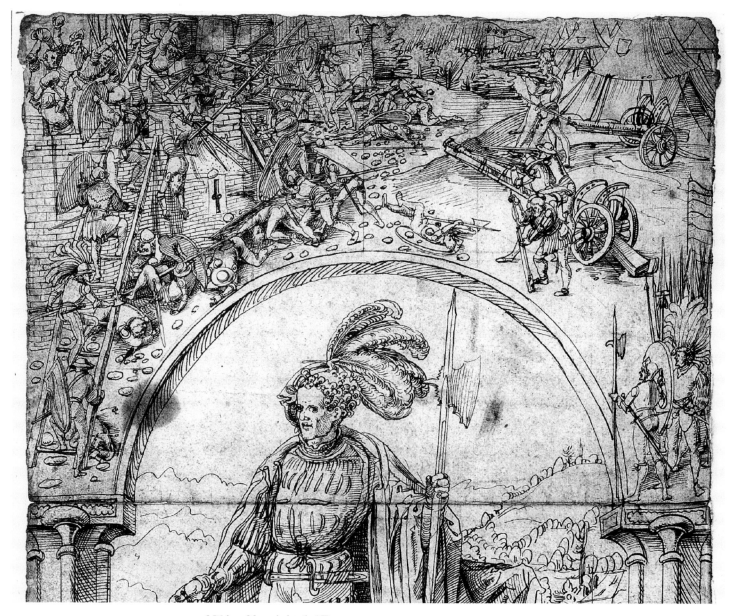

FIGURE 1.2. *Niklaus Manuel, detail of Figure 1.1.*

design on the banner at the top of the drawing. In what may have been another reference to himself—a young artist who was a commoner but had pretensions of a more distinguished lineage—he clothed the halberdier under the arch, an ordinary man-at-arms, with a cloak, the mark of a noble.

At first glance, the sketch of the siege is exceptionally convincing in its specificity and violence. It might be taken for an eyewitness account; but even if Manuel did participate in the campaign, he may not have been present at the siege, and we cannot be certain that he had seen what he sketched. In later years he experienced war in many of its forms. In 1516, when he was already known as a painter of religious subjects, he served as secretary of the Bernese contin-

gent hired by Francis I to help defend Milan against the Austrians. In 1522 he was wounded at the siege of Novara and survived the defeat of Bicocca, in which some three thousand Swiss were killed. Without ever leaving Bern, a town filled with soldiers coming and going, he could have produced the realistic and allegorical portraits of Swiss fighting men and their women that form a major theme of his work. But his later sketches of camp life and of soldiers on the march and in battle have an immediacy not present in the early drawing. By then Manuel had not only matured, he had certainly seen war with his own eyes.

Whether the drawing is an eyewitness account or not, did Manuel wish to represent the reality of a siege in 1507? And if this was his intention, how well did he achieve it? It is apparent that he not only tried to give a vivid impression of the fighting as such, but that he also paid attention to the unique detail. Weapons and clothes are rendered accurately, as are the methods of attack and defense. Even the shields of the men climbing the ladders were justified. Swiss infantry no longer carried shields, but shields were issued to members of scaling parties. Only the large oval shield held by the halberdier observing the assault from the capitol of the pillar on the right is a fanciful embellishment; a man thrusting and parrying with the two-handed halberd would not have been able to hold anything else. The halberdier and his comrade with the fantastic array of ostrich feathers—real or artificial—sprouting from his cap are heraldic Renaissance figures, not Swiss mercenaries. Nevertheless, Manuel repeated these fictions in the melee itself. The bunch of plumes reappears even less believably on the cap of one of the men climbing the ladder on the left, and just above the apex of the arch another halberdier lies dead on his shield. But neither the artist's occasionally uncertain handling of perspective nor these inaccuracies weaken the initial impression of an image that—though filtered through a sieve of aesthetic conventions and judgments—gives a good account of the climactic minutes of an attack on a fortress or walled city in the early sixteenth century.

It is only when we move from artifact to art that we realize that much of the image is an assemblage of stock figures or types—the man falling headfirst from the wall, for one, and the man loading his gun in the right foreground or—moving to larger groups—the four men climbing the ladder and the four defenders above them. The diagonal of the attackers, their trunks and legs turned alternately left and right, topped by the neat circle of the defenders' raised arms, forms a strong pattern. But each human component of the pattern is static; the soldiers' movements are stylized gestures, and the whole tumultuous scene retains something of the gravity and symbolism of an earlier way of seeing and depicting.

The campaign against Genoa in 1507 is the subject of another contemporary picture, one of the illustrations of the *Chronicle of Lucerne* by Diebold Schilling the Younger (Fig. 1.3). Schilling, born around 1460, fought in several campaigns for the German emperor and the dukes of Milan. He wrote the chronicle sometime between 1507 and 1513, and is believed to be the artist of the traditional miniatures that make up the larger part of the illustrations. The miniature, which still follows the stylistic conventions of late-medieval illuminations, shows Swiss mercenaries marching past Genoa toward battle, while between the column and the town a high French noble, perhaps the king himself, knights two members of the Swiss contingent for

their services. The town is drawn without clearly marked features; it could be any medieval town by a body of water, Lübeck or Bordeaux as well as a port on the Ligurian coast. And the mercenaries, too, lack individuality. Their weapons, caps, and the way they hold themselves and step out are of a pattern—they are interchangeable ciphers, which in the aggregate signify "armed force." Even in the melee on the left most of the fighters, whose affiliation is often difficult to determine, are shown in two or three standard poses. Only their banners with the fleurs-de-lis and the emblems of Swiss cantons add a particular note to the schematic image of town and besieging force. Manuel's drawing has left these conventions far behind; he seeks the specific and verisimilitude, whether directly perceived or reconstructed from other sources. He wants to do more than produce symbols that convey a general idea of the campaign against Genoa, even if underneath the turmoil and variety of his image links to an earlier static and undifferentiated treatment of the external world remain visible. His sketch of carnage above the arch and of the fortunate survivor below, who may or may not possess attributes of the artist himself, tells us as much about the early stage of Manuel's development and about the clash between late gothic and Renaissance ways of representing reality as it does about the murderous struggle of a siege in 1507.

If we feel somewhat uncertain about the drawing's mimetic power, there is no doubt that it accurately expresses attitudes toward war then prevalent in Bern, which coincided with the artist's own point of view. The drawing raises no question about war in general or the campaign of 1507 in particular. Neither, on the whole, did public opinion of the time. The participation of Bernese forces in the campaign against Genoa was authorized by the city government and approved or accepted by the population. Some men not in the units sent to Louis XII joined the French on their own. Expeditions of this kind were regarded as a normal and economically necessary feature of Swiss life, even if concern was frequently voiced over the problems of foreign recruitment and the social and political consequences of itinerate Swiss men-at-arms seeking pay and booty under any flag.

To the extent that Manuel's sketch expresses any judgment at all, the manner in which the central figure is presented suggests that the judgment is positive. Knowing what we do of Manuel's later life—that he volunteered for more than one campaign, sought and received military appointments, wrote about war, including a famous song mocking the German Landsknechte against whom he had fought at Bicocca—everything indicates that he was not opposed to war, either in general or in the peculiarly populist form it assumed in sixteenth-century Switzerland. We also know from his later work that his nonjudgmental acceptance of war did not prevent him from taking a critical view of aspects of the mercenary's life—his destructive and self-destructive behavior, his relations with women—even if in this early drawing by a young artist with little or perhaps no experience of war these reactions are muted.

We may, therefore, interpret Manuel's drawing as an unambiguous expression of the values of an energetic, combative society that expected its young men to go to war. The artist seems confident in what he is saying; he is not engaged in advocacy, not even in the kind that instead of aiming to persuade seeks to sustain attitudes already held.

But, finally, beneath the surface of the drawing on which large social and cultural forces of the artist's world meet and interact, Manuel addresses an extreme human condition, which is also the basic fact of war: the individual confronting the reality of killing and being killed. The central figure of the drawing has met this challenge, but his halberd points to the dead man-at-arms lying on his fictional shield just above the glorious plumes and suggests how easily he might not have survived.

Some scholars have suggested that the tip of the young man's sword, shrouded in the folds of his cloak, points to an enclosed cemetery beside the church that is part of the figure's background. It is no more than an assumption, if a reasonable one; if they are correct, however, it would reinforce an interpretation that might be proposed in any case: the dramatic account of the drawing resembles a compressed narrative that celebrates the fighting man's survival in a dangerous world but also points to his inevitable end. Manuel universalized this theme in the *Dance of Death* he painted after 1516 on the walls of the Dominican cloister in Bern. We do not know whether in the *Man-at-Arms* he meant to take the further step of asking us to see ourselves in the temporary survivor: the Swiss halberdier standing for mankind. But it is part of the strength of his drawing that the analogy is possible.

Niklaus Manuel's drawing and the miniature in the *Chronicle of Lucerne* raise a number of issues concerning the representation of war in art. Among these are the character of the representation; the artist's purpose, knowledge of the subject, position in society, and place in culture; and the correspondence between the artist's view of the subject and the views taken of it by various social groups. Behind these issues rises the overwhelming significance of the subject itself. War has figured in nearly every generation of which we have some knowledge, and no doubt in most or in all that have not left a record, and individuals and the societies that war has touched have rarely been left unmarked by the experience.

War has been a perpetual phenomenon in human affairs, and—whatever its present state and the forms it may assume in the future—everything about its past is worth knowing: how it was waged, how it affected society, and how society reacted to it. Paintings and graphics that address war are among the sources of information we possess. But what exactly can they tell us? Works of art rarely convey reliable information on how large numbers of men in a particular period went about the business of fighting and killing. When they do, as Manuel's drawing probably does, their information is not unique but—at least in societies with written records—tends to confirm and perhaps add to what is already known from other sources. Often they are informative on such matters as the cut of clothes or the design of a belt or harness, details that otherwise might be lost in the void of the past. But what art conveys best, and sometimes uniquely, has less to do with the mechanics of war—whether these are depicted accurately or in a stylized manner or allegorically—than with the feelings about war of individuals and societies, with their attitudes toward the enemy and their own armed forces, and with the ways they

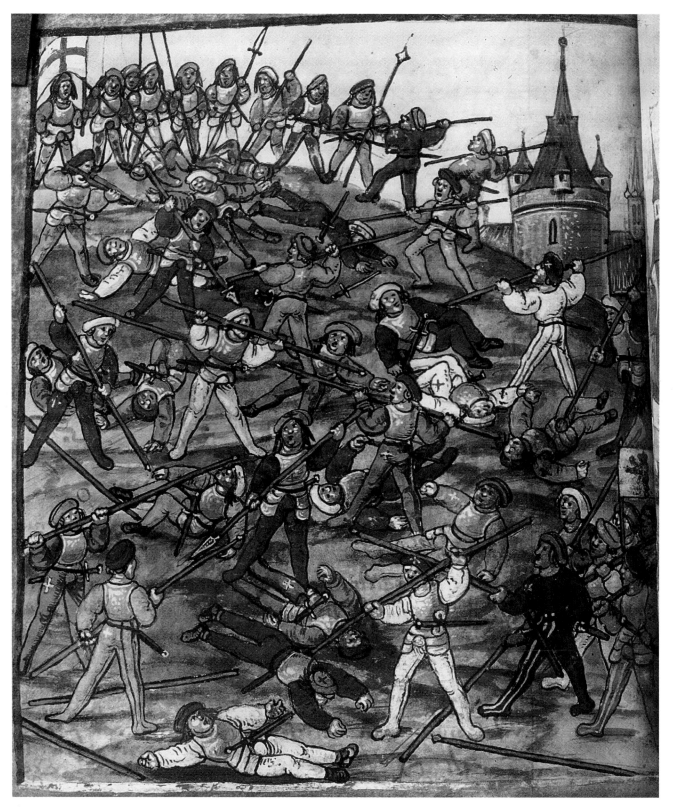

FIGURE 1.3. *Diebold Schilling the Younger,* Assault on Genoa. *From the* Luzerner Chronik, 1513, *Zentralbibliothek, Lucerne.*

connect war to other major elements in their lives — economic activity, social and political authority, beliefs, personal relationships.

Like every important human experience, war has been a common theme in art, and the evidence of art about its different aspects and their links with society and culture is abundant. But war has also proved a difficult subject for the artist, and its reflections in art pose problems as well as offer opportunities to the later interpreter. The reasons for these difficulties lie both in the nature of the subject and in the conditions under which it is treated by the artist.

In art as in brute reality, war is a compound phenomenon. Its defining core is the organized use of violence on a large scale: one belligerent employs force to change the policies of the other or, sometimes, to destroy him. Yet war consists of more than fighting. Troops must be brought to the battlefield, earlier they must be equipped and trained, and initially they must be created by taking men from civilian life and organizing and training them for a new purpose. The effort by one side to destroy the other side's ability to use force defensively or aggressively is the ultimate activity in war, but it is always an exceptional activity, and the many necessary actions preliminary to combat link war closely to almost every other element of social existence.

Had Manuel drawn his young Swiss without adding the scene of fighting above the arch, the single halberdier would still address the theme of war, though perhaps not as directly as does the sketch of the siege. Each from its own perspective, the image of a soldier and the image of combat confront the reality of the subject, with its many ambiguities and contradictions. In representations of an armed man or of a small group, the contradictions have to do mainly with personal feelings, social needs and demands, and political restraints and opportunities. In representations of combat and of the activity of large forces, the contradictions rest in the coexistence of order and violence. War organizes human energy not to build but to tear down and kill; it releases the individual from some of the constraints of ordinary life and private morality. The artist need not address these opposites openly, but both artist and public know that they are part of the subject.

The most important ambiguity has to with the reasons, ranging from idealism to greed and aggression, that bring men to the battlefield. Primarily, men fight because they are forced to fight, whether by the power of the state or by social pressure, and whatever the emotional effect of being pushed into a new kind of life (which may include positive reactions to shedding one's former existence and to new opportunities), coercion remains a basic element. More often than not, images of war are images of men acting under duress. Manuel's drawing illustrates another motive — economic need, the impact on young men of inadequate resources and overpopulation in Swiss society. The motive may be as straightforward as the wish to defend one's community against a recognized or assumed threat. Whatever constraints are in force, often the individual does not understand the reasons for war, and as political societies increase in size and complexity the links between the individual and war become more intricate. Then it is no longer a matter of the free men of a community or tribe in council deciding to oppose a predator or to attack a weaker neighbor. Instead, decisions are made and transmitted to the

individual fighter or potential fighter by a chain of mediating institutions, which may or may not add an explanation of their policy.

The more heavily the political leadership relies on mercenaries, the less significant are its measures to justify war and to persuade men to serve. Under those circumstances military service is regarded as an economic transaction. But increasingly in the last three centuries, at least in the Western world, men and now sometimes women are taught, entreated, and ordered to fight with arguments that an essential interest of the community or a valued abstraction—the nation, a religious belief, a political ideology—must be asserted or is under attack. The coercive powers of the state usually compel most members of the target group to serve, but the persuasive power of the ethical and ideological arguments that accompany them is more limited. Even in genuinely representative political systems not all soldiers serve from personal conviction. Some support the war, others oppose it; some are at one with the ideals held out as standards of civic behavior, others might prefer to be left alone. The assumed universal validity of the ideals and conditions put forward to justify killing and self-sacrifice is never fully accepted by all social groups or by every individual within a group, and the contradictions between official standards and demands and personal attitudes cast a mystifying if not distorting shadow over much of the art that addresses themes of war.

Nor are soldiers the only participants in war. Even in those intermittent periods of the past, now far behind us, when some care was taken to protect the population from the effects of fighting, civilians died and the economy and society suffered. As soldiers are maimed and killed, their families become indirect victims. Images of war, in any one of its phases, include this unseen mass of victims, a fact that may affect the artist's interpretation and our response to it. We know that whatever else war achieves, it brings suffering and death with it, just as our response to Manet's *At Père Latherille's* or to Renoir's *Breakfast of the Boaters* draws on our awareness and experience of love. Manuel's sketch of a siege is filled with both visible and invisible victims—the attackers and defenders who are being killed, their wives and children at home, the defenders who are still resisting but will be killed eventually because the Swiss take no prisoners, and huddled unseen behind the walls the noncombatants, who may or may not survive.[1]

1. Orders against taking prisoners were frequently issued, because stopping for any reason during battle broke up the close formations in which the Swiss fought, slowed their advance, and made them vulnerable to counterattacks. Examples are the War Orders of the Confederation of 1476 and the Lucerne Decree of March 1499, which states: "Every community should have its men swear not to take prisoners when we have a battle and fight, but to kill everyone 'as our pious ancestors always did.'" Printed in Eugen von Frauenholz, *Entwicklungsgeschichte des deutschen Heerwesens*, vol. 2, part 1, *Das Heerwesen der Schweizer Eidgenossenschaft* (Munich, 1936), pp. 141, 192. When contingents of Swiss mercenaries faced each other, they were usually prepared to take prisoners. Stripping one's own and the enemy's dead and looting the enemy camp after battle was a matter of course, but opinions varied on the treatment of captured towns and fortresses. Swiss troops frequently killed a garrison that had surrendered; looting was expected, but some efforts were made to limit it. The statement sometimes found in the literature—for instance, C. von Mandach and Hans Koegler, *Niklaus Manuel Deutsch* (Leipzig, [?1942]), p. xi—that Manuel was denounced for looting a church in the sack of Novarra in 1522 seems to be based on a misinterpretation of the documents.

The difficulties of representing and interpreting war that lodge in the relationship between war and the individual are reinforced by two impersonal problems. We think and speak of war in the singular, but even the most overpowering surprise attack does not consist in a single, sharp blow. It extends over time. Representations of war must reduce the complex process to moments in which opposites always confront each other, overtly or implicitly. Nor is it insignificant that war, although a universal phenomenon, tends to create its own world. Until recently, a battle was seen mainly by the participants, and its extension over time and space made it a notoriously difficult object to observe even for those in the thick of it. Film and television, but also the renewed expansion of war by the practice of targeting the civilian population, have made war more accessible to people who are not actually fighting, and this has had an impact on art; but it is not surprising that for centuries the aspect of war that presented the artist with the greatest problems was battle.

The relationship between art and war would be challenging enough if it consisted merely in the working of a powerful theme on the creative imagination. But as is true of all art, representations of war are affected by the specific context in which each image emerges, made up of elements that initially are not part of the mechanics and drama of conflict and of their impact on the artist. They range from aesthetic theories and characteristics of style to market forces, the interests of a patron or the tastes of the buying public, and to such general political and attitudinal characteristics as the place of soldiers and their institutions in a given society. Two paintings of soldiers in the late nineteenth century—one by an English, the other by a German artist—will likely employ somewhat different emotional vocabularies. Analysis can rarely draw an absolute distinction between the context and the artist's personal conception of the subject, but both are better understood in themselves, and their interaction is more clearly seen, if they are kept separate for as long as the evidence allows.

The subject of this study is the serious representation of war in European art from the Renaissance to our own day. The phrase "serious representation of war" may require a few words of explanation. Not every image of a subject as multifaceted as war seeks to depict and interpret war. Wars have causes and results, and often art deals with these, not with war itself. A portrait of Louis XIV, the king encased in ceremonial armor, holding a combined scepter and marshal's baton, is a painting that uses war merely as a setting for its true purpose, the apotheosis of the monarch as supreme commander and triumphal symbol of state power. Even with the nearly obligatory addition of a pitched battle in the background, the painting is less about war than about the concepts of authority and policy.

Another, related kind of image goes further in addressing war but again passes over its reality in order to illustrate and make apparent something else. A painting of German university students in 1914 rushing into battle in serried ranks, patriotic verses on their lips—and there are such paintings—memorializes beliefs and attitudes that did exist, if not exactly as they are recalled here, but the artist is not concerned with the reality of the attack on Langemarck and

its sad end. The ambiguities that attach to war and the forces of politics, the market, and other circumstances under which the artist works may encourage a move away from the serious interpretation of the reality of war.

No firm division can be drawn between art that interprets this reality—however experienced by soldiers and civilians—and art that abstracts war into concepts or a political or even commercial message. If they wish, painters, like writers, combine both. Advocacy of a particular cause or idea may be joined in the same work with an interest in war as part of the human experience and with the effort to depict it. To varying degree and in different form this interest and effort are present in Manuel's drawing and in the other prints, paintings, and frescoes discussed in the following pages.

Each of these works says something about war, about reactions to war, and about the relationship of art and war. Many also contain other elements, not all of which can be explored here. When Otto Dix's paintings and graphics of the First World War began to appear in the early 1920s, the links between them and his images of women were soon noted. A monograph on the artist should explore this relationship, which a brief and more general study on representations of war might only examine briefly or may even leave aside altogether. Nor are the pictures in this volume more than a few out of the very many that might have been chosen. Is it necessary to add that they are not meant to form a corpus of the most important works on the subject? The field is so large, its configuration is so complex, and it is crowded with so much of interest that no two students would agree on the same canon. I have merely chosen a small number of images that seem to me to bear on the themes I discuss. In a short book—scarcely more than an extended essay—it may in any case be advisable to consider fewer works rather than more.

That is also a reason for limiting this discussion to works from early-modern and modern Europe. But there is another reason as well. Most if not all serious representations of war since the Renaissance, together with many derivative works, are marked by an outlook that is less frequently found in medieval art: the reality of war dominates its aesthetic representation. It might be more accurate to say, comes to dominate, because at first in these five or six centuries some artists continue to visualize armed men and fighting in terms of Christian belief and thought. In late-medieval art, even images of everyday life, of which armed men and fighting are a part, often appeared as elements in the drama of salvation. With all its specificity, humility, and strength, medieval realism is pious. Piety need not disappear from life or art when people begin to see the functions and effects of a social force such as war in its own terms rather than as a symbol, but now piety no longer sets the scene. It has become no more than a component in the representation of a process in which men's actions and their consequences remain earthbound. To a degree, the glorification of the temporal leader and of his political system—which had, of course, also been present in medieval art—replaces the Christian faith as a determining interpretive force. But it never achieves similar universality. More and more, artists address war not only as an act of belief and unbelief, but also—and often mainly—as a sequence of events, the concrete reality of which poses the main challenge to their work.

The nature of this reality varies according to the artist's way of seeing war. Some artists may see it, or are expected to see it, primarily as organized violence employed for a political end—maintaining and extending the power of a prince, a dynasty, the state. Others may find the reality of war lodged in human effort, emotion, and suffering; in sadism and degradation; or in the manipulation and exploitation of some social groups by others. In some works these perspectives coexist. The realities of war, whether political, social, or concentrated in the individual, may be interpreted in many different ways—by means of one or the other kind of realism, symbolically, but also in styles that reject the mimetic depiction of physical phenomena altogether. At the beginning of the twentieth century, when the pragmatically realistic representation of war had achieved its most powerful expression, comparably powerful symbolic and abstract reformulations of war appeared in art. But however expressed, a concern with the realities of war, which may, of course, not result in a "realistic" work of art, has motivated many of the artists who have worked on this theme in the past five or six hundred years, and their outlook lends a certain unity—if only of the dialectic variety—to the representation of war from the Renaissance to the present.

The interpretation of art has been a contentious activity and continues to be so today. That also holds true for the study of the past and for the writing of history. On such matters as the integrity of the text, concepts of objectivity, the relationship between subject, interpreter, and viewer or reader opinions vary, and some are irreconcilable; but not all are held with the degree of intolerance often shown in debates over theory and methodology. The pursuit of a particular course of analysis need not imply the absolute rejection of all others, but—as here—merely the belief that it best suits the particular author and the problem at hand. It may nevertheless be useful to say something more than has already become apparent about the concepts of historical analysis that underlie this essay. The discussion is not shaped by a highly abstract interpretive theory. I take it as self-evident that a work of art may be studied for different purposes and from many different perspectives, and I regard the work and its context as possessing greater authority than do their interpretations. In the following pages, images are discussed as documents that contain information on conditions, attitudes, and ideas, and I value the possibility that unlike many documents historians use—which are often paraphrased, quoted in part, or merely referred to—these may be examined by reader and author together. All but the most derivative of them, to be sure, are documents of a peculiar kind, made so by the talent or genius of their creator. By joining the work of art and its subject, war, in the context of their time, the study addresses the overt text as well as the nonmilitary subtext of these image-documents.

2

Imagined Battles

The Renaissance artist who painted a battle and looked to contemporary practice for information was faced with changing and contradictory evidence. By the fifteenth century, the mounted knight's symbolic and real supremacy in war had faded, but his former domination of the battlefield had not yet passed to a new type of fighting man and new methods of fighting. Instead, battle, for a time, was characterized by organizational and tactical variety, by uncertainty and experimentation. Armored horsemen—either knights with their retainers or troops of mounted mercenaries, armed with an array of weapons from lances to war hammers—retained a presence, but men fighting on foot assumed a larger, increasingly important part. Some carried crossbows, longbows, or handguns; others were equipped for hand-to-hand combat with lances and two-handed swords, or with the lighter halberd or pike. Artillery began to be used not only to break down walls but also against troops in the field. In this heterogeneous military world, the individual fighter was expected to have some proficiency in the use of his particular weapon; however, he was rarely trained as a member of a larger body of men. For most participants in a campaign, fighting was not their primary occupation. Some princes kept a few companies permanently under arms; in towns, detachments of paid guards provided security together with the civic militia; castles maintained small garrisons from year to year; but the majority of fighters were called up or hired when the need arose.

Some theorists and no doubt many commanders in the field recognized that uniformity in the action of members of a unit was as important as cooperation between the units, but it was not fully understood how this was to be achieved.

Men might march and camp together, only to be divided among temporary formations on the eve of battle, possibly under the command of officers they did not know: the administrative unit was not yet the tactical unit. Because men did not often train in large groups, they found it difficult to carry out basic tasks in combat—individual crossbowmen and pikemen protecting each other, lance carriers maintaining the close proximity on which their strength and safety depended as they advanced or changed direction in their crude columns and squares. A primitive command structure made the coordinated movement of separate units even more difficult than it would have been in any case. Underlying all these problems was the fact that temporary formations implied uncertain discipline. Not only did tactical effectiveness suffer; in battle after battle a rumor or the misunderstood action of one's own forces led to panic.

The flaws in the ways men fought did not go unchallenged. Examples are the regulations that Charles the Bold issued in the 1460s and 1470s that called for extensive training exercises. But the improvised character of the Burgundian forces, in which a few innovations fit uneasily with traditional institutions and methods, and the feeble administrative framework that held together the thousands of differently organized and equipped men meant that ideas could not be turned into reality. It was the victors in the Burgundian Wars, the Swiss, who pointed to the solution of the military problems of the age. They maintained few mounted troops, primarily scouts and messengers; men on foot were the decisive tactical force. Massed in thick squares, lance carriers on the outside, pikemen and halberdiers in the center, preceded and surrounded by screens of crossbowmen and handgunners, whom pikemen protected against sudden cavalry charges, they learned to support each other in defense and to generate unheard-of force in attack. The individualism of the knight was replaced by the common action of hundreds, even thousands of men. Not that the Swiss had overcome the problem of indiscipline inherent in forces called up to serve for a few weeks or months. But the cohesion of men from the same town or village fighting side by side went a long way. Moreover, the demand of Swiss society that all able-bodied men should be prepared to take up arms, as well as the importance to the community of such institutions as musters, target-shooting contests, and military pageants, provided a workable substitute for hierarchical obedience and formal training until the early years of the new century, when the Swiss in turn began to be overtaken by organizational and tactical innovations of their enemies.

The Italian city-states lacked the social and political preconditions of the Swiss model. Much of their military energy went into the development of siege warfare on the one hand, and the design of fortifications capable of withstanding artillery on the other. Their field forces followed an older, mixed pattern, made up of patrician and plebeian groups and the city's dependents and rural subjects—each segment usually serving in its own formations—of hired men from other parts of Italy and Europe, and of organized bands of mercenaries. It was often difficult to get the various parts of the machine to work together. Tactics continued to emphasize horsemen, contrary to Swiss practice, but also large numbers of archers. Heavily armed foot soldiers did not develop into a decisive element, and battles—though far from the bloodless

encounters that Machiavelli found so disgraceful—increasingly assumed an old-fashioned, un-dynamic character.

The principal battle paintings of the Renaissance do not clearly or directly reflect these conditions, nor, generally, did the artist mean to convey them. But the variety that marked the often small Italian armies and the pronounced individualism of the combatants emerge clearly.

Piero della Francesca introduced two scenes of battle into the sequence of frescoes on the legend of the true cross that he painted—probably in the late 1450s and early 1460s—in the Cappella Maggiore of the church of San Francesco in Arezzo. One, *The Battle of Maxentius* or *The Battle of Constantine* (Fig. 2.1), does not depict combat. The emperor Constantine, mounted on a white charger, with a retinue of heavily armed horsemen, lances at rest, enters the picture at a walk from the left. Only an officer on a rearing horse near the edge of the fresco disrupts, but also underlines, the group's majestic progress. The recently converted emperor thrusts a small crucifix at the pagan forces of Maxentius, which are fleeing toward the right across the river Tiber. One horseman, his head turned back toward the solemnly advancing Christian knights, is still in the river, his horse struggling up the far bank. The fresco is a celebration of the supreme power of the Christian faith, which conquers not by combat but by virtue of the truth.

The second panel, *The Battle of Heraclius* or *The Battle of Chosroes*, celebrates another aspect of Christianity: its wish to destroy its enemies physically (Fig. 2.2). The battle between Byzantium and Persia in 628 A.D., an episode in the centuries-long conflict between the eastern empire and its neighbors, was turned by Christian legend into a struggle between the forces of good and evil. To make himself the supreme ruler of the world, Chosroes, the king of Persia, stole the cross on which Christ was crucified, and Heraclius, emperor of Byzantium, went to war to recover the sacred relic for Christianity.

The fresco shows the battle as well as its outcome. On the far right, ending the pictorial narrative, Chosroes kneels before his executioner. Behind him stand the three donors of the chapel's frescoes, merchants of Arezzo, and Heraclius, on his head an elaborately decorated reddish-brown helmet. To the left of this solemn group the battle rages, a dense mass of men on horse and foot, among whom Heraclius appears again, this time wearing a plain helmet; he is shown beneath the Persian banner with two Moors' heads, which is already sinking in defeat, as he stabs the Persian commander, Rhazates, in the neck with a crucifixlike dagger. Some of the combatants wear the leather armor of antiquity, imaginatively embellished, perhaps to indicate that these are Byzantine soldiers, not Roman legionnaires. In a general way they suggest the period when the battle was fought, but also—since Rome stands for universal values—the timeless character of the struggle. Other men wear the clothes and use the weapons of fifteenth-century Italy—contemporary references that would help the few worshipers who could see the fresco on the left wall of the chancel understand that the image was not merely of an incident in a war long ago but of the eternal war between faith and unbelief.

Across the length of the fresco, the old and the new confront each other. In the left foreground a barefooted man, wearing a short, belted robe over his nearly naked body and hold-

FIGURE 2.1. *Johann Anton Ramboux, copy of Piero della Francesca,* The Battle of Maxentius, *ca. 1835. Kunstsammlung Nordrhein-Westfalen, Düsseldorf.*

ing a slightly curved sword, faces an opponent in the close-fitting, long-sleeved coat and colored hose of the fifteenth century. To the right of this pair a man is marked by the attributes of both an earlier and a later age. He wears a Renaissance version of Roman armor, together with the shallow, faintly medieval helmet that the artist uses for several of his figures. On the ground before him, a man on his knees, whose hair he grasps and whom he is about to kill, is dressed in a modern tunic. Nor do the clothes, armor, and weapons of the combatants indicate their allegiance. The Byzantine emperor, the Persian king, and the Persian commander are identified, as are a few of their followers, but Piero often leaves uncertain whether a particular knight or man-at-arms fights for Christ or for the anti-Christ whom Chosroes, according to legend, had become. The fresco expounds a religious tale and its message in a new and astonishing manner, which addresses the human reality of war as much as it depicts an allegory of faith. Except for the men in the epilogue of the king's execution after the battle and one or two others, it does not clearly define the two opposing sides. The struggle over the true cross is shown as a dense melee, the outstanding characteristic of which is not that two separate forces are in conflict but of conflict itself. In the fresco, the Battle of Heraclius appears as a many-headed mass of humanity, whose true and false natures are at war. If we change our focus from the whole to the individual fighter, a perspective the artist makes available to us, the battle takes on the character of an extreme challenge to which every Christian and Persian must respond.

The compact mass of fighters that crowds the fresco and pushes against its edges is made up of strongly delineated personalities. Not only the emperor and his defeated Persian enemy, but also many horsemen and foot soldiers are conceived individually, distinguished from one another by character, personality, and intelligence. They have *virtù*. And with only a few exceptions they show little emotion as they kill and die—their expressions are sober and dignified,

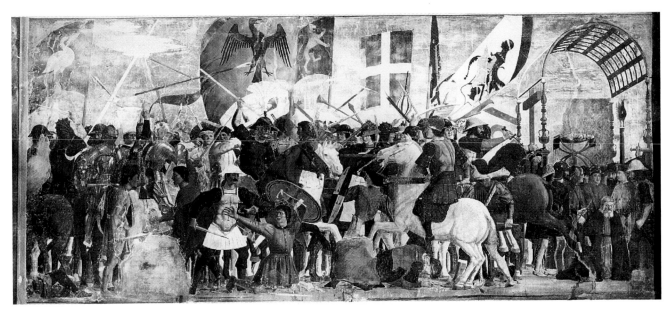

FIGURE 2.2. *Piero della Francesca,* The Battle of Heraclius, *1452–66. San Francesco, Arezzo.*

appropriate for men engaged in a struggle over ultimate values. Throughout Piero's work, his male and female figures express an awareness and acceptance of the tragic in life, but here the artist's vision combines with references to earlier cultural values. The gravity and calmness with which he portrays violence are reminiscent of the friezes on Roman triumphal arches and sarcophagi, which helped inspire the overall composition of the fresco and provided models for several of the individual figures.

It has been suggested that in the fresco "we see the heat of a real fifteenth-century battle."[1] If this is meant as more than a general reference to the intensity of the scene and implies that the fresco shows a battle or an episode of a battle as it was fought at the time, the statement can hardly be accurate, even if we disregard the mix of clothes and weapons, the lances falling indiscriminately on friend and foe, the horsemen so closely pressed by foot soldiers that they would not be able to move, each man in this human knot fighting on his own, apparently with little awareness even of his immediate surroundings. But it is improbable that Piero wanted to convey the reality of a contemporary battle and unlikely that he had seen much of it. In 1440, when he was a young man, the Battle of Anghiari between Florentine and Milanese forces had been fought ten miles from his hometown. We do not know that he witnessed the event; probably he saw soldiers on the march and listened to men who had taken part in the fighting. But whatever he saw and heard, it is not reflected in the fresco, which does not address the actuality of battle whether of the fifteenth or of the seventh century, but instead infuses Roman models with new concepts and attitudes to convey the *idea* of warfare and of the human situation that war creates.

1. Ronald Lightbown, *Piero della Francesca* (New York, 1992), p. 165.

In the same general period—the middle of the fifteenth century—in which Piero della Francesca painted *The Battle of Heraclius*, Paolo Uccello painted three large panels that depict the course of the Battle of San Romano. Uccello's paintings are almost certainly the earlier by a few years or even decades, but they are less indebted to Roman models than is the fresco and convey some aspects of war of the time with greater descriptive fidelity.

The Battle of San Romano was fought between Florentine and Sienese troops in 1432. Uccello could draw on better sources than the thirteenth-century *Legenda Aurea*, which provided the program for the Aretine frescoes on the legend of the true cross. But although the battle took place within thirty miles of Florence at a time when Uccello, then a man of thirty-five, was in the city, it is not clear how much he knew of the event, since the battle was immediately distorted by rumor and propaganda. Sienese forces had been foraging in Florentine territory southwest of the city, occupying small towns and castles, and an army of some four thousand men under Niccolò da Tolentino was dispatched to drive them out. On Sunday, June 1, after a week of marches and small engagements, in the course of which many of the militia units had drifted home, the advance guard encountered the enemy, led by Bernardino della Carda or Ciarda. Niccolò da Tolentino and a small group of horsemen engaged the Sienese, who initially appear to have been the stronger. Over time, additional troops entered the fight on both sides. Eventually, a large Florentine force under Micheletto da Cotignola reached the area, and the Sienese withdrew. If it was not a major victory, it did achieve the purpose of the expedition. The battle was proclaimed a triumph, with claims of numbers of prisoners taken that were larger than the Sienese forces actually engaged, until gradually the facts became known, and even in Florentine writings the battle was reduced to a nonevent.

Probably a few years after the battle, while it still enjoyed a positive connotation, Cosimo de' Medici commissioned Uccello to depict it for the glorification of Florence and the Medicis, and as a memorial to Niccolò da Tolentino, Cosimo's friend and political ally, who had died in 1435. When the three panels were hung in a row in the new Medici Palace, the left panel showed Niccolò da Tolentino at the beginning of the battle, attacking the Sienese from left to right. The right panel showed the reinforcements under Micheletto da Cotignola advancing from the right. In the central panel a Sienese knight is thrown off his horse by a lance thrust (Color Plate 1). He is not the Sienese commander, as the panel's customary title, *The Unhorsing of Bernardino della Carda*, asserts; Bernardino della Carda was neither hurt nor taken prisoner at San Romano. But, whoever he is, the falling knight signals the defeat of the Sienese, who are seen retreating in the right half of the panel. Together, the three works record the main stages of the battle, with the central panel—which alone of the three will be discussed here—encompassing its last two phases.

A level stretch of ground extends from the lower edge of the painting between the legs of men and horses to the middle distance. Two riders and their horses have fallen; around them lie broken lances, shields, and parts of armor forming a perspectival grid. A group of Florentine knights and foot soldiers accompanied by trumpeters is attacking from the left. One

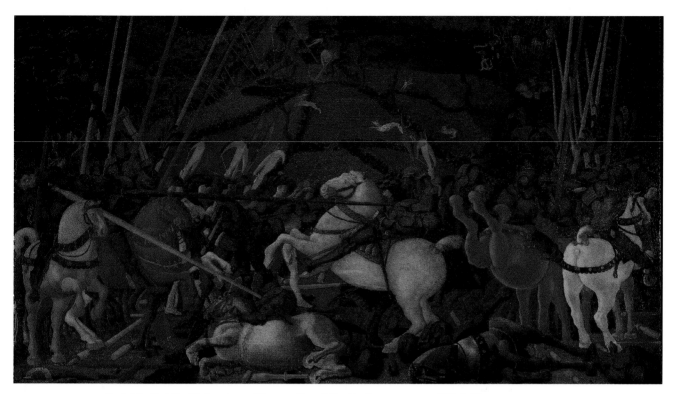

COLOR PLATE 1. *Paolo Uccello,* The Unhorsing of Bernardino della Carda, *ca. 1435–40. Uffizi, Florence.*

knight, his white horse rearing toward the viewer, has just brought down the left of the two horsemen lying on the ground; the point of his lance is still thrust against, or into, the chest of the fallen man. Another knight in full armor, mounted on a reddish-brown horse, his lance extended across half of the painting, is striking the man who is supposed to be Bernardino della Carda. The Sienese commander is falling backward on his white charger; his left foot is still in the stirrup, but he is about to slide off the horse and reaches out in vain to keep his balance. Behind him, a young Sienese, wearing a checkered *mazzocchio* instead of a helmet, jabs with his sword at a group of Florentine foot soldiers, who carry pikes and crossbows. To the right of the pseudo Bernardino della Carda, a dozen Sienese horsemen are turning away from the battle, toward their own troops in the far background. A brown horse kicks out its hind legs; at the right edge of the painting a knight, seen from the back, a mace held in his raised right hand, urges on his horse or is about to strike at an unseen enemy. Green foliage forms a backdrop for the horsemen left and right. Between and beyond the thick branches rises the Tuscan hillside with tilled fields, low grass borders, and olive trees. Over the steep, undulating ground, a greyhound chases hares. From the valley to the left, a column of foot soldiers climbs into view, the two men in the lead hurrying past a crossbowman who is making his weapon ready. In the far right distance, a Sienese trumpeter blows the signal to retreat, while a few crossbowmen and pikemen are preparing to hold off the pursuit.

In his remarkable study *Artists and Warfare in the Renaissance*, John Hale writes that Uccello's panels show the "battle as episodes in a pageant, well removed from any apprehension of the reality of war, let alone from the fairly copious documentation of the action that was, possibly, available to the artist."[2] The processional, decorative character of *The Battle of San Romano* has often been noted, and it is certainly true that Uccello only intermittently conveys the external appearance of a fifteenth-century battle. Yet the panels are full of realistic touches, and in conception and general interpretation they are a closer translation into another medium of the event that is their subject and of war as such than the frescoes of Piero della Francesca.

Clothes, armor, and weapons are of the time and place, and the weapons are handled as they would be in life—carrying the crossbow at an upward slant is an example. In the foreground, the soldiers are pressed almost as closely together as they are in *The Battle of Heraclius*; but rather than an empty, flat band, the space in which they move is given depth and recognizable features. The combatants are grouped in units of horse and foot. We can identify separate formations, and yet the scene is crowded with individuals. Even the armored knights, their visors closed, have distinct personalities. Above all, the Florentines and their opponents face each other not as duelists isolated in a shifting crowd, but in compact, articulated forces, front against front. The painting conveys not only the confusion of battle, but also something of its structure and pattern.

Beyond these surface verisimilitudes, the panel presents an allegory of war itself. It does so by giving perceptible form to the two principal dualisms of war: the confrontation of adver-

2. John Hale, *Artists and Warfare in the Renaissance* (New Haven and London, 1990), p. 155.

saries and the prospect of immediate death as part of everyday existence. The composition, it-self the link between the other two panels as well as their narrative conclusion, is built up on opposites and parallels, from the encounter of the two armies to smaller pairings and relation-ships across the painting: the two riders and their horses on the ground; the white and the brown horse advancing from the left mirrored by the brown and the white horse leaving on the right; helmets with closed visors seen from the front on the left, from the rear on the right; ten Florentine foot soldiers, advancing two by two, the heads and expressions of each pair var-ied until the last two, whose faces are partly hidden by the lance that is unhorsing the Sienese knight; the trumpeters blowing the charge echoed in a different mode by the Sienese trum-peter signaling the retreat diagonally across the panel. On the hills in the background, past the greenery left and right—the branches on the left bearing oranges, suggesting the balls in the Medici coat of arms—Florentines advance and Sienese withdraw. At the center of the paint-ing, the coexistence of opposites is given its most powerful expression in the momentary illu-sion that the head of the young Sienese next to the mane of the white horse belongs to the ar-mored body of "Bernardino della Carda." For an instant the young man's face, charged with emotion, replaces the unseen face behind the closed visor of the wounded or dead knight who is about to fall to the ground.

With these variations, the painting—less a representation than a summary of the depicted reality—catches the give-and-take of battle. Uccello's decision to open up the space in which the action takes place and to choose a point of view from below contributes to the result. The flat frieze treatment of battle on Roman monuments and sarcophagi and by painters who fol-lowed their model usually found it difficult to show the confrontation of masses arrayed in broad fronts. Only occasionally did artists suggest a certain depth, which enabled them to de-pict the organized action of larger groups. The Trajan frieze on the Arch of Constantine and particularly the Pompeiian mosaic of the Alexander Battle are examples. The mosaic already places the action on level ground rising to the middle distance. Nor are the Persians and Greeks fighting in empty space as they are in *The Battle of Heraclius*. A barren tree around which the Greeks advance defines the grim atmosphere of the scene.

The use of perspective could not, however, ensure a more accurate depiction of combat. In the early 1520s Guilio Romano painted a fresco of *The Battle of Constantine* in the Vatican—the same event that Piero della Francesca had included in his cycle on the legend of the true cross. In the later work the setting is far more specific—a range of hills and a bridge outside of Rome can be identified—and perspective has opened up the battlefield, which is crowded with men fighting and dying. The many separate incidents join to convey an impressive sense of movement, but the picture does not avoid a note of bombast. The bravura execution is hand-icapped by an oddly mechanical repetition of rhetorical devices: wide-eyed horses with flut-tering manes, bearded soldiers staring with determination or despair, the fleshiness of horses and of nearly naked men. The armor, weapons, and scraps of clothes are partly Renaissance fantasies, partly those of Imperial Rome; more than a few poses are based on Roman friezes,

so that despite the work's turbulence and pathos, it has been suggested that "as a whole [it] is strongly influenced by Roman sculpture."[3]

The same commentator writes that "in its general conception, the *Battle* may be considered a descendant of Leonardo's unfinished painting on the walls of the Sala del Cinquecento, the first battle scene of modern times which really looked like a battle." It is difficult to agree with this judgment, either in respect to the character of Leonardo da Vinci's fresco or in the claim of a relationship between it and Guilio Romano's work. Leonardo's fragment was destroyed by Vasari, when he, in turn, painted the walls of the council chamber in the Palazzo Vecchio. We know Leonardo's intentions only from a few surviving sketches of details, some descriptions of the cartoon he prepared, now also lost, and from copies by Rubens and others of a central episode, *The Fight for the Standard*, in which Leonardo explores the emotions of violence and fear in a monumental, intensely dynamic cluster of men and horses. Perhaps this was a step toward the first work of art since antiquity that "really looked like a battle," but it is impossible for us to know.

❀ ❀ ❀

Both Piero della Francesca and Uccello painted pictures of imagined battles. Piero painted an episode of the remote past, about which practically nothing was known and that had become part of a religious legend. Few directives and prohibitions stood in the artist's way. Uccello painted a contemporary or near-contemporary event about which a great deal was known—from the time and place of the battle and the size and makeup of the forces engaged to details of dress and weapons—even if some of the information was distorted. The artist's patron and the environment in which and for which he worked imposed certain demands and guidelines but nevertheless left him considerable scope.

The fresco interprets the Battle of Heraclius as an ethical challenge accepted, as a supreme duty owed by Christian warriors to the true cross and to the values it represents. But, as noted above, except for the emperor and a few others the Christians are not clearly differentiated from their Persian opponents, who—although unenlightened—are equally committed, and the battle may be read as a double allegory of the struggle between good and bad in man and of the existential drama of the individual isolated in the mass, facing death. The Battle of San Romano is also a matter of life and death, but it is shown as a disciplined action of the community against a clearly defined enemy, serving the policy of the Florentine state and the politics of the Medici, who supported the expedition that led to the battle and who paid for its commemoration.

In the fresco, the commanders of the two armies are identified, but they nearly disappear in the unformed mass of fighters. In each of the three panels a commander is the focal point,

3. Frederick Hartt, *Guilio Romano*, vol. 1 (New Haven and London, 1958), p. 47. The following quotation is from the same work, pp. 47–48.

and in the two flanking panels it is not only their place in the composition but also their appearance that makes the two condottieri stand out. In the midst of charging horsemen they wear enormous ceremonial hats, almost as large as banners, an instance of poetic license that leaves their faces free and allows them to be recognized. But unlike their counterparts in the fresco, they are surrounded by clearly articulated groups of men, acting in concert under a hierarchy of command. The structure is somewhat obscured in the right panel, which is dominated by armored knights. In the left and central panels, however, differences in function and rank are apparent in the Florentine forces that spread from the compact groups in the foreground to the separate units and dispersed individuals on the hillside behind them. The figures in the background especially, who are too often inaccurately dismissed as extras engaged in a hunt—an unlikely activity at this juncture—expand the glorification of the two condottieri and their principal lieutenants into a true outline of an armed force engaging an enemy. Pageantry is if not replaced then joined by something more down-to-earth and important than a procession or tournament. Despite great differences in rank and status, commanders, knights, and ordinary men-at-arms are shown acting together in a common enterprise.

❀ ❀ ❀

In the middle background of *The Unhorsing of Bernardino della Carda* (Fig. 2.3), near the painting's vanishing point, a crossbowman draws back the string of his weapon, and with this closely observed figure of a soldier engaged in his professional task we return to the world of Niklaus Manuel's halberdier. The soldier is one of a number of crossbowmen of both armies in *The Battle of San Romano*. Some are scattered over the hillside in the left and central panels; others are in the middle of the clash in the foreground. The man, his legs in parti-colored hose far apart, bends over his crossbow, which like the others in the painting has a long stock, over half the man's height. Crossbows were of different types, made with different methods of drawing back the bowstring, an action that required mechanical assistance of one form or another, and Uccello shows exactly the kind of weapon the man is using and the stage he has reached in the process of arming it. A few seconds earlier the man had placed his right foot in a stirrup fixed at the front end of the bow and now holds the weapon firmly to the ground. A cord runs from his belt over the wheel of a small pulley, which is hooked over the bowstring, to a rivet or nail on the stock. When he straightens his legs and back, he tightens the cord, which draws back the bowstring to a nut. The man has just fixed the string in the firing position. He must still unhook the pulley, turn the weapon, and place a bolt or arrow into the groove on top of the stock. Finally he will pull the trigger to depress the nut, which releases the bowstring.[4]

4. My analysis is based on Ralph Payne-Gallwey's detailed study, *The Crossbow* (London, 1903 [reprinted 1990]). The author refers to *The Martyrdom of San Sebastian* by Antonio and Piero del Pollaiuolo for a contemporary picture of crossbowmen drawing back the strings of their weapons. Their crossbows are shorter than those painted by Uccello, but the method of drawing the bowstring is the same, and the cord and pulley and the construction of the stock are shown in precise detail.

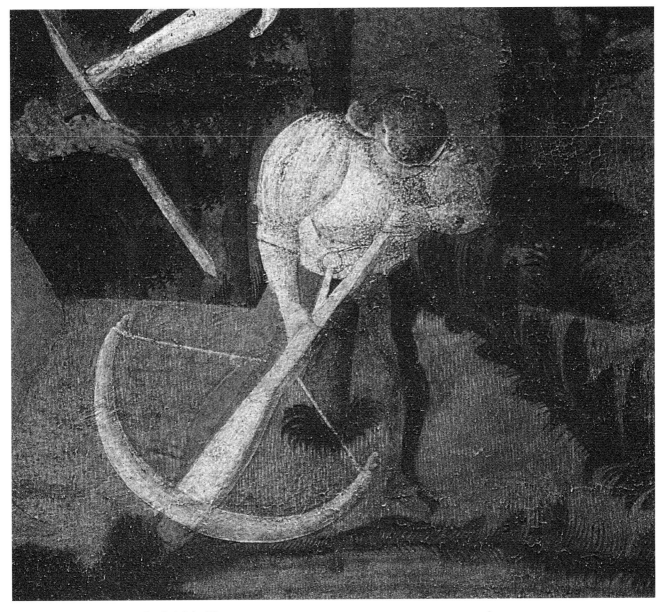

FIGURE 2.3. *Paolo Uccello, detail of Color Plate 1.*

The small metal attachments and notching are on top of the stock, turned away from the viewer. But Uccello shows the taut cord, of the same color as the man's white blouse and belt, that runs from his belt to the stock of the crossbow. The stirrup is difficult to make out but is clearly visible on other crossbows in the panel. The man, busying himself with his modest mechanical device, in his plain steel cap and simple clothes far removed from the splendor of his betters, is certainly not part of a pageant even though he is placed in the center of the painting; he is merely a cog in the military machine that is at work in the Tuscan hills. But he and his peers are essential cogs nonetheless, and they are not dismissed by the artist as ciphers or stock figures.

Another, more complex indication of the relationship between commander, subordinate officers, and rank and file may be the young Sienese behind the falling knight. He is of higher social rank than the crossbowman, but only a step or two above him in the military hierarchy. Yet he is pictorially conflated with the falling condottiere, and as a visual extension of his commander he once again compels us to visualize war as more than a contest between princes and their deputies.

Behind Uccello's sober and realistic depiction of the common fighting man, a tradition stretches far back to the Middle Ages. Early stylized representations gave way over time to more detailed renderings, in which the individual emerged from the shell of the general and typical. Not only princes and commanders but also their many ordinary followers were shown in depictions of recent events—as in the Bayeaux Tapestry or in the illustrations to the chronicles of the many wars, crusades, and local quarrels—but even more often in scenes from the Old and New Testaments. Because arms and armor survive better than do leather and cloth, much of our knowledge of the ordinary men-at-arms and retainers who made up the mass of the armed bands and levies of medieval Europe comes from images of religious themes. Renaissance artists continued to paint the soldiers, town guards, and armed peasants of their own day as participants and witnesses in episodes of the Gospels and of the lives of saints, together with men wearing the helmets and armor of antiquity or the turbans and chain mail of an imagined, timeless Muslim or Jewish world. A work such as Dürer's *Large Passion* includes an exhaustive survey by the endlessly fascinated artist of the clothes, equipment, and mannerisms of Central and South German knights and armed men.

In Germany and Switzerland, in particular, the theme of the individual soldier gained in importance. Artists began to study knights and men-at-arms not merely as supporting actors to be inserted in larger compositions as needed, but for their own sake and even as the central or sole figure in a finished work. They might still be presented in religious guise—St. George appears in every conceivable martial form, from a member of the high nobility in profusely decorated tournament armor to the local squire, in breastplate, dented helmet, and floppy half boots. But often they were lifted out of a formal religious context altogether. Woodcuts and engravings based on sketches of figures and scenes of contemporary urban and rural life and of men-at-arms on the road, in camp, and in battle found a market among a wider public, in part because service in the ranks did not yet signify a serious loss of status. Sons of solid burghers and well-to-do peasants joined a levy or hired themselves out for a campaign, then returned to civilian life, an alternation especially frequent in Swiss society. The burgher who had fought in Lombardy or against the Burgundians, and might serve again, could even become a buyer of images that reminded him of his experiences as a fighting man. When the easy movement between life as a civilian and as a soldier was inhibited by political and economic changes and more rigidly stratified societies, the serious treatment of the common soldier in art also faded. An aspect of the reality of war that artists like Dürer and Holbein the Younger readily incorporated in their work had largely disappeared from art by the age of the baroque and the growth of the centralized, absolutist state.

The prints were sold by printers and publishers, by the artists themselves, and by peddlers like the otherwise unknown Contz Sweytzer, who in 1497 signed a contract with Dürer under which, in return for a weekly salary and expenses, he bound himself for a year to offer the artist's prints for sale, "from one land to another, and from one town to the other," to seek high prices, waste no time in places where there was no demand for the goods, and periodically remit the proceeds to Nuremberg.[5] Because armed men were a part of the daily scene, prints of soldiers combined the authority of eyewitness notations with the appeal of the familiar. When, as occasionally happened, an artist was present at a siege or battle, or himself served as a soldier, the scope of the genre was further expanded.

Urs Graf, one of the strongest among the artists who worked on these themes, served with Swiss contingents for a number of years and in 1515 fought in the Battle of Marignano, a climactic event in the military and political history of the Swiss, to which this essay will return in a later chapter. In the year of Marignano, Graf drew a scene that may refer to disagreements among the Swiss before the battle (Fig. 2.4): Swiss mercenaries are gathered around their captain, the bearded man with a shock of ostrich feathers in his cap, and—John Hale suggests—may be debating whether they should fight even though they have not received their promised pay.[6] The troop's banner, a billowing dark mass, strengthens the composition and symbolizes the group's unity, which is never in question, whether the men decide to march home or toward the enemy. Their clothes and weapons, and the way they stand, talk, and listen, are observed in exact detail. Like Manuel's halberdier and Uccello's crossbowman they convey a sense of the soldier on campaign as autonomous in the work of art as he is in life.

Images such as Urs Graf's sketch of Swiss mercenaries could combine the careful notation of external appearance with symbols and the supernatural to state a general message in another way: the soldier's freedom from constraint and convention, the threat he posed to the peaceful routine of society, but also his changeable and dangerous existence. He is shown burdened with loot but crippled, or dependent on a camp follower, or conversing or fighting with Death, imagined as a skeleton or moldering corpse. Some prints go further—Manuel's *Swiss Man-at-Arms* may be an example—and interpret the fighting man as the representative of mankind, himself made a symbol by his dangerous calling. Dürer chooses this subject in a broadsheet in which he combines an image with a poem of thirty-eight couplets on a godly life as the only force that can overcome the fear of death (Fig. 2.5). The woodcut is a variant of the old theme of man in discourse with Death. A Landsknecht and the personification of Death meet in what appears to be a field or yard. High walls, which may enclose the entire space beyond the border of the image, bar any exit; an open coffin, leaned against the wall behind Death, repeats the rectangular space in which man and apparition face each other. On the ground, a bone and

5. Entry in the Verbriefungsbuch von Nürnberg, July 8, 1497; Nürnberg, Stadtarchiv (Lib. Cons. K, fol. 132ᵛ), cited in *Albrecht Dürer, 1471–1971*, catalogue of the exhibition in the Germanische Nationalmuseum (Nuremberg, 1971), p. 43.

6. Hale, *Artists and Warfare in the Renaissance*, p. 2.

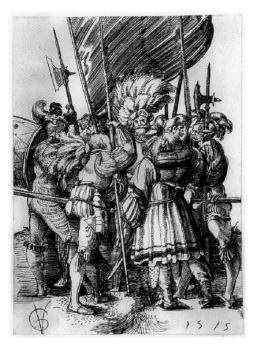

FIGURE 2.4. *Urs Graf,* Swiss Men-at-Arms in Council, *1515. Kupferstichkabinett, Öffentliche Kunstsammlung Basel.*

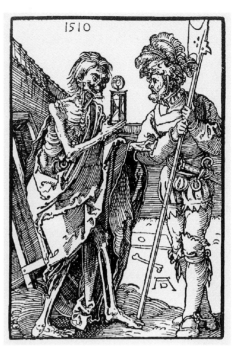

FIGURE 2.5. *Albrecht Dürer,* Death and the Landsknecht, *1510. Private collection.*

FIGURE 2.6. *Hans Holbein the Younger,* The Knight, *from* The Dance of Death, *1523–26. Private collection.*

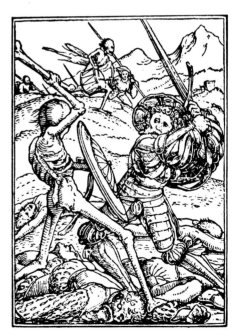

FIGURE 2.7. *Hans Holbein the Younger,* The Landsknecht, *from* The Dance of Death, *1523–26. Private collection.*

what appears to be the lid of the coffin underscore the equivalence between the larger and smaller space. Death holds up an hourglass to the Landsknecht, who calmly awaits his inevitable fate. The man's vigorous face, framed by a strong beard and a profusely plumed hat, is matched on the other side of the hourglass by the apparition's head—half face, half skull—with lank hair and a few wisps on his chin. A couplet above the woodcut—"There is no cure for death / Therefore serve God early and late"—spells out the lesson of the image, repeated in different terms throughout the poem, with the ultimate promise that "Wer ein lauters gwissen hat / Der furcht den tod nit frü und spat."[7]

A more dynamic but perhaps less subtle variation of this motif is included in Holbein's *Dance of Death*, his version of the medieval pageant in which men and women are swept or dragged away, whatever their character and position in life. In the woodcut *The Knight* (Fig. 2.6), Holbein adds a twist to the theme of mankind's common fate by noting the heightened danger that men face who live by the sword. Death, wrapped in chain mail and sporting a cuirass and thigh guards, has driven his lance through a knight, whose somewhat outdated armor and massed plumage—both status symbols—are unable to save him. A note of social criticism, intermittently heard throughout the *Dance of Death*, is sounded in this image. It is absent in another print of the sequence, *The Landsknecht* (Fig. 2.7). A German mercenary, wielding a two-handed sword, battles Death, who strikes at him with a thigh bone. Dead soldiers lie at their feet, and in the distance a second wasted corpse, beating a drum, runs ahead of other mercenaries and leads them to perdition.

The images we have considered mark stages in a process of aesthetic recognition and interpretation. The process does not yet constitute an evolutionary or even a developmental line, but accommodates a variety of options between which it moves back and forth. As these options unfold we recognize the beginnings of subsequent patterns, which in the nineteenth century will coalesce into definable advances toward specific goals.

We have seen battle depicted in a traditional vocabulary, often drawing on Roman precedents, but also with a new interest in contemporary phenomena and a sense of their importance. Battle may be shown as the action of undifferentiated followers of a leader, who fights in the service of God or the community, or as the agent of his own greatness, and is singled out in the composition. In some works, and increasingly so in the later sixteenth and seventeenth centuries, the event depicted may appear as little more than an extension of the leader's stature. The glorification of the prince or commander or of an elite such as a group of knights may narrow the interpretation of the mass of fighters, but it need not do so. The common halberdier or archer may also emerge as an individual, whose humanity the artist studies with the same serious interest that he devotes to a condottiere or to a figure of the Gospels. Under certain social and economic conditions—in which a market develops for graphics and the artist is released from certain constraints of patronage, and in which no firm line is drawn between an

7. The woodcut with the verses is reproduced in *The Illustrated Bartsch*, vol. 10, *Albrecht Dürer*, ed. Walter L. Strauss (New York, 1980), p. 227.

underclass of mercenaries and the rest of society, which then may make the mercenary a more appealing and saleable subject for the artist—the ordinary soldier may even become the focus of if not a fresco, then of a woodcut or an engraving. Changes in warfare and the social movements of the fifteenth and early sixteenth centuries facilitate his emergence, until further changes in society, in military organization, and in the economic opportunities of the artist again restrict the place of the ordinary soldier in high art.

3

The Revenge of the Peasants

In the seventeenth etching of Jacques Callot's *Les Misères et les malheurs de la guerre*, a series published in 1633 usually referred to in English as *The Large Miseries of War*, peasants are seen ambushing a column of soldiers (Fig. 3.1). The scene—Callot's theatrical arrangement of the setting suggests this word—is a dirt road at the edge of a forest. The road runs from a church and a few houses in the far background toward and past the viewer, and continues beyond the left edge of the image. In an organic version of an architectural stage design, heavy oaks—slightly set back on the left—frame the area where the action takes place.

From branches of the two trees at the extreme left and right, peasants fire their muskets at soldiers below. Three peasants, two armed with pitchforks, the third with a club, have burst from their hiding place behind the tree on the right and are beating a bearded soldier, who has already fallen to the ground. In his right hand he holds up a bag in a vain attempt to save his life by surrendering goods he has stolen. Behind him, other peasants are running from the trees into the road. A soldier, sword drawn, faces them; he has just been shot and is falling backward. Another lies dead on the ground. Still farther in the background, near the center of the scene, a man strikes at another who is lying on his back. Toward the left, a four-wheeled wagon, loaded with trunks and bags, has been halted. A peasant has jumped on the wagon and is swinging his club at a woman, a camp follower who makes up part of the wagon's load. Another hits with his flail at a man who is falling head first from the wagon. A third peasant climbs up the spokes of one of the wheels, and a fourth already carries off a large trunk. Above the wagon, from a dead tree at the edge of the woods, hangs a body—presumably

FIGURE 3.1. *Jacques Callot,* The Revenge of the Peasants, *no. 17 of* The Large Miseries of War, *1633. The Art Museum, Princeton University. Bequest of Junius S. Morgan.*

a peasant killed earlier by the soldiers who have now become victims or by another group of marauders. The corpse is an explanation and justification of the carnage, and signals the breakdown of civil order and the general horror of the times.

In the middle distance and foreground to the left of the hanged man, peasants armed with flails and pitchforks are chasing the lead part of the column. In the center foreground a peasant strikes with his flail at a soldier who has already collapsed, while another man has dropped a club to free his hands and is pulling off the victim's boots. Beside them, a peasant kneels over a dead or dying man and triumphantly holds up the object or objects he has recovered—a purse, perhaps, or a chain or two. Debris of the ambush litters the ground: clothing, corpses, a sheep—its legs tied—and two chickens, which the fleeing soldiers are leaving behind, a banner, and a drum, its drumskin torn.

The Revenge of the Peasants is one of a group of plates in *The Large Miseries of War* that deal with retribution for the misdeeds committed by soldiers on campaign. If this statement seems a little vague—why does it not specify "undisciplined soldiers" or "soldiers who have deserted and now loot and kill"?—it is because of an ambiguity that runs through the series. The subjects of the first two plates after the title page are normal activities of armed forces—recruitment and battle. They are followed by five etchings that depict instances of violence against the population. Between this group and five plates detailing various punishments from hanging to burning at the stake, an etching shows a small detachment of soldiers searching for deserters who are hiding in bushes and among trees. Seven or eight have already been caught and, hands tied behind their backs, are being marched alongside the searchers until the patrol returns to camp. After the five plates on punishments, two etchings expose the sad fate that even disciplined soldiers may expect. Some eke out their existence in a hospital; others beg or

FIGURE 3.2. *Jacques Callot,* The Pillage of an Inn, *no. 4 of* The Large Miseries of War, *1633. The Art Museum, Princeton University. Bequest of Junius S. Morgan.*

die by the roadside. Then comes *The Revenge of the Peasants*. The last etching shows the distribution of rewards to men who have served honorably. Neither this image nor the first two that show men enrolling and fighting directly address the miseries and misfortunes of war; they provide a narrative framework for the rest.

Callot's placement of *The Revenge of the Peasants* in the series seems to suggest that being ambushed by peasants is a fate that may befall any soldier—similar to being killed, crippled, or abandoned. The etching is not associated with the plates that have military justice as their subject, but with two images that emphasize chance and danger in the soldier's life and that deal with the interaction of soldiers and civilians in situations in which soldiers are no longer dominant. But not too much should be read into the sequence of the images. More important are the specific circumstances of mistreatment of civilians in the five plates devoted to this theme. Three of the plates do indeed show small groups of soldiers acting or seeming to act against orders. In *The Pillage of an Inn* (Fig. 3.2), looters running from an inn are confronted by a detachment of soldiers. In two other etchings, soldiers loot, rape, torture, and murder without anyone attempting to stop them. The three plates conform to the general theme of deserters, now perhaps banded together in gangs of outlaws, who are tracked down by the military authorities and punished, whereas honorable soldiers are rewarded.

The other two etchings in the group of five devoted to crimes against society do not fit this pattern. In both, large and disciplined forces are at work. The soldiers in *Destruction of a Convent* (Fig. 3.3) appear to carry out the various tasks of pillage, burning, and driving away the convent's sheep under the orders of a senior officer on horseback on the far right, who is gesturing with a commander's baton. The crucifix, candelabras, monstrance, and other objects from the altar of the church that is burning in the background are neatly laid out on the ground

FIGURE 3.3. *Jacques Callot,* Destruction of a Convent, *no. 6 of* The Large Miseries of War, *1633. The Art Museum, Princeton University. Bequest of Junius S. Morgan.*

in the center of the image, preparatory to being loaded on a wagon with other booty. That two or three of the nuns are about to be raped, and that an old priest is mocked and threatened, may be no more than unavoidable incidents in the process of a unit resupplying itself, although the soldier, wearing a chasuble and carrying a large book, perhaps a Bible, under his arm, who is walking toward the commanding officer seems to point to a religious motive for the outrage: the destruction of a Catholic institution by Protestant forces.

The disciplined rather than undisciplined character of mistreatment is even more apparent in the fifth plate of the group, *Plundering and Burning of a Village* (Fig. 3.4). A sizable force of cavalry and infantry has looted a village, set it on fire, and is now leaving. On the left, a troop of horsemen makes its way out of the village, followed by a few musketeers, prisoners, and some of the villagers' livestock. A mounted trumpeter, instrument at his lips, calls on laggards to assemble and move out. Men are still carrying bags and trunks from houses that are already burning. In the background, a large number of soldiers leave a church, also burning, to join the main group, urged on by a drummer, who repeats the trumpeter's signal on his own instrument. In the right background, another troop of horsemen has formed a rear guard. In the foreground more farm animals are being driven away, past two corpses, while by a tree at the extreme left a soldier kills one last villager.

Whether the soldiers in these two etchings are large gangs of outlaws or disciplined troops under the control of their commanders is thus at best left unclear. It may be added that the captions the Abbé de Marolles wrote for each image contribute nothing to its interpretation. As poetry they are banal; as commentary, so general and superficial as to be almost meaningless. Nor can we ascertain the extent to which the poet reflected the artist's intention. In any case, the actions that form the core of *The Large Miseries of War* are not fantasies but were carried out

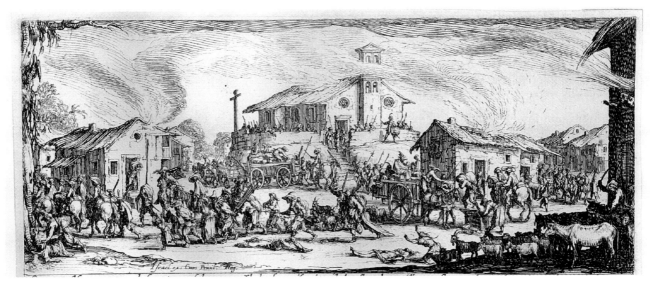

FIGURE 3.4. *Jacques Callot,* Plundering and Burning of a Village, *no. 7 of* The Large Miseries of War, *1633. The Art Museum, Princeton University. Bequest of Junius S. Morgan.*

numerous times on all sides during the Thirty Years' War, when supply systems were slow and inflexible, pay could be late, soldiers often lived off the land, religious ideology still played a major role, and the devastation of territory was a recognized and frequently practiced method of applying pressure on one's opponent. The companies and squadrons that pillaged the convent and destroyed the village certainly were not the scattered deserters tracked by the patrol in *The Discovery of the Criminal Soldiers.* That the victims of the ambush in *The Revenge of the Peasants* carried their banner and a drum with them reinforces the impression that in some of the etchings Callot was thinking not of small groups of criminals but of soldiers in general and of the effect that war had on society.

The Large Miseries of War reflect in accurate detail not only some aspects of warfare of the time, but also the nature of its military institutions. By the 1630s a long transition had led from the untrained or barely trained men thrown together for a campaign in the early Renaissance to closely administered forces, equipped with standardized arms, commanded by an increasingly complex hierarchy of officers and noncommissioned officers, and drilled according to manuals that steadily refined tactical and operational doctrine. War was being bureaucratized. The Swedish articles of war of 1621, for example, listed 150 delicts, punishments, and admonitions, to which 20 more were added in the revised version ten years later. Under the pressure of codified discipline, the knight's sense of personal sovereignty and the rough democracy of the Swiss mercenary and the German Landsknecht withered. Most soldiers still hired themselves out, and permanent units still made up no more than a small segment of the armed forces of Europe, which consisted mainly of short-term mercenaries, serving in units raised by the state or a military contractor for the duration. But the institutional framework of the standing army was being built into the expanding administration of the centralizing state, and some

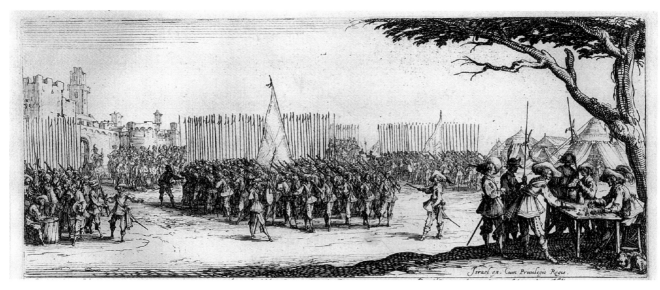

FIGURE 3.5. *Jacques Callot,* The Enrollment of Troops, *no. 2 of* The Large Miseries of War, *1633. The Art Museum, Princeton University. Bequest of Junius S. Morgan.*

governments were already recasting their views concerning the military obligations owed by their subjects. The traditional duty to defend one's village or county was being transformed into a more encompassing duty of military service owed to the larger community. Gradually compulsory enrollment—for the time being affecting only the poorest groups—began to take its place alongside the hiring of native and foreign volunteers in the manpower policies of the major as well as some of the smaller states on the European continent. By the end of the eighteenth century that development was to change the relationship of the individual to the state, the nature of the state itself, and with it the nature of war.

If Callot did not himself witness the worst excesses depicted in *The Large Miseries of War*, he certainly observed much military activity in the years before he produced the series. His native Lorraine, to which he had returned from Florence in 1621, lay across a north-south route heavily used by armies during the Thirty Years' War. To assert control over the region on France's eastern border, French forces entered Lorraine in 1631 and again the following year. After the reigning duke joined the anti-French alliance in 1633, French troops returned and besieged and occupied Nancy. The etchings are the work of an informed eye. The first, *The Enrollment of Troops* (Fig. 3.5), reports details of the organizational changes—the regularization and standardization—that now marked armed forces. Under a tree on the right, soldiers are collecting bounty money from an officer as a clerk checks off their names. At the left edge of the picture, two newly enrolled men, hats under their arms, report to an officer or sergeant, who is using a drum as his desk while entering their names on the company rolls. Watched by the rest of the company, one half armed with muskets, the other with pikes, another newcomer is handed a musket by an officer. In the open field between this group and the recruiting officer on the right, other formations are drawn up in two lines: in front two units of infantry, the

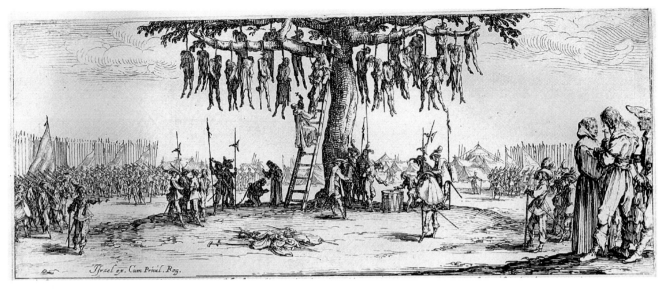

FIGURE 3.6. *Jacques Callot,* The Hanging, *no. 11 of* The Large Miseries of War, *1633. The Art Museum, Princeton University. Bequest of Junius S. Morgan.*

first ranks armed with muskets, the rear ranks with pikes. Officers and sergeants check their alignment under the supervision of a senior officer. Farther back, in the intervals between these formations, two squadrons are aligned with similar precision—one armed with carbines, the other with lances. In each unit, the soldiers are dressed identically. In the campaign ahead their clothes will revert to the profuse variety of earlier years, and the men will make do with badges or armbands, but the times of uniforms and uniformity are at hand.

The geometric formations in which the men train will bend and come apart in the confusion and mayhem of the second plate, *The Battle,* but they reappear in the later etchings on military punishments (e.g., Fig. 3.6). Troops are drawn up to witness executions, banners unfurled, lances at parade rest, muskets shouldered; officers and noncommissioned officers maintain silence while the sentence is carried out on the condemned men and others waiting their turn receive final absolution. The military power of the political community has been rationalized and given a more mechanical cast, which disciplines and subordinates the native energy of the individual for the greater effectiveness of the whole.

It is this engine, its parts more numerous and varied and their interaction more complex than had been the case two centuries earlier, that appears in *The Large Miseries of War.* In the 1630s, when armies had devastated Central Europe for half a generation and peace seemed far away, a sophisticated pictorial narrative of contemporary war might be expected to find an interested audience, even if it eschewed the usual heroics for a close examination of the impact of war on society and of the physically dangerous and morally ambiguous existence of soldiers, whether criminal or honorable. The work was not commissioned. Callot chose the subject himself and determined how he would approach it: by looking at the actions of the soldier, not at their political or ideological causes. In the etchings Callot speaks neither as a Lorraine

patriot nor—although the work was published in Paris—in the interests of the French monarchy. Despite the mass of contemporary detail in each image, he takes care not to associate his scenes of devastation with any particular army or party. Only one etching, *Destruction of a Convent*, suggests partisanship, and presumably the sale of the work on the international market—it was issued in 1,500 sets and proved a commercial success—was assisted by its political ambiguity.

The almost complete separation of war from its political moorings, and the emphasis placed on the part played in war by criminality and violent punishment, may tempt us to assume that the work equates war and crime. Perhaps its message is no less universal but more complex: war, whatever its causes, nourishes crime and visits misfortune on the just and unjust alike. Callot repeats and develops these themes in the two subject areas that take up the most space in the series: violence spilling over to civilian society, which I have already discussed at length, and the life of the common soldier.

In a reference to three earlier works by Callot, which combine military topography with genre scenes, Daniel Ternois observes that "what seems to have interested Callot above all is the depiction of a soldier's life."[1] His comment applies with even greater justice to *The Large Miseries of War*. The etchings break away from the topos—now common—of glorifying the great commander. Only the last and least interesting plate in the series places the general or monarch at the center as the fount of honor. In the others there are no principal and supporting or minor figures; even where senior officers appear, they are not singled out but perform their duties as members of a large organization. Instead, the common soldier is examined in various states of existence: encadred in his unit, committing crimes in obedience or in defiance of orders, pursued by the authorities, awaiting execution, the victim of popular outrage, the abandoned and broken veteran, and the good and fortunate soldier who is rewarded. The life of the rank and file is depicted in many—though certainly not in all—of its phases, with a matter-of-fact realism that neither patronizes him nor turns him into a hero. He is met on his own level; on his *kreatürliche Ebene*, as Erich Auerbach might have put it had he extended *Mimesis* to images. Missing, and what Callot cannot provide because of the small scale in which he works—most of the etchings in *The Large Miseries of War* measure 82 by 185 millimeters—is the intense concentration on the individual and on his psychology that characterizes earlier images of the common fighting man by Dürer or Urs Graf.

It does not detract from the etchings' aura of circumstantial and credible violence that some of the plates, as was noted at the beginning of this discussion, are marked by a distinct theatricality. Even common soldiers may appear in the images with a degree of elegance that quickly strikes us as entirely natural. And despite their earthiness and their bloody work, more than a few seem interchangeable with the figures that populate the ballet scenes that Callot drew nearly twenty years earlier at the court of the grand duke of Tuscany or his illustrations of the tragedy *Il Solimano*. A pose encountered in many of the etchings of *The Large Miseries of*

1. Daniel Ternois, *L'Art de Jacques Callot* (Paris, 1962), p. 195.

War—though not in *The Revenge of the Peasants*, where all is motion—has men standing with the weight on their rear leg and the other leg thrust forward, the foot pointed and slightly turned to the outside. The posture, which conveys the self-image of elegant masculinity often encountered in Baroque realism, is the same whether assumed by an officer or a musketeer; it is an element in the code of images by which the common brutality of the subject is raised to the level of formal drama.

Each of the motifs of the soldier's existence in Callot's narrative had been treated before. Even the theme of civilians turning on soldiers was not without precedence in Renaissance and Baroque art. Exceptional in the eighteen plates, however, is Callot's combination of these situations into an account of warfare at its lowest level, a string of incidents involving common soldiers and ordinary people, each of which intensifies and adds to the series' depiction of a vast human tragedy.

❀ ❀ ❀

The life of the ordinary soldier, which Callot dignified by giving it dramatic value and unity, a sequence of events in which the leading character is not an individual but a social group, could also be treated on a lower plane. By the seventeenth century, the market for graphics and paintings of scenes of everyday life had greatly expanded, and works on historical and military themes made up an important segment of the genre. The many artists who now specialized in this field drew some of their inspiration from motifs in classical and Renaissance depictions of battle. Such well-known practitioners as Nicolaes Berchem and Pieter van Laer transposed the friezelike representations as well as many individual motifs from antique sarcophagi to their large and often gory oils of cavalry encounters or of wagon trains ambushed. Another example of borrowing from the past is the motif of men fighting on a bridge, which became very popular. The struggle on the Ponte Molle over the Tiber, which Guilio Romano had incorporated in his version of the battle between Constantine and Maxentius, and which Titian and Rubens had transposed to other or imagined locations, reappeared in dozens of tame adaptations. Among the compositional drawings Callot made for *The Large Miseries of War*, one shows a battle on a bridge, but he did not include the motif in the series. The contrast between solid ground, the flowing river (itself a source of danger), and the elevated band of masonry across the water, which concentrates the opposing forces into the narrowest of arenas; men fighting on different levels and falling or jumping from the bridge—these theatrics appealed to buyers who undoubtedly valued their own prosperous existence, feared its disruption by the violence of the time, and exorcised the danger by hanging rectangles of painted mayhem on the walls of their libraries and dining rooms.

Whether on a bridge or across open fields, the preferred type of combat in these paintings was the clash of horsemen, which offered richer occasions for drama than soldiers on foot could provide—another sign that the reality of the subject was not foremost in the minds of the artist and his customers. Nor were the adversaries invariably identified. The paintings— often the equivalent of undemanding adventure and robber tales in print—tended to take war

in general as their subject. An exception was the work of artists holding official positions. To them, identifiable references were important, and these are often present even when their paintings were intended for private buyers.

Not all works of military genre painting depicted battle. Soldiers making camp, standing guard, requisitioning food and fodder, drinking, and quarreling—the whole array of military life was represented in hundreds, if not thousands of images sold across Europe. In these works, writes Jacob Burckhardt, "there is much haste and much plagiarism, but at least they are true to nature and full of life"—a comment perhaps more applicable to particular figures and other details than to the overall concept of the clash of two large forces.[2] An example of some quality is a camp scene of an unidentified force by Jacques Courtois, called Le Bourguignon, who as a young man served with armies in Italy and knew combat and the daily life of the soldier at firsthand. The painting, called *Battle Scene* (Fig. 3.7), should really bear the title "After the Battle." In an undulating plain a commanding officer receives a report from a subordinate, who has taken off his hat as a sign of respect. To the left, a standard bearer marks the location of the general; officers on horseback go about the business of reorganizing troops after the battle; in the foreground and middle distance soldiers are plundering the bodies of men who died in the fighting. In the left rear we see a typical Italian hilltown, and on the right the tents of the army. The earthy realism of the scene is not lessened by the artist's use of poses that recur in his other paintings: the s-curve of the commander looking to the right, his horse to the left; the standard bearer seen from the back—these are elements of a familiar alphabet that depicts the reality of war soberly, often in a narrative manner, but on the whole uncritically as the natural behavior of men and states.

Genre paintings present one side of war, the side that is seen by the men in the ranks and by their immediate superiors. Other aspects of the subject are approached from a different perspective. One subtype, which became fully developed in the seventeenth century, shows the formation of the opposing forces at the beginning or climax of a battle—the two phases might be compressed in one image—wide-angled *vedute* that encompassed the entire battlefield, often combined with the portrait of the victorious commander in a cartouche or in full figure on a rise of ground overlooking the scene of his triumph. Callot produced several pictures of this kind, among them *The Siege of Breda* in 1628, a work that won him fame throughout Europe. It consists of six etchings, joined in a rectangle as large as a mid-sized painting. Four-fifths of the work shows the topography around the fortified town and the positions of the besieging and defending forces. In the foreground, the Spanish commander, the Marquis Spinola, observes a high personage—probably the Infanta Isabella—and her entourage proceed to the captured town, while to the left Callot and a military engineer survey the terrain preparatory to drawing the map on which the engraving is based—an allusion to Callot's visit to the battlefield two years after the town had surrendered.

From the image that combined a representation of the commander with a serious account

2. Jacob Burckhardt, *Erinnerungen aus Rubens* (Vienna, 1938), p. 183.

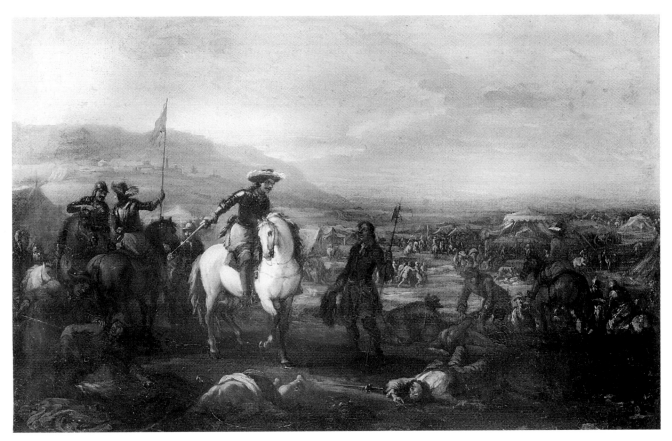

FIGURE 3.7. *Jacques Courtois,* Battle Scene, *ca. 1660. Musée des Beaux-Arts, Caen.*

of the battle it was only a short step to the image that reduced battle to an event incidental to the commander's glorification. By the seventeenth century the ceremonial battle portrait, often the work of an artist holding an official appointment, had become an established topos. Characteristic practitioners were Pieter Snayers, painter to the Spanish Habsburgs in Flanders, and his pupil Adam Frans van der Meulen, employed as *peintre des conquêtes du Roi,* who accompanied Louis XIV in the Dutch Wars. Both master and pupil became known for the care they took in the detailed rendering of the topography, formations, and uniforms of particular battles. But these merely set the stage for the work's real purpose. Of van der Meulen's panoramic stylizations of battle from a royal perspective it has been said that "he was more interested in the accurate representation of the king and his protagonists than in violent scenes of war, which were minimized for the benefit of spectacular and decorative effect."[3]

A variant of what may be called the decorous, ceremonial approach can be found in the work of such an artist as Jan van Hughtenbaugh, for many years in the service of Eugene of Savoy, whose well-known paintings of his patron's victories formed the basis for a profitable serial production of smaller copies in his workshop. His works contain specific references to

3. J. de Maere and M. Wabbes, *Illustrated Dictionary of 17th Century Flemish Painters* (Brussels, 1994), 1:276.

actual events, highlighted by imagined, dramatic incidents. The more ceremonial treatment on the one hand and the more vivacious treatment on the other, both glorifying the ruler or his military deputy, set the style for much of what was considered battle painting well into the nineteenth century.

An early paradigm of the ceremonial battle portrait at its most extreme is *The Cardinal-Infante Ferdinand at the Battle of Nördlingen* (Fig. 3.8), by Jan van den Hoecke, retouched by Jacob Jordaens, for the Cardinal-Infante's solemn entry into Antwerp in 1635. The large canvas shows the young man on a charger, accompanied by King Ferdinand II of Hungary, in the victory gained over the German Protestants and their Swedish allies in 1634. The two horsemen take up more than half of the painting. They are surrounded by troops on horse and foot, moving up a hill on the right and advancing across lower ground in the center. The hundreds of soldiers are seen from the back, their faces invisible except for one man at the right edge of the painting, whose profile we see as he turns his head to look at his commander and with this movement helps guide the viewer's eyes back to the focus of the painting.

Intellectually as well as artistically this was hack work, and the appearance of the two princes in a row, exuding authority and charged with divine grace, does not lack a humorous touch. But the point is made with all possible clarity: what counts in the victory of Nördlingen are not the soldiers, but solely their supreme commanders, the imbalance going so far that any link between soldiers and commanders almost disappears.

Paintings such as these are less depictions of war than ideological statements. They are at once assertions of the authority of the prince, propaganda for his policies, and definitions of a political and psychological ideal that is part of a new system of governance, the centralizing state. The prince is shown at the moment of triumph, his calm heroism a function of his personal and dynastic qualities and of his cause, which is just because he has made it his own. On this level of rhetoric and imagery, war appears as an attribute of kingship. The prince has entered the world of gods and heroes of antiquity, the world of allegory, in which political and military conflicts are identified and discussed in terms of universal abstractions. The prince himself often disappears from the allegory, which is then painted as addressing the great issues of faith, authority, war, and peace only with allusions to specific rulers and events, or even without any direct references at all to the present and the recent past.

In March 1638, two years before his death, Rubens sent a recently finished painting to Justus Sustermans, court painter to the grand duke of Tuscany, in Florence. The painting, evidently commissioned by the grand duke, is variously entitled *The Horrors of War*, *The Outbreak of War*, or *The Consequences of War* (Color Plate 2). In an accompanying letter, Rubens described his work in some detail: "As for the subject of the picture, it is very clear, so that with the little I wrote to you about it at the beginning, the remainder will perhaps make itself better understood to your experienced eye than through my explanation. Nevertheless, in order to obey you, I will describe it in a few words."

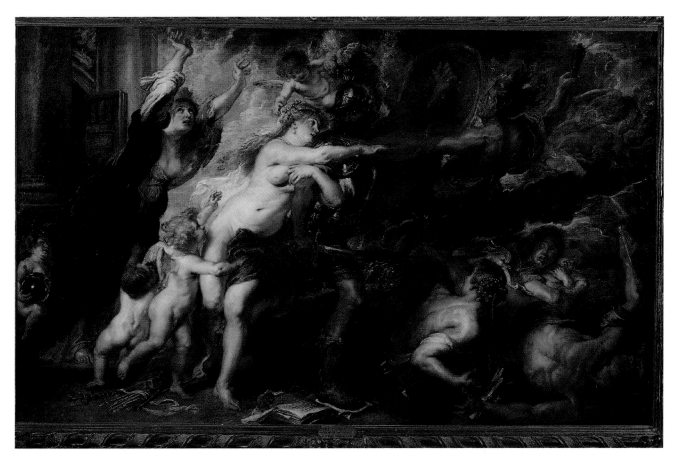

COLOR PLATE 2. *Peter Paul Rubens,* The Consequences of War, *1638. Palazzo Pitti, Florence.*

FIGURE 3.8. *Jan van den Hoecke,* The Cardinal-Infante Ferdinand at the Battle of Nördlingen, *1635.*
© *The Royal Collection, Her Majesty Queen Elizabeth II.*

The principal figure is Mars, who has left the opened temple of Janus (which in time of peace, according to Roman custom, remained closed) and strides forth with shield and blood-stained sword, threatening the nations with great disaster. He pays little heed to Venus, his mistress, who, accompanied by her Amors and Cupids, attempts to hold him back with caresses and embraces. From the other side, Mars is pulled forward by the Fury Alekto, with a torch in her hand. Nearby are monsters, representing Pestilence and Hunger, those inseparable partners of war. On the ground, her back toward us, lies a woman with a broken lute, representing Harmony, which is incompatible with the discord of War, and also a mother with her child in her arms, who shows that fecundity, procreation, and parental love are thwarted by War, which devastates and destroys everything. In addition, one sees an architect thrown on his back, his instruments in his hand, to express that which in time of peace is built for the use and embellishment of cities, is hurled to the ground by the force of arms and falls to ruin. I believe, if I remember rightly, that on the ground under the feet of Mars you will find a book and a sketch on paper, to indicate that he stamps out the sciences and the arts. There ought also to be a bundle of arrows with the ribbon that held them together undone; when bound they form the symbol of Concord.

Beside them I have placed the caduceus and an olive branch, symbols of Peace. But that grief-stricken woman, clothed in black, with torn veil and robbed of all her jewels and her adornments, is unfortunate Europe, victim for so many years now of plunder, outrage, and misery, of which everyone is so fully aware that it is not necessary to go into detail. Europe's attribute is the globe, carried by a small Angel or Genius, and surmounted by the cross, to signify the Christian world.[4]

In his description, Rubens does not say that at the center of the painting, underneath the naked sword of Mars, he painted a distant battle through a gap between the heroic figures who act out the unleashing of war and its consequences. The tiny soldiers—miniatures compared to the vast personifications that fill the canvas—appear like additional drops of blood falling from the curved blade. It is the only direct reference to war in the painting, which otherwise treats its subject allegorically and in the language of classical antiquity. But the battle is a detail that requires no elucidation. That Rubens introduced it at all may have to do with his encompassing sympathies and his familiar eagerness to explore and strengthen the links between symbol and the thing symbolized everywhere. Nor is the detail essential to the interpretation. Despite the dramatic scene, Rubens here treats war from a distance, as it might appear in the cabinet of the prince or the study of the philosopher, where suffering and destruction are certainly understood to be parts of war, but the human costs largely disappear in abstractions, which in the painting are given superhuman form.

The painting's message is unambiguous, if not surprising. War is a misfortune for society and culture. Rubens does not inquire into the causes of this misfortune. It is the nature of Mars to fight and to set men fighting, as it is the nature of the state to use its power. This particular misfortune, like many others, is unavoidable.

We can see that *The Consequences of War* comes close to corresponding on an elevated level to *The Large Miseries of War*. What in 1633 Callot explores through the actions of some soldiers and peasants, Rubens a few years later lifts into a realm where the fates of men and women coalesce into large historical events and the individual disappears in generalizations that are given allegorical expression. Educated society in the seventeenth century valued both approaches. No one can doubt the popularity of paintings of life on a common plane, of the appeal of works of such artists as the Bamboccianti, who aggressively, with irony, sometimes obscenely, painted the world of street markets and inns, of travelers ambushed, and of soldiers clashing in Europe's interminable wars. But fascination with the earthy did not eliminate admiration for depictions in the most elevated manner of the basic forces in public as well as in private life, an approach that produced much of the greatest art of the period.

It was a cultural achievement to be able to treat a subject like war in large concepts. Not

4. Peter Paul Rubens to Justus Sustermans, March 12, 1638, in *The Letters of Peter Paul Rubens*, trans. and ed. Ruth Saunders Magurn (Cambridge, Mass., 1971), pp. 408–9. I have amended a few passages of the translator's version.

that Rubens's painting was an intellectual exploration of war; it was a moral statement that gave voice to a general recognition that war was a form of human and political energy, joined to a sense of sadness over its use and abuse, from which even responsible statesmen and the best-intentioned societies seemed powerless to escape. Ultimately, despite Callot and the hundreds of military genre painters, it was this view, expressed in apotheoses of the prince and allegories of the human condition, that dominated the image of war in the seventeenth century and in much of the following century as well.

4

The Death of General Wolfe

In June 1807 Benjamin West discussed the manner in which a modern painter should depict important and exemplary events from recent history with his fellow artist Joseph Farington, who recorded West's pronouncements in his diary. West was addressing a matter of considerable importance to artists of his time and one relevant to a project that he was soon to undertake; but his declaration was also motivated by a work he had recently completed and by others he had painted in earlier years, and beyond these reached further back to aesthetic conventions of the early and middle eighteenth century. He knew that the opinions he expressed to Farington were no longer universally held—indeed, a painting inspired by an opposing view had led to the discussion—but it is unlikely that he realized how feeble their authority had become.

Thirty-seven years earlier, West, then a young artist best known for his interpretations of subjects from mythology and classical history, had painted an event of the recent past, *The Death of General Wolfe*, a work that caused a sensation and, as West wrote to a colleague, "procured [him] great honour."[1] To satisfy prospective buyers, West produced at least seven replicas of various sizes, and an engraving after the painting sold many thousands of copies. For reasons that had to do both with West's subject and with his manner of treating it, *The Death of General Wolfe* profoundly impressed the segments of British society that took an interest in art.

1. Helmut von Erffa and Allen Staley, *The Paintings of Benjamin West* (New Haven and London, 1986), p. 213.

FIGURE 4.1. *Edward Penny,* The Death of General Wolfe, *1764. The Lord Egremont.*

In June 1759 a British force commanded by James Wolfe scaled the bluffs of the Plains of Abraham south of Quebec, defeated the French garrison, and occupied the town. The victory, during the final stage of which Wolfe was mortally wounded, assured the conquest of Canada. West's painting mourns a hero, brought low at the moment of triumph; it also celebrates a major expansion of British rule overseas. The event lent itself to commemoration, and West was not the first artist to choose it. George Romney treated it in 1763 in a painting that is now lost. The following year Edward Penny took up the subject (Fig. 4.1). Penny painted Wolfe half sitting, half lying by the side of the road, supported by two of his men, a third standing behind them, while yet another soldier is running toward the group, waving his casque and evidently bringing news of victory. All wear the uniforms and carry the weapons of the time, so that Penny's rather awkward composition is an attempt at a factual depiction of the death of a senior officer in a modern battle.

West intended something far grander. He painted a secular pieta or descent from the cross as it might have been conceived by Rubens or Van Dyck, with Christ replaced by the British general and the central figure and the men surrounding him wearing regimentals (Fig. 4.2).

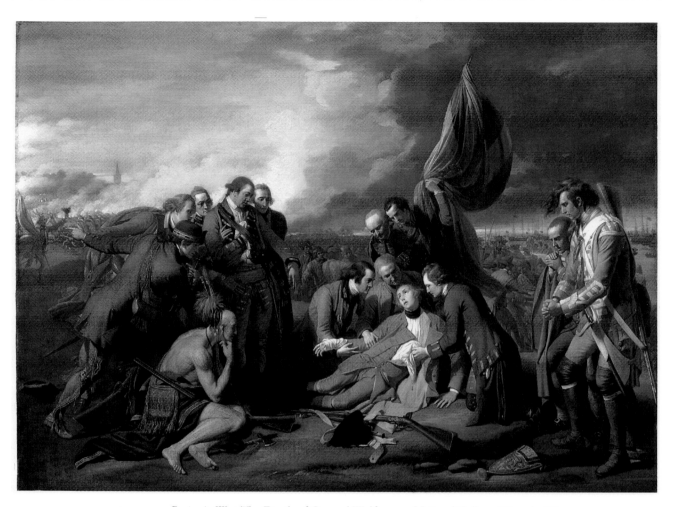

FIGURE 4.2. *Benjamin West,* The Death of General Wolfe, *1770. National Gallery of Canada, Ottawa.*

West was urged not to exchange the robes and togas of antiquity for British uniforms of the 1750s; to the minds of his friends and patrons an inspiring scene of heroism and sacrifice should emphasize the universal and timeless rather than the specific and contemporary. Ordinarily that was West's belief as well, but now he followed his sense of the concerns and feelings of the public and painted his cast of characters in the clothes they might have worn during the battle, but arrayed according to classical principles of composition and expressing in their faces and with their gestures the sublime drama of the occasion. George III, who had first rejected the painting for the error in taste that led the artist to present "heroes in coats, breeches, and cock'd hats," relented and commissioned West to paint a replica, a change of heart that signaled an interesting shift in public taste. Evidently, it was the painting's effective combination of realism with classical grandeur that so impressed the British upper and middle classes, and that also spoke to some further down the social scale. It reflected and stimulated their self-confident sense of belonging to a society and a nation of expanding energies. Seen from this perspective, West's painting marks a stage in the historical process—of which the United Kingdom was as much a part as were France or Prussia—of strengthening central authority at

home and expanding power abroad, in both of which military force played a part. *The Death of General Wolfe* is witness to an early stirring of militant nationalism, which in the power it exerted over peoples' feelings and actions in the course of the Industrial Revolution took on some of the characteristics of a new religion. Inevitably, a new type of painting celebrated the new religion.

Although West's painting depicts a death, it is filled with movement. A surge of energy from the left, where two officers leaning toward their fallen commander point to a messenger behind them announcing victory, sweeps across the large canvas until it is stopped by the half-furled Union Jack, which stands in the place the cross would have occupied in a religious painting, and by the head of the dying man, turned at an angle to his body, his breaking eyes looking up at the stormy sky, now clearing over the town that his troops are about to occupy. Wolfe is surrounded by officers, a surgeon who seeks to stem the flow of blood from a wound near his lower ribs, a reflective American Indian in war paint, armed with musket and tomahawk, and on the far right a British grenadier and a man in a dark suit and cloak, who may be the general's servant. These two, heads lowered and hands clasped in sorrow, form a vertical mass that further blocks the painting's movement from left to right and carries our eyes back to the center. In the background, the British fleet lies at anchor, men scale the heights, sailors pull heavy equipment—perhaps cannon—forward, and toward the left a line of British grenadiers fires a volley into the retreating French.

West knew that the elements he painted did not add up to a truthful rendition of his subject. Of the men identified in the painting, no more than one or two were present at Wolfe's death. But West did not seek reportorial accuracy. He interpreted the death of the British general as a human tragedy subsumed in the larger national drama of sacrifice and victory, a drama through which ran the subsidiary theme of the country's leaders fulfilling their duty. The modern uniforms and weapons carried the metaphor into present reality: these are the ideals that animated the British troops, government, and society in 1759, and this is how General Wolfe might have died on the Plains of Abraham.

West adopted a similar approach in 1806, when he painted *The Death of Lord Nelson* at the Battle of Trafalgar (Fig. 4.3). The very large painting—it measures 70 by 96 inches—shows Nelson, his life fading, not in the hold of his flagship, where his death actually occurred, but on the quarterdeck, surrounded by a large crowd of officers, sailors, and marines, while in the background French and Spanish ships are dismasted and strike their colors. Again, a recent battle in which the commanding officer is killed, a British victory even more important than the Battle of Quebec, is interpreted by West as a dramatic epic, a struggle in which modern Britons act as champions of a universal ideal, and their triumph is consecrated by the death of a national hero.

West's *Death of Lord Nelson* was only the most famous of the many paintings and engravings on the subject, and it was one of these works, a small painting by Arthur Devis, that provoked West's discussion with Farington. Devis painted the wounded Nelson lying in the cockpit of the *Victory*, where he had been carried after he was shot by a French sniper, and where he died

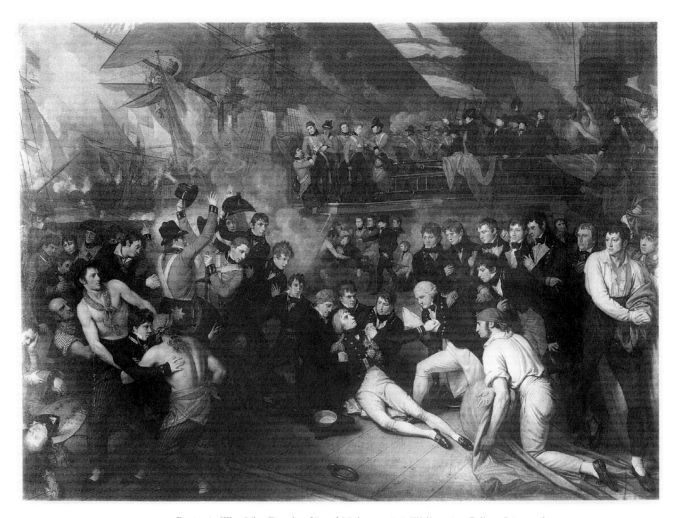

FIGURE 4.3. *Benjamin West,* The Death of Lord Nelson, *1806. Walker Art Gallery, Liverpool.*

some hours later. Devis's painting was historically far more accurate than West's crowded panoramic invention, but West believed that the setting—a narrow, dark space below deck—while historically true was philosophically and psychologically inappropriate in a painting that proclaimed the epic character of Nelson's death and triumph. He himself would soon paint a second interpretation of the event, a small oil, *The Death of Lord Nelson in the Cockpit of the* Victory (Fig. 4.4), which was not unlike Devis's treatment. But the new painting was intended as a model for an engraving that would illustrate the relevant chapter in a biography of Nelson, and West's treatment had to agree with the text. Nor was West likely to demand the same degree of didactic power from a book illustration that he expected in a large oil, which critics and the public would measure by the standards they applied to other serious art. In such a painting, he informed Farington,

> there was no other way of representing the death of a Hero but by an Epic representation of it. It must exhibit the event in a way to excite awe & veneration & that which may be re-

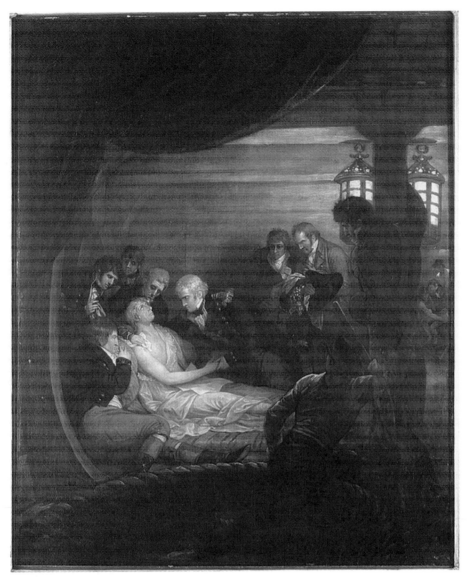

FIGURE 4.4. *Benjamin West,* The Death of Lord Nelson in the Cockpit of the "Victory," *1808. National Maritime Museum, London.*

quired to give superior interest to the representation must be introduced, all that can shew the importance of the Hero. Wolfe must not die like a common soldier under a Bush, neither should Nelson be represented dying in the gloomy hold of a ship, like a sick man in a Prison Hole. To move the mind there should be a spectacle presented to raise & warm the mind, & all shd. be proportioned to the highest idea conceived of the Hero. No boy, sd. West, wd. be animated by a representation of Nelson dying like an ordinary man. His feelings must be roused & His mind inflamed by a scene great & extraordinary. A mere matter of fact will never produce this effect.[2]

2. Ibid., p. 222.

With these words, West did no more than restate principles that eighteenth-century artists generally observed, at least those who sought goals that were regarded as the highest of their calling: the interpretation and elucidation of situations in which moral forces expressed themselves in an exemplary manner. The Old and New Testaments and classical antiquity provided the most powerful of these themes, in which gods and humans acted as agents of universal truths. Philosophers, dramatists, and historians had plumbed the depths of these ancient parables, and their accumulated testimony greatly increased the evidentiary strength of the texts. Painters and sculptors had the means of revealing additional insights and lessons. Some events of the more recent past were equally appropriate themes for artists, as long as they treated them as they treated the great models from the Bible and from Greece and Rome. It was the search for the universal, and its discovery, that ultimately mattered. As Sir Joshua Reynolds declared in 1771, in his fourth Discourse to the students of the Royal Academy: "An History-painter paints man in general; a Portrait-Painter, a particular man, and consequently a defective model."[3] Reynolds did not mean this as a criticism of portraiture; he simply stated the accepted truth that rather than the artist's analysis of the character and personality of a particular man or woman, it was the principles of human nature, made visible in their ideal form by the artist's genius, that constituted the more significant cultural achievement.

In modern times, according to this view, the qualities of "man in general" were most powerfully conveyed by the Wolfes and Nelsons of the world, men distinguished by birth or achievement whom others might emulate. That a painting of a common man might say something about the general human condition was a concept that still posed problems to the Enlightenment. The greater part of its artists and critics found it difficult to separate the ethical teachings in an image from the great symbolic events of antiquity and the Christian faith and reveal these truths in paintings of everyday life. Even more troubling were suggestions that serious paintings could teach by indirection or might lack any didactic purpose altogether. There were not many Chardins about; his profound discoveries in the ordinary circumstances of bourgeois existence were a rarity.

The obligation to teach by pictorial example was taken for granted, and the types of appropriate subjects were narrowly defined, as was the manner in which they were to be presented. Even if artists chose to paint a contemporary as a hero illustrating the eternal verities, they should not place him in a setting that, though factually accurate, might be considered ignoble and therefore uninspiring. Painting the modern hero in the dress of his time was no longer unheard of, although it continued to startle conventional taste; but even this degree of surface realism had its dangers. In his fourth Discourse, Reynolds warned his young listeners that factual details might be seductive, but that they could mislead by interfering with the expectation and mental picture that viewers had formed of a sublime episode: "Some circumstances of minuteness . . . frequently tend to give an air of truth to a piece . . . but if there be

3. Sir Joshua Reynolds, *Discourses on Art*, ed. Robert Lavine (New York, 1961), p. 66.

anything in the Art which requires peculiar nicety of discernment, it is the disposition of these minute circumstantial parts; which, according to the judgement employed in the choice, become so useful to truth, or so injurious to grandeur."[4] As between the two—external truth or moral and intellectual exhortation—dominant academic opinion in the 1770s was agreed that the latter counted for more.

War was only one of the settings in which events suitable for memorialization could occur, but it was a setting that imposed its own peculiar conditions. In their reflections, West and Reynolds left unmentioned two matters closely related to their subject, but, so far as they were concerned, not central to it. To concentrate on the conflicts, heroism, and fate of the great man as appropriate themes of serious art, and to prefer the didactic interpretation of these themes, was to discourage choosing subjects from among the incidents and scenes that mainly make up war. This negative implication was strengthened by West's observations that Wolfe must not be shown dying like a common soldier under a bush, nor Nelson like a sick man in a prison hole. His statements, the brutality of which the speaker probably did not even recognize, left open the question as to whether the common soldier or common man were appropriate subjects for the painter, but they seem to suggest that if at all then only in genre paintings or as subordinate figures in major compositions. If the artist was discouraged from painting incidents in war as everyday events, and moreover was urged to exclude the great majority of individuals who took part in these events, then the range of possible interpretations of war in art was greatly restricted. As always, there are exceptions, and it may indicate a changing cultural atmosphere that the crowd surrounding the dying Nelson includes more members of the lower classes, some prominent in the composition, than do the men West painted thirty-six years earlier grieving over Wolfe. But it is worth noting the general attitude that found expression in *The Death of General Wolfe* and in Reynolds's *Discourses*, and that still had its advocates during the Napoleonic Wars.

❀ ❀ ❀

The aesthetic theories West and Reynolds sought to express in their history paintings were, they believed, applicable to all subjects that dealt with the condition and behavior of mankind. The nature of these conditions and the patterns of human behavior mattered less than did the extent to which they lent themselves to idealizing and didactic interpretations. When it came to painting scenes of war, a new characteristic of this particular subject further encouraged the idealization of the hero and the exclusion of the rank and file. By the eighteenth century the common soldier had come to count for less in war, either as a self-reliant fighter or as an autonomous human being, than at any time since the early Middle Ages. His marginalization in fact, which must have influenced artists' choices of what to paint, is explained by the ways in which men now became soldiers, and by the conditions in which they served and the methods with which they fought once they wore uniform. Put differently, an element specific to the mil-

4. Ibid., p. 56.

itary culture of absolutism and of the Enlightenment played a part in limiting serious inter-pretations of military subjects in art.

The principal form of military force in eighteenth-century Europe was the standing army, made up of volunteers and of men who were compelled to serve. A long historical develop-ment lay behind this type of organization. In medieval Europe, wars were fought by men who owed various forms of military obligation, from a vassal's duty to his lord to townspeople and peasants following the call to defend their homes or to join a punitive campaign. Small groups serving for longer periods or even permanently gave some stiffening to the armed host, with-out as yet affecting its largely improvised, preprofessional character. Gradually service for pay over extended periods grew more common, and by the Thirty Years' War had become the rule. From there it needed only a few generations for administrative and fiscal refinements and the standardization of dress and equipment to achieve the standing army of the absolute monar-chy and its constitutional variant across the English Channel. In the same period, the practice of calling up civilians to meet a crisis and of mobilizing militias became less frequent. But these forms of obligatory service were never completely abolished in law, which subsequently en-abled governments to exploit them as the basis for new and more encompassing manpower policies.

In different states, the standing army, identical in its essentials, assumed somewhat differ-ent forms. To consider only two forces: the French army consisted of long-serving volunteers, motivated mainly by economic necessity. They were both natives and foreigners, encadred in separate regiments. In the Prussian army the rank and file was also made up of natives and foreigners, but they served together, and their entry into the service differed. Foreigners vol-unteered; natives were forcibly enrolled in recruiting districts, each of which had to provide a specific number of men. The period of service varied but could be very long. A Prussian reg-ulation of 1792 specified that natives might be discharged after twenty years, provided they could support themselves. With some exceptions—such as the Swiss in French service—most of the common soldiers came from poor families, which were not protected by one or the other privilege of corporate society. Even when, as in Prussia, the son of a low-ranking official or small-town merchant was subject to enrollment, an exemption could usually be arranged, but sons of day laborers or small tenant farmers had few possibilities of evasion.

The officer corps of these forces still included many foreigners, though everywhere natives formed the majority. In some states—as in Hanover and Prussia—their members were drawn mainly from the nobility; in others—as in Bavaria—many were the sons of bourgeois officials, parsons, and prosperous landowners. Even the armies that most sharply emphasized social distinctions employed some bourgeois officers, and throughout Europe officer careers served as channels of upward social mobility. But the differences in privilege and opportunity that separated descendants of great families from those of the lower nobility, and nobles from bourgeois, caused resentment and were one reason for the generally critical view in which mil-itary service was held by the European bourgeoisie.

The standing army was an institution that both responded to and offended against impor-

tant values of the time. It met the military needs of the state more rationally and reliably than had short-term mercenaries hired by military entrepreneurs a few generations earlier. Its operational and tactical methods were carefully thought-out solutions to the problems of bringing large numbers of men to bear rapidly on the desired spot and of making the most effective use of the weapons available. Of more questionable rationality were the means by which these goals were achieved. Only the harshest discipline and drill, it was thought, could turn crowds of semiliterate peasants into the mechanically reacting human components of the close-order formations required by linear tactics. Economic need reinforced by stringent supervision kept the men from running away, and to an unsympathetic observer an army on the march, each unit policed by noncommissioned officers, the whole surrounded by light-cavalry patrols to catch the more enterprising deserters, could appear as a vast, stinking prison moving across the land. As much as possible, soldiers and war were isolated from the civilian environment. Frederick the Great's famous wish to wage war without disturbing the burgher in his office and the peasant tilling his field expressed not only a reasonable concern for maintaining productive society by keeping violence within military bounds, but also a cultural ideal: armies, essential though they were as agents of state power, should not otherwise be much in evidence.

For the Enlightenment, the standing army easily turned into an object of derision. Aside from the barriers it often placed in the path of bourgeois advancement, its rank and file were automata who fought and died for causes they neither understood nor were meant to understand; loyalty centered on the regiment rather than on the state; the treatment of the common soldier ranged from the undignified to the inhuman; the economic burden posed by armies and war held back progress. Voltaire scoffed at slaves in uniform, kept in line by the rod. Rousseau declared that "standing armies, the plague and scourge of Europe, are good for only two things: to attack and conquer one's neighbors, or to enchain and enslave one's citizens."[5] In the place of professional soldiers, he wanted every citizen to take up arms when the need arose—a return not to the Middle Ages but to the still earlier social contract. Unlike many of his contemporaries, Rousseau did not fear the passion and violence of combat; but these qualities, too, were often suspect in an age when even military theorists strove for the ideal of the tamed Bellona.

Under these conditions and in this cultural atmosphere it may not seem surprising that soldiers and war were ignored by artists who were ambitious to do more than repeat old patterns. Only Watteau, in a few camp scenes and scenes of troops on the move that he painted in the early years of the century, transformed familiar military genre subjects into thought-provoking studies of groups with a common purpose in an enveloping but indifferent landscape. Other, less enterprising colleagues continued to produce *vedute*, apotheoses of conquering princes, allegories, and genre scenes of horsemen outside a tavern or soldiers standing guard at a gate. A Voltaire on canvas might have changed this, and William Hogarth, in *The March to Finchley*,

5. Jean Jacques Rousseau, "Considérations sur le gouvernement de Pologne," in *Oeuvres complètes* (Paris, 1964), 3:1013–14.

with its clash of military discipline and elemental human wants, suggests what might have been done. But Hogarth did not pursue this vein, nor was it followed by others except for caricaturists, and the printed page remained a more effective vehicle than the canvas for intellectual criticism of war. In particular, the reality of battle remained unexplored. A similar reticence did not affect painters of marine scenes, a field that maintained the popularity it had gained in the seventeenth century. Were naval battles more acceptable because images of the clash of great wooden and canvas structures were less dependent on the presence of humans? Many did show sailors smashed by falling tackle or swimming and drowning. Benjamin West himself painted a melodramatic episode of hand-to-hand combat in his fanciful depiction of the seventeenth-century Battle of La Hogue, and *The Death of Lord Nelson* is a crowd scene in a naval setting. But as often, paintings of naval engagements did not show a single sailor. A painting of a battle on land, on the other hand, could ignore soldiers and their fate only if it focused exclusively on the commander.

Exceptions to the apotheoses, allegories, and genre works existed, but they were rarely impressive. Apart from stylized battle paintings, they consist of two varieties: images of military subjects that pay close attention to the uniforms that soldiers now wore and works that use military themes as vehicles for the expression of sentiment. Uniform prints, distinguishing between units and between officers and men, became popular, but it was not until the French Revolution that some reached levels of interpretation that rose above the detailed reporting of dress and posture. More interesting is the second type, which used war as scenery for the display of human emotions in general, and in this way managed to bring the subject of war back into the orbit of Enlightenment feeling, if not of thought. An example of this amalgamation, which turns even the common soldier into a human being, albeit at a steep price of pathos, is the painting *The Dead Soldier* by Joseph Wright of Derby (Fig. 4.5).

The canvas, dated 1789, is one of four known versions Wright painted of the subject. The painting is divided into two parts by a large cloth, thrown over the branch of an oak. The cloth is meant to suggest a soldier's tent, but it rather resembles—and functions as—a curtain or backdrop and thus emphasizes the theatricality of the scene. Before this tent-curtain lies a dead British soldier, his body radically foreshortened, face to the ground. A young woman sits by the side of the corpse. In her right arm she holds an infant to her half-naked breast; with her other hand she has lifted the dead man's right arm and is pressing her temple against his wrist, while the child, which looks out of the picture at the viewer, seems to hold two of the soldier's fingers in its small hand. A cannon is revealed behind the sloping edge of the cloth, its barrel pointing in the direction of a distant battle. We can see infantry in line firing a volley, apparently at a troop of horse. Over the ground between this group and the cannon, a single horseman gallops toward the fight. The flashes of muskets combine into a reddish-yellow cloud, which dissipates in the evening sky and repeats the red coat of the dead soldier and the light skin of the woman's shoulders and breasts in the painting's foreground.

Today we might think that the most persuasive passages of Wright's painting—the bravura treatment of the glow of battle in the dark sky, the soldier's coat, and the woman's upper

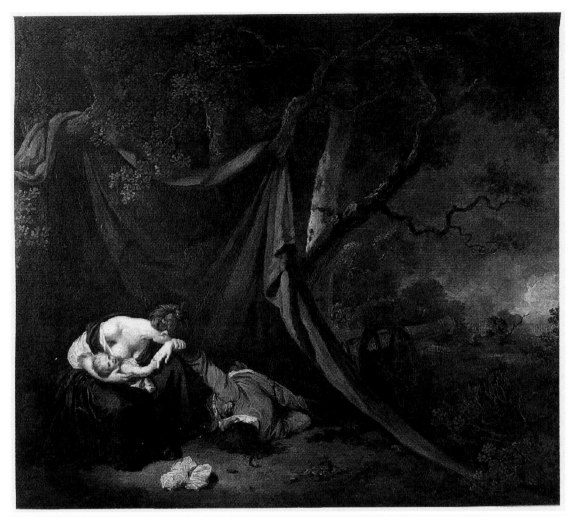

FIGURE 4.5. *Joseph Wright,* The Dead Soldier, *1789. Holburne Museum and Crafts Study Centre, Bath.*

body—are compromised by the doll-like face of the child and by the cloying stare with which it fixes the viewer. But in the 1780s it was the woman left behind and her forlorn child, abandoned in a dark and fiery world, that impressed the public. Engravings after one or the other of Wright's several versions were among the most widely distributed prints in late-eighteenth- and early-nineteenth-century Britain.[6]

The subject was suggested to Wright by some lines from John Langhorne's poem *The Country Justice,* which appeals to the magistrate for understanding when the very poor commit crimes:

> On pressing Want, on Famine's powerful call,
> At least more lenient let thy justice fall.

6. David Irwin, "Der tote Soldat," in *Triumph und Tod des Helden,* ed. Ekkehard Mai and Anke Repp-Eckert (Cologne, 1987), p. 360.

The woman, grieving over her soldier, and her infant

The child of misery, baptized in Tears!

now have no future but a life of poverty and petty crime.[7]

A social comment is added to the various messages of *The Dead Soldier*, which we should now try to separate. Wright's painting makes a straightforward statement about love, loss, and grief. The presence on the battlefield of the woman and her infant may seem puzzling, but the puzzle is easily solved. For the sake of dramatic unity the artist combined two scenes: the soldier's death and the woman back in England receiving the news. Faced with this theatrical or operatic invention, we have no difficulty in suspending our disbelief. That the painting's human, lachrymose play on our sympathies is accompanied by a less overt but sufficiently plain note of morbid sexuality no doubt added to the popularity of the image. But it is apparent that despite the painting's title, the soldier on the ground, who seems to exemplify Benjamin West's antihero or nonhero dying under a bush, is not the work's central character. In the painting as in the poem that inspired it, war and the men engaged in war do not constitute the primary subject; rather, they provide the occasion for the drama, whose melodramatic progress seems to encourage melancholy reflections on the fragility of human bonds, the suffering of the innocent, and the transitory nature of life. For once, these familiar themes are not developed in a classical vocabulary, nor are they interpreted through the actuality of battle; instead, they are illustrated by three stage characters—a soldier, his woman, and their child—poor people without standing in society, outcasts, in their own way as remote from the lives of visitors to the exhibitions of the Royal Academy as were the gods and heroes of antiquity.

But the painting is about war. Wright shows a casualty of war and the woman and child as additional victims; he generalizes their pain by pointing to the hurt society suffers when war turns people into vagrants and thieves. The tragedy of the dead soldier and of the woman and child condemned to a hopeless existence expands into a comment on the evil effects of war in general. And it is the woman and infant placed in the alien setting of a battle through whom this further message of the painting is conveyed.

Of the changes that occurred in European art in the second half of the eighteenth century, two, in particular, are important for our discussion and should be noted here: a new interest in painting historical subjects and the rise of the artist-antiquarian. Benjamin West was an early member of this group and, as is often the case with transitional figures, seems not to have recognized the contradictions between the old and the new opinions he held simultaneously. His decision to show participants in significant events of whatever period as they actually appeared

7. *The Poems of John Langhorne*, vol. 65 of *The British Poets* (Chiswick, 1822), pp. 119–20.

could not but call into question his larger aesthetic assumptions. Once the past had been an un-limited field open to the artist's imagination and idealism; now it was also owed historical ac-curacy. And, inevitably, the rise of modern history painting—combining a new interest in the past with a new concern for external accuracy—strengthened the realistic, pragmatic character of paintings of contemporary and near-contemporary events.

This new attitude was already well established, though far from universally held, at the be-ginning of the French Revolution. Soon Europe was at war, and wars remained a major pres-ence in Europe for the next twenty-three years. They brought about vast political and social change, and they could no longer be waged in relative isolation from their environment. Rev-olutionary rhetoric and at times revolutionary practice made war the business of French soci-ety as a whole. Although the burden continued to fall disproportionately on the poor, men of all classes became soldiers, and the steep barriers that had once divided officers and other ranks were lowered. At least some of the states that opposed France also broadened their so-cieties' participation in war. It was indicative of the penetration of formerly immune social en-claves that when Prussia joined the alliance against France in 1813, the government declared that able-bodied young men who did not serve in the army would be seriously handicapped in any future career in the state bureaucracy.

To take account of the new breed of men in the service, methods of training and discipline and principles of promotion had to be changed. Even methods of fighting were affected; here and there the old pattern of automatic execution of formulaic tactics was expanded to give some scope to initiative and individual judgment at the lowest level. Armies became more fully integrated in their societies, even those that remained firmly in the hands of traditional elites. In France from the Revolution on, among its Continental opponents particularly during the second half of the Napoleonic era, the former isolation of armies fell away as they became as-sociated with important concerns of the bourgeoisie: professional and social prospects, polit-ical idealism, enthusiasm for new cultural norms. Here and there even the mass of common soldiers were treated as thinking human beings, who could be taught to transfer and expand their loyalty from the prince and the regiment to the nation. These changes, and with them the greater role that war now played in general, increased interest in its institutions and processes, their dynamics, and the human tragedies they inevitably produced, and made war into a more significant subject for the artist. The new pragmatic, realistic concepts that had taken hold of some artists in previous decades ensured that they would interpret this subject in new ways.

Even before the outbreak of the Revolution, the American War for Independence inspired steps toward a more literal representation of war. In 1786 John Trumbull, influenced by Ben-jamin West and John Singleton Copley, two other American painters who had settled in Eng-land, painted *The Death of General Warren at the Battle of Bunker's Hill*, which shows the fallen of-ficer surrounded by colonists and British soldiers fighting at close quarters. Trumbull, who had been at Bunker Hill that day, painted common soldiers and Negro servants with the same care for their individuality that he gave to the central figure, and his delineation of social char-

acteristics is one of the strengths of the painting. But the work remains a glorification of one man and of the values he represents, and the fighting itself is depicted as a dramatic set piece, with swords waving and flags flying, that cannot bear much relation to the events of that day.

The work of those European artists who in the 1790s and subsequently gave serious attention to the processes of war tends to fall into three broad and often overlapping categories: the "realistic," up-to-date framework of the traditional apotheosis, about which something will be said in the next chapter; the battle picture that seeks at least a degree of surface accuracy; and the uniform print—by definition committed to the correct detail—that expands into scenes of military life. Examples of attempts to show the facts of battle are the twenty-eight etchings by Jean Duplessi-Bertaux after sketches by Carle Vernet, *The Campaigns in Italy of General Bonaparte*, produced and published soon after the events shown. Aiming for the greatest possible accuracy in setting the scene, Vernet consulted maps, studied eyewitness accounts, and treated the antagonists in an evenhanded manner. He was as objective in his images of specific historical episodes as Jacques Courtois had been in his generalized scenes of camp life and battle in the seventeenth century. But since Napoleon had moved from triumph to triumph in Italy, some temporary setbacks notwithstanding, Vernet's overall note sounds the inevitability of French victory, which presumably contributed to the wide sale of the series and of its individual plates.

Representative is the engraving of the Battle of Montebello and Casteggio in June 1800 (Fig. 4.6). As in most plates of the series, the commanding general is treated as a minor figure (he is the tiny horseman in front of three aides at the left edge of the picture); the main subjects are the soldiers who do the actual fighting, seen at a climactic stage in the battle's tactical development. In the battle, one of the engagements leading to the Battle of Marengo, a French column attacked a stronger Austrian force between the two towns but was repulsed. A second French column then arrived and turned the flank of the defenders, who retreated beyond Montebello before coming to a temporary halt. Vernet compressed this extended sequence into an image of the battle's decisive minutes. On the level ground below the towns, Austrian infantry has been surprised by French hussars, who are emerging from behind rocks and bushes in the left foreground. An Austrian pandur, galloping away, fires his pistol at the French while the infantry is retreating. One man has fallen, some are turning and firing, officers are trying to restore order, and in the middle distance Austrian cavalry is hurrying to the rescue. These and other details are executed with great technical competence, and the crowd of fleeing, turning, and firing Austrians reveals an observant eye and an aesthetic intelligence at work. But the picture as a whole does not express strong aesthetic impulses. It is a report in visual shorthand, addressed in the first instance to the viewer's curiosity about the events of June 9, 1800.

And yet, as this mode of scholarly re-creation matured, its best work achieved the most truthful and impressive depictions of Napoleonic battle that we possess. Examples are the watercolors of Giuseppe Pietro Bagetti, a topographical engineer who entered the French army at the beginning of the century, first to survey and sketch possible future battlefields,

FIGURE 4.6. *Carle Vernet and Jean Duplessi-Bertaux,* The Battle of Montebello and Casteggio, *ca. 1804. Private collection.*

eventually to record the major battles and many lesser engagements of the Napoleonic Wars—sometimes as an eyewitness. No less persuasive is the oeuvre of an artist of the following generation, Siméon Fort, also in the French service, whom Louis Philippe commissioned to make large watercolors of the battles of the Empire. These *vedutes* show the structure of the contending forces, usually at a decisive stage of the action, with exceptional clarity and power—it might be said from a general-staff perspective, without anecdotes or sentimental flourishes. But they were and are rarely exhibited, and their attraction seems limited to the specialist.

The general public, less concerned with facts, asked for drama of a more personal nature and found it in the great glorifications of the emperor, his marshals, and the Grande Armée. In these paintings and in their non-French counterparts, the political message is packaged in an accurate rendition of plumage, epaulettes, and braid, which received more attention than did the actual course of the battle and the reaction of the men engaged in it to its physical and psychic challenges.

The limitations of this approach are apparent and will occupy us again. Here it may be suf-

ficient to point to the great differences between the treatment of battle exemplified in Carle Vernet's conception and the allegories, paeans to the commander, and imaginative groupings of combatants that characterize the picture of battle in the preceding two centuries and continue to mark the work of many artists during and after the Revolution. Something resembling the scene shown did occur at Montebello and Casteggio that day, and some of the elements of that scene were present in other battles of the time. In that respect, the etching responded to the expanded place that war now occupied in European society and culture.

A similar interest in how people actually look and behave when they are engaged in the processes of war runs through those increasingly frequent uniform prints that now depart from the conventional detailing of military dress and insignia on figures shown standing still, and bring the figures alive in their environment. Occasionally they also introduce, openly or by suggestion, the note of human and societal tragedy already sounded in Joseph Wright's *Dead Soldier*. An example is *The Chance Encounter* (Color Plate 3), engraved in 1808 after a painting by Johann Baptist Seele, a well-known South German painter and printmaker, who specialized in military subjects. The print shows an episode in the world of common soldiers and ordinary people; no officer is present. The central figure is a mounted trooper of an Austrian light-cavalry regiment (the artist has drawn his helmet, uniform, and shabraque with such specificity that the unit can be identified as the Chevauxlégers Regiment Hesse Homburg No. 2). He is leading a horse by the reins and has stopped to talk with a comrade from the same regiment who is sitting before a makeshift tent by the side of the road. Next to the second soldier sits a woman cradling an infant; she is typical of Seele's female figures, which are often drawn in a cool, classicistic outline somewhat reminiscent of Fuseli. Behind them, under the canvas, a third soldier is resting or sleeping on a pile of cut grass—we see his boots and the scabbard of his sword—and beside the woman a brown-and-white dog looks up and perhaps barks at the horseman addressing his master. At first glance the scene appears to be an idyllic variation of Joseph Wright's *Dead Soldier*. Even the rudimentary tent cloth is present. Closer attention reveals the print to be a morality play in three parts, which turns the innocent group of the seated soldier, his woman, and their infant into a prelude of tragedy.

We do not know whether the mounted trooper is merely chatting—whether the title of the print is free of ambiguity and we really are shown a chance encounter—or whether he is a messenger, conveying an order for his comrade to carry out, perhaps on the horse he is leading. Whatever the occasion, the trooper's narrative as well as compositional function is to link the group on the right, basking in peaceful domesticity, with the very different group on the left. A wagon has passed the tent and now disappears on the road that dips down to an invisible valley. The wagon, like the tent, is laid out with cut grass. Two weary or wounded men sit hunched over on the grass. One man in a blue hussar's tunic and dolman has lost the plumes from his shako; only the bare rod remains. Next to them, almost hidden in the grass, lies a third man. We see merely his right arm and hand, and the lower half of his face, mouth open, staring at the sky. A fourth soldier in a red cloak, strips of white cloth wrapped around his head and neck, walks heavily by the side of the wagon. The four exhausted or wounded men, who

COLOR PLATE 3. *Johann Baptist Seele,* The Chance Encounter, *1808. Private collection.*

COLOR PLATE 4. *Christian Gottfried Geissler,* Scene in Lübeck, *ca. 1806–7. Private collection.*

are drawn with greater pathos than the other figures, foretell the conclusion of the print's narrative—the future of the two splendidly appareled troopers and of their comrade still resting in the tent.

Uniform prints that expanded into images or anecdotal scenes of military life were published in large numbers during the Revolutionary and Napoleonic eras. I choose one more example, different in subject from *The Chance Encounter*, but also using a woman and an infant to point to the cost of war, a print of 1806 or 1807, *Scene in Lübeck* by Christian Gottfried Geissler (Color Plate 4). During the later Napoleonic Wars Geissler produced many military prints and cartoons on political themes, fields that he abandoned after 1815. In contrast to Seele's invented picture of camp life, Geissler used an actual and recent event in his *Scene in Lübeck* as the context of an incident that was probably imagined. On October 14, 1806, Napoleon defeated the Prussian army in the two battles of Jena and Auerstedt. Remnants escaped in various directions; some ten thousand men under General von Blücher made their way toward the Baltic, closely pursued by the French. On November 5 this force reached Lübeck. Blücher was still organizing the town's defenses when the French stormed the gates, and after a brief and confused struggle in the streets the town was taken.

The print carries the viewer into the heart of the fighting, in a street that, judging from the ship's mast in the left background, is near the harbor or the river Traave. Again, the uniforms are detailed with sufficient care to allow identification of the units of most of the figures. On the right, three soldiers of the French Ninety-sixth Infantry Regiment are stepping forward and firing; a fourth, identified by his bicorne hat, has already broken into a house and is about to drop his loot, wrapped in a sheet, from a window to the pavement below. From other windows people are firing into the crowd. A French hussar, swinging his saber, rides into the smoke that envelops the street farther back. Across the street to his left, a Prussian officer in the red dolman trimmed with white fur of the Blücher Hussars has just been struck by a bullet and is falling backward from his horse. Behind him, a French gunner fires a light cannon. Four men occupy the foreground—two standing and two who have fallen with their horses to the cobblestones. The bearded man on his knees on the left is bleeding from a cut on the temple. His regiment cannot be identified, but he does not wear a Prussian uniform. In the center, a French *chasseur à cheval*, his back to the viewer, faces a tall French cavalryman, possibly of the Sixth Hussars, who holds a naked infant in his hands. On the right, an officer of the Polish Legion in French service holds up a cloth bloodied from his wounds on arm and knee, which he seems to offer to the hussar as a covering for the infant. The child has become separated from its parents, the man and woman on the far right, civilians caught up in the violence that has suddenly erupted in the street. For a moment the four soldiers in the center are turning away from the street battle that rages around them to save a new life.

No doubt Geissler used the infant to make the scene of street fighting more interesting. But that could have been achieved in more sensational ways. Here, the infant is not a victim, shot or trampled underfoot; on the contrary, although absolutely vulnerable, the child by its presence has awakened a basic sense of humanity in the soldiers, who interrupt their bloody

work and expose themselves to danger for the child's sake. More than that, the German artist specifically shows the child's saviors to be members of the French army. His motives may have been political or economic, but the soldiers' allegiance also underlines the picture's message of universal values that transcend political antagonisms and physical violence. In this crisis the mother and father are helpless, but the infant—and the religious allusion would have been clear—retains the power to guide at least some men to salvation.

Like Seele's print of the incident by the side of the road, and like Joseph Wright's painting, Geissler's *Scene in Lübeck* introduces a woman and an infant to an alien setting as a way of contrasting life and death, and—after noting the humanity of some soldiers even in the heat of battle—of pointing to the human and social cost of war. In Wright's painting, the loss created by the death of the husband and father is the central subject; without the woman and her child, the picture of a dead soldier lying under a tree with a battle in the background might not carry much meaning. With them, even when their presence demands a suspension of the viewer's sense of realism, the painting carries a powerful message: the death of the soldier condemns mother and child to an economically and socially hopeless existence.

The two German prints, on the other hand, could carry out what may be called their overt task without showing the mother and infant, who are important but on this level not essential. Seele's cavalrymen would still form a convincing picture of the zone of communications somewhere in the rear of the army and would still demonstrate the coming transition from well-being to casualty—in the words of a poem that soon became a well-known song, "Today on proud horses / Tomorrow a bullet through the heart."—although without mother and child the prediction of a terrible future in contrast to the present would not have the same impact. Geissler's French and Prussian soldiers would still clash in the streets of Lübeck, although in the absence of the infant and its frightened parents the drama is reduced and the street battle becomes a more commonplace event. But as they are, the two prints do more than respond to the public's interest in seeing accurate depictions of uniforms and military activity. They add a further theme, one that will appeal to the sentimentality of some viewers, whereas others will interpret it as pointing—realistically or perhaps even critically—to the direct and indirect costs of war. It is only one of a number of subsidiary themes that were introduced in military prints; I have singled it out as an example of the development of the genre. Carle Vernet's broad perspective on an entire battle catches the actions of thousands of men; Seele and Geissler choose a narrower focus to isolate a detail or two and to discover the individual in the mass. In the attention they give to accurate externals, but also to the ways soldiers behave and battles are fought, all three leave West far behind. It is interesting that even when they incorporate moral issues into their expansion of the uniform print, the realistic character of their work is not diminished.

5

Academic and Other Perspectives

Battle painting and history painting in general reached their greatest flowering in the years between the French Revolution and the First World War. Work in the two fields was driven by broad cultural forces: a new intellectual and emotional concern with the study of history—the links between the elevated standards of material accuracy now valued in history painting and the development of scientific history are apparent; the belief that art interpreted and re-created the past with a special power; and the conviction that faithful documentation enabled art to uncover the deepest truths, often truths that escaped other approaches. Conversely, history ennobled art. History included contemporary history; the direct knowledge of present-day life and objects became the model for re-creating the past, to which contemporary assumptions and ideas were also extended.

Two political and social forces, above all, put their stamp on this art: the growth of the nation-state and the expansion of political activity to broader groups of society. The thousands of paintings by contemporaries and near-contemporaries of battles from the 1790s to the wars of Italian and German unification and of the colonial campaigns in Africa and Asia became pictorial testimony to the violent course of state building and imperialism. Paintings of subjects of the more remote past—whether chosen from antiquity, the Crusades, or, as the century progressed, the Napoleonic era—documented claims of political rights on the one hand, and the reality of the nation and the validity of its demands on the citizen on the other. They encouraged change and provided many of its symbols. They could equally validate the stewardship of autocratic governments, which now felt it appropriate or advisable to pay some attention to certain segments of public

opinion. Since men fought as well for one set of political concepts as for another, paintings celebrating the commitment and suffering of the junior officer or the common soldier, which demonstrated the bonds that tied him to his community and his state, were commissioned as readily in Vienna and St. Petersburg as in London and Paris.

Often these paintings were modern versions of the apotheosis of the commander—the mass of soldiers, their uniforms and equipment accurately copied, serving as extras in the drama of the hero—but they could also celebrate the energy and bravery of the many. From the end of the eighteenth century, both types—pictures of the hero and pictures of the mass—become more explicit in their treatment of the human cost of battle, even if this new emphasis is sometimes little more than a device to elevate the superhuman leader for whom men are sacrificed and sacrifice themselves.

The coming together of the apotheosis and a sympathetic concern for the soldier is exemplified by an official competition for a painting of the Battle of Eylau of February 8, 1807, at "the moment in which Bonaparte, visiting the battlefield, comes to bring help and consolation to the innumerable victims of combat." The competition was won by Antoine-Jean Gros, one of Napoleon's favorite recorders of the triumphs of the Consulate and Empire, and an influential teacher of a generation of history painters. Another contestant was Charles Meynier. His sketch in oil *Napoleon on the Battlefield of Eylau* (Fig. 5.1) shows the emperor, triumphant at the end of the day on a dreary, snow-covered plain, a nationalist saint, whose gesture is both command and blessing. Gathered around him like a decorative wreath are his staff and masses of wounded and dead, prominent among them a bank of corpses—already stripped of uniforms and boots—piled up in the foreground. A police agent surveying the exhibition was moved to comment: "The artists have accumulated all sorts of mutilations, the varieties of a vast butchery, as if they had been specifically requested to paint a scene of horror and carnage and to render war abominable."[1] That was hardly the case, but the agent did recognize the new tendency of taking the soldiers and victims of war seriously, even if—as here—what mattered to the artist was not to glorify the sacrifice but its cause: Napoleon and the nation he claimed to personify. That also seems to have been the view of the jury, which awarded Meynier one of two honorable mentions, a gold medal, and six hundred francs.

Less numerous and rarely chosen for official support were works that ignored the leaders and ideals that led men to die and only showed their death. An example is a work by J. M. W. Turner, *The Field of Waterloo*, whose elegiac description of a search at night for relatives and friends among the dead further underscores the academic brutality of Meynier's canvas. Turner was inspired by the stanzas on the battle in Byron's *Childe Harold's Pilgrimage*, which conclude:

> Last noon beheld them full of lusty life.
> The earth is cover'd thick with other clay,

1. Quoted in *French Painting, 1774–1830: The Age of Revolution*, catalogue of the exhibition in Paris, Detroit, and New York, 1974–75 (Detroit, 1975), p. 546.

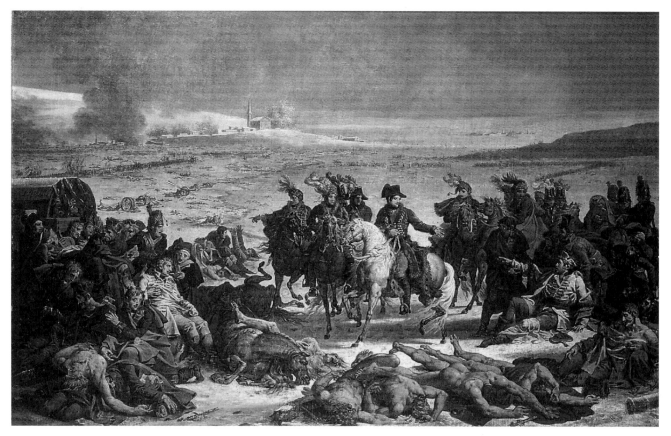

FIGURE 5.1. *Charles Meynier,* Napoleon on the Battlefield of Eylau, *1807. Musée Nationale du Chateau, Versailles.*

> Which her own clay shall cover, heap'd and pent,
> Rider and horse—friend, foe,—in one red burial blent![2]

But these were ideas and attitudes that the academic battle painter of the Napoleonic age and the Restoration could not yet easily accommodate.

Accuracy in uniforms, equipment, tactics, and topography could add conviction to the glorification of the commander on the battlefield, and accuracy was now widely regarded as essential in the depiction of battle itself. But artists were rarely eyewitnesses of the events they painted, and accuracy in details was easier to gain from models and manuals than an informed conception of the whole. That the nature of the subject was changing added to its difficulty for the artist. Battlefields continued to expand as armies grew larger and as more powerful firearms increased the distance between the opposing sides. To encompass a battle with many thousands on each side in an effective composition was now almost impossible, unless the painting was a traditional *vedute,* resembling an outline of units arrayed in suggested three-dimensionality on a topographical map. A more promising approach was to paint a segment of the event that might stand for the whole. Except for portraits in a battle setting, this reduction

2. Lord Byron, *Childe Harold's Pilgrimage,* Canto III, 28.

in focus brought the common soldier—already an object of greater interest—to new significance. Changes in warfare, changes in aesthetic theory and taste, the new importance of the common soldier—all affected and gradually altered the character of battle painting. Carle Vernet's efforts to design plausibly factual images of Napoleonic battle had still been something of an innovation. For his son Horace, who painted both battle scenes and portraits of the great in battle settings from the end of the First Empire to the heyday of the Second, the innovation had become a tradition, which he and his contemporaries and successors developed further and enriched with the technical and scholarly refinements of nineteenth-century academic art.

For a time, the most impressive examples of works claiming to be factual images of modern war were painted in France, inspired psychologically and economically by the wars of the Directory and Empire, the armed expansion of French power over much of Europe, and the demand by the emperor and society for art to chronicle and above all to celebrate the national triumph. That most of the paintings were devoted to elevate and reflect the glory of the emperor and of his generals merely accorded with the character of the regime. The energy that marked the years between the Italian and Egyptian campaigns and the War of 1809 against Austria is reflected in the vigor and inventive rhetoric of the best works of such painters as Antoine-Jean Gros and François Gérard. But there was a limit to what military exaltation in the hands of academicians could achieve. In a refined analysis Lorenz Eitner has pointed out that the patronage of the imperial regime put artists in a moral as well as a technical dilemma: "On the one hand they found it difficult to resist the rewards offered them. . . . They were, most of them, enthusiastic admirers of the emperor and gladly participated in his glory, stimulated by the grandeur of the events that he called on them to commemorate. But except for such outsiders as Carle Vernet, their higher artistic commitment was to classical subject matters and to a pure and noble style. Modern costume, realistic portraiture, topographical landscape, unavoidable in battle scenes and ceremonial pictures assigned to them, frustrated their aesthetic aspirations and violated their principles."[3] Nor had their training prepared them for the compositional and atmospheric challenges of the battlefield. Fatigue in even the strongest works of officially inspired art set in at the same time that the emperor overreached himself with his Spanish and Russian adventures and the Empire began its rapid decline.

In this last phase of the Napoleonic era, French academic painting gave rise to something beyond itself. Soon after his brief apprenticeship in Carle Vernet's studio, the twenty-one-year-old Théodore Géricault painted a large *Equestrian Portrait of M. D...* for the Salon of 1812. It was a painting that in its verve, in the violent energy of the charging horse and the gravity of its rider enveloped in the smoke and explosions of battle, far surpassed even the strongest military portraits of the time. Nor was Monsieur D..., the man portrayed, a dignitary of the Empire, but a junior officer, friend of the artist, whom Géricault painted as a representative of his generation. The painting, occasionally called *The Charging Chasseur*, was a portrait of the

3. Lorenz Eitner, *Géricault: His Life and Work* (London, 1983), pp. 20–21.

Grande Armée itself, at the edge of its destruction. After Napoleon's first abdication, Géricault again entered the *Chasseur* in the Salon of 1814, together with a counterpart, the *Wounded Cuirassier Leaving the Field of Battle*. Once more the painting shows an anonymous soldier, but this time not rushing toward the enemy. The soldier on foot, suffering from an invisible wound, the chinstrap of his classicist helmet undone, leads his horse down a slope while looking back at the battle or perhaps at a pursuing enemy. Together the two monumental paintings define the apogee of the Empire and its collapse.

During the next years Géricault painted several other works on military themes, among them two oils of imperial carabiniers, which have been rightly characterized as exploring "a social condition and a state of feeling peculiar to their time: they are historical rather than individual portraits. . . . Géricault, alone among French painters of his immediate period, had documented the twilight of the Napoleonic soldier caste."[4] Between 1817 and 1818 he also produced a number of lithographs on battle and military life that concentrate on the fortitude and suffering of the common soldier. The subject of one of the lithographs, a cart loaded with wounded soldiers, he also painted in oil (Fig. 5.2). The painting, showing the cart from behind, followed by two soldiers who lift a badly wounded man into the already crowded vehicle, is reminiscent of the wagon in Seele's *Chance Encounter*. The painting expands Seele's brief notation of the soldier's fate into a massive depiction of human suffering. But Géricault's work left little imprint on the academic art of Restoration France. Like most artists of the time, he began with academic painting; but the academy was slow to learn from the few who broke out of its mode. Géricault painted men in extreme danger and emotional travail who happened to wear French uniforms; for even the most accomplished practitioners of history and battle painting, its anecdotal character and didactic program, clothed in historically accurate costume, proved a sufficient challenge.

Academic history and battle painting spread through European culture. Its works dominated art exhibitions; they decorated the public rooms of palaces and parliaments, of administrative buildings and the salons of private houses. It was an art that linked the assumptions and achievements of older elites with the expectations of the new bourgeois world, and that addressed the thinking man and woman. But beneath its smooth, carefully finished, glossy surface, another art of war, rooted in the past but moving in new directions, was waiting to break into the open.

❀ ❀ ❀

The acknowledgment of the human cost of war, which fit easily into celebratory and exhortative images, and was a major element in Géricault's analyses of French soldiers and veterans at the end of the Empire, could also become the basis for criticism of its inevitable cruelties and even for the condemnation of war itself. The emphasis on casualties gained strength throughout the century as more artists incorporated a questioning or critical note into their

4. Ibid., pp. 71–72.

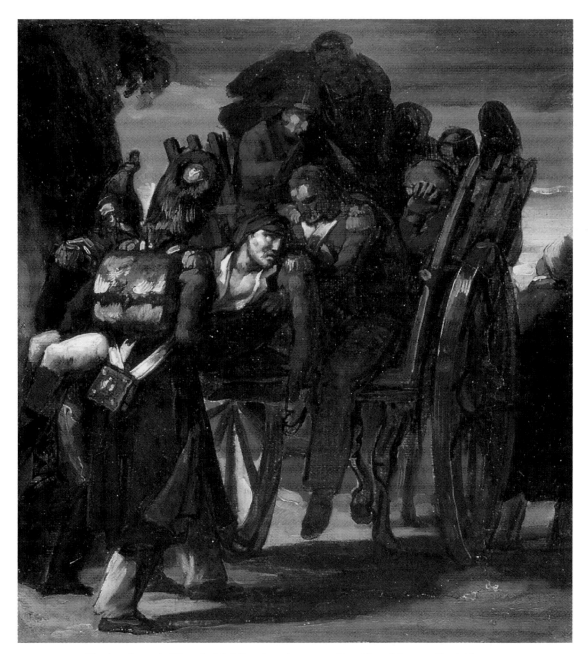

FIGURE 5.2. *Théodore Géricault,* Wounded Soldiers in a Cart, *1818. Fitzwilliam Museum, Cambridge.*

work, or simply developed a more comprehensive realism; but its most powerful expression came at the very beginning of the period, although for nearly half a century it remained unseen. Goya worked on his series of etchings, *The Disasters of War,* from late in 1809 to 1820. The series was not published in his lifetime. When the first edition came out in 1863, the etchings had lost nothing of their revolutionary modernity. They were as unlike academic representations of war in the 1860s as they had differed from the usual images of Napoleonic campaigns when Goya drew them. In their bitterness and irony and in their bringing together the specifically historical with universal themes, the etchings are the most powerful images of war of the peri-

od; from a long perspective, they appear as the most significant bridge between the art of the first years of the century and modern art that deals with war.

The first forty-seven plates of the series, preceding the group that deals with the famine in Madrid and elsewhere in 1811 and 1812, show fighting between soldiers and civilians and the working of a military machine that cuts huge swaths through civilian life. Some of the men and women who are being tortured and killed, or who strike back at the malignant force that has suddenly appeared in their midst, wear Spanish dress, and the soldiers' uniforms are recognizably French. But these distinguishing marks are insignificant except as signs that the images are not inventions without a link to reality, but refer to events that recently took place in Spain. Even the soldiers' shakos and busbies are broadened and simplified into universal symbols of brutality. In the same manner, the war fought in Spain and the French occupation of the country are generalized into savagery and slaughter that may happen anywhere.

In his journey through this moral wasteland, Goya takes up several themes that were treated—if in a very different manner—by other artists of his generation. The links between his graphic work and popular British and French prints have been studied, and it is not improbable that he was familiar with the engravings after paintings by Joseph Wright and Benjamin West, many copies of which had found their way to the Continent. Even the theme of the dying hero appears in *The Disasters of War*, but stripped of its nobility and placed in a context that takes account of both antagonists and weighs the moral worth of invader and defender.

The sixth plate, *It serves you right* (Fig. 5.3), shows a severely wounded officer or official lying on a barren hilltop, behind which towers a dark mountain. The man, on his back, his neatly shod feet still pointing up as though he could rise if only he wanted to, his right arm folded over his waist, perhaps to cover his wound, has lifted his left hand in a gesture of sorrow and pain. He looks helplessly at the three soldiers bending over him, who are already mourning his end. A fourth is hurrying toward two other men a little distance beyond him. It is not clear whether they are fighting or one is wounded and is being cautiously lowered to the ground by the other. To their left lies a corpse. The body is hidden by the crest of the hill, except for the feet, already turned outward in the relaxation of death. In the far distance several men appear to be fighting, while in the lower right a soldier, sword in hand, hurries up the slope. Far from being a messenger of victory, he seems almost unable to believe that his superior, who, the etching's title states, deserves his fate, is dying. The scene conveys no elevating message, except perhaps the declaration that even an evil force may contain soldiers who are decent men liked by their subordinates—which should not spare them from death.

More frequent in the series are images that show the fate of the common soldier—soldiers dying under a bush. The plate with the most interesting narrative, although visually perhaps not the most successful, is plate 17, *They do not agree* (Fig. 5.4), which contrasts the indecisive and presumably haphazard manner in which a command is arrived at with the fate of the soldiers who carry it out. Two officers, their horses stationary among corpses and broken weapons on the ground, argue over the action their troops should take. A foot soldier leans against the rump of the horse in front. Behind him, two other soldiers push an invisible object for-

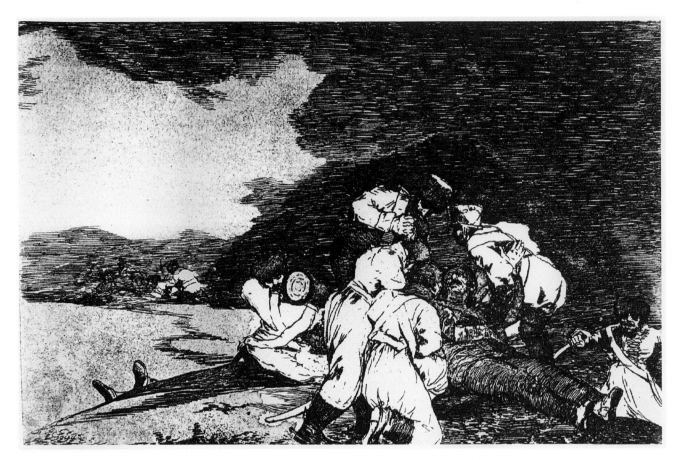

FIGURE 5.3. *Francisco de Goya,* It serves you right, *no. 6 of* The Disasters of War, *1809–14. Princeton University Library.*

ward. Despite their disagreement, the officer in the foreground extends his saber in a gesture of command, while he continues to talk with his comrade at whom he is looking rather than at the enemy or at the men he has ordered to advance. Disagreement is also central to the right half of the image, where men are hacking each other to death. The etching denies not only the validity of the action it portrays — that is, of war, which is the extreme way of settling disagreements — but also the processes of war, in which one man's half-formed idea leads to the death of other men. To think of the etching in relation to West's *Death of General Wolfe* may be to conclude that Goya's officer is the counterpart of General Wolfe before he was struck down, and that the British grenadiers under Wolfe's command were driven to their death as needlessly as are these French soldiers on a Spanish hillside. From an inappropriate motif, to be avoided by serious artists, the common soldier dying under a bush has evolved into a major theme in *The Disasters of War.*

Fourteen of the forty-seven plates in the series show women, some with children, as victims and even as participants in war. The introduction of women and infants into scenes of military life and even of extreme violence, which had shocked and attracted the viewers of

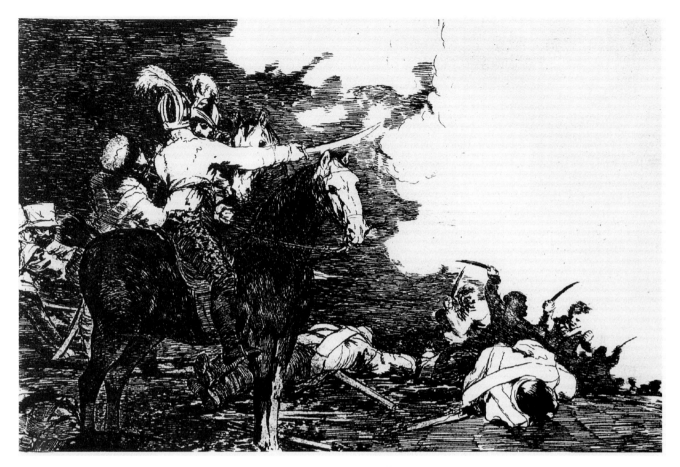

FIGURE 5.4. *Francisco de Goya,* They do not agree, *no. 17 of* The Disasters of War, *1809–14.*
Princeton University Library.

Joseph Wright's *Dead Soldier* and the many thousands who bought the engraved version of the painting and the graphics by Seele and Geissler, has lost all strangeness in Goya's plates. Far from being outsiders in a masculine world, the unique characteristics of which they point up by their presence, they have become part of its brutal and sad reality.

Not every image with women presents them in a new light. Women fleeing with their children from a burning village or from dangers that are not shown (plates 41, 44, and 45) still fall within familiar parameters. That can hardly be said of the women who together with men are executed by a firing squad (plate 26), or the women who are killed when a cannonball smashes their house (plate 30), or the woman in plate 28, *Rabble*, who beats a man being dragged on his stomach over cobblestones and thus becomes part of the rabble, while her male companion jabs him with a pitchfork and other men and women watch. Horrible though they are, the scenes of rape and of women fighting off rape return to more familiar ground, frequently explored by the great Renaissance and Baroque masters, and on a nonmythological plane included by Callot, for one, among the many misfortunes of war. Truly exceptional, on the other hand, is the content of three plates that show women when rape is not the issue

or not the only threat. Of these, plate 5, *And they are like wild beasts* (Fig. 5.5), is the most extraordinary.

A patrol has encountered a group of women, and in the fight that has broken out a woman, her left arm holding a small child against her back, a pike in her right hand, lunges at a soldier. The point of the weapon has gone deep into the man's stomach, and he is collapsing. Two other soldiers have already fallen to the ground, one toward, the other away from the viewer. Above their shoulders, along the line of the pike, the heads of three people appear: a woman on the ground; to her right another woman, apparently on her knees, screaming; and to her right and slightly above her a man or woman in profile. Behind the woman with the infant, a soldier, his back toward the viewer, fends off another woman who jabs at him with a sword. At the far right of the plate, a soldier has just fired his musket over the knot of struggling and falling bodies at a woman on the far left. She has fallen to the ground but supports herself on her elbow, her hand still gripping a knife or a broken sword. A woman behind her is about to throw a rock, which she holds with both hands over her head. In the far background, the small, dark shape of a soldier aims a musket at her.

The clash without stated cause, in a featureless gray space, shows no sign of ending until both groups have done away with each other. Goya adds to the explosiveness of the scene by imposing an austere three-dimensional composition on the contorted faces and twisted bodies, consisting of several intersecting diagonals: On the left a steep line is formed by the woman about to throw the rock, the front edge of her skirt leading to the white skirt and knee of the woman with the pike and to the head of a soldier on the ground. A second diagonal runs from the woman on the ground at the left, along the back and head of the woman holding the pike and along the barrel of the musket, which continues the line of her back and neck, to the soldier at the far right of the plate. A third diagonal runs toward the foreground from the hooded woman jabbing at the soldier in the middle distance, down his shoulders and past the head of the woman with the pike (the foreshortened body of her child reinforces the line), to the right hand and left knee and foot of the falling soldier. The purity of the composition seems to attest the logic of the struggle and demonstrate its necessity.

It hardly needs adding that an actual fight between women and soldiers in Spain in 1808 and 1809 would not have assumed such concentrated form, but the etching's truthfulness goes beyond the reportorial accuracy of battle painting. The image reveals the emotional core of actions that in a village street or country road would have been carried out in a more haphazard and dispersed way. Nor does the somewhat artificial posture and expression of the rock thrower in the middle distance detract from the etching's power. Similar excursions into a different stylistic vocabulary occur in a number of the plates, and Goya has sometimes been criticized for slipping from his usual standard and drawing "wooden, puppet-like figures." But the appearance of formulaic figures only strengthens the impact of others that are completely thought through—here, above all, the woman with her child and her pike—and the contrast adds a further dimension to Goya's interpretation: what I have to say is too important for me to worry about every external.

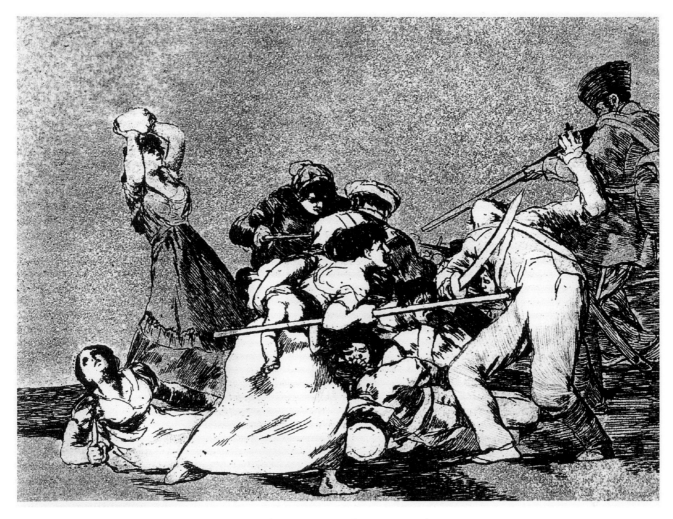

FIGURE 5.5. *Francisco de Goya,* And they are like wild beasts, *no. 5 of* The Disasters of War, *1809–14.*
Princeton University Library.

This goes far beyond Callot, whose *Large Miseries of War* have often been compared with Goya's *Disasters* and from whom Goya learned. Not only did the small scale in which Callot worked limit the range of facial expressions and the complexity of dense compositions he was able to depict; he did not give free rein to his feelings. As might be expected from a Baroque artist, he expressed emotions in formal terms, which detracts nothing from their power but demands that today's viewer see past decorum and poise to recognize the artist's heart and mind at work. Goya conveys his anger, disgust, and pity more openly. He submerges himself in ideas and fantasies—parts of bodies tied to a tree, a woman raped in the presence of her husband or father, a man vomiting on a heap of corpses—and lifts their images to the surface with fewer intermediary screens, striking though his reticence in treating naked bodies in this context.

As in Callot's shorter, symmetrically architectonic series, the soldiers in Goya's sprawling universe are both perpetrators and victims. But they are subjected to different measures of morality. Callot passes over the political background of the scenes he draws but distinguishes between good and bad soldiers and soldiers who may have been good but are unlucky and end as cripples and beggars. Goya draws a moral distinction between aggressor and defender, but that is merely a first step. The defenders, too, are flawed and subject to the same cruelty and heartlessness that afflict their attackers. Even women are shown succumbing to pettiness and sadism. War is a force that brings out goodness and courage in some—as in the heroine who fires a cannon in plate 7, *What Courage!*—but that may reveal the worst in everyone. Goya's impartial recognition of flawed human nature, which leaves such official ideals as patriotism, revolutionary principles, or monarchial loyalties far behind, constitutes the most powerfully realistic strain in the narrative, if not in the aesthetic, of *The Disasters of War*. If any political consideration prevented him from publishing *The Disasters of War*, which is not certain, it must have had to do with Goya's readiness to show evil in everyone—Spaniard as well as Frenchman, nobles and priests as well as peasants, women as well as men. There is no reason to doubt that had those plates that he produced before Napoleon's defeat been given a partisan national twist, they would have found buyers at the time. They would have been as acceptable commercially as the scurrilous and sometimes obscene attacks on the French Revolution and Napoleon by British and Continental cartoonists.

Goya's evenhanded moral outrage and his analysis of the structure and form of violent acts point to the future. *The Disasters of War* identify just and unjust causes of violence but assert that regardless of the cause for which they fight and suffer, men and women are capable of the worst cruelties. In demonstrating this belief and fact, the etchings do, indeed, plumb depths that other approaches had illumined only from a distance. However, these truths do not become apparent unless the artist treats war not as something separate from the rest of social existence but as an encompassing force in which all distinctions between the people engaged and caught up in war—soldiers and civilians, men and women—are reduced or eliminated. Some of the images discussed in the previous chapter are steps in this direction: the image of the hero dying at the moment of triumph, beautifully, gives way to less glorious images of death, until the demonstratively unglorious deaths of untold numbers of anonymous soldiers become a main subject for the artist—just as the wife and mother mourning over her dead soldier is succeeded by images of women and infants in camp and in the midst of fighting in the streets, until finally the woman with her child is drawn as victim and killer.

A conception of war that could hardly be more different than Goya's in ideas, emotions, and style is *The Battle of Valmy*, a major work of historical reconstruction and interpretation that was painted by Horace Vernet for the duke of Orleans in 1826. Several years after the work was completed, in July 1830, Charles X abdicated, having failed in his effort to revise the constitution and increase the power of the Crown, and the duke of Orleans succeeded him on the

French throne as Louis Philippe. To help give permanence to the new liberal monarchy, it was believed useful for the arts to demonstrate how far its roots ran in the French past. The creation of a great patriotic and dynastic memorial in the Palace of Versailles was a centerpiece of this program of national education. Parts of the palace were remodeled to make galleries for paintings and statues that marked the country's heroic course from a tribal duchy to the latest version of the French state, and that lent authority to the Orleans dynasty by knitting together its history with the history of the Old Regime, the French Revolution, and the Empire. For the Hall of 1792, Jean-Baptiste Mauzaisse painted a much enlarged copy of Vernet's *Battle of Valmy*, the original of which remained in the gallery of the Palais-Royal.

The painting, nearly three meters high by seven meters wide in the version of Mauzaisse, offers a panoramic view of the Cannonade of Valmy, an artillery duel rather than a regular battle, in which a force made up of regulars of the old royal regiments commanded by noble officers and of volunteers from the new National Guard brought the invading Prussian army to a halt (Color Plate 5). The French troops are drawn up on high ground overlooking the flat expanse of the Champagne southwest of Verdun. Near the center of the position, the horse of the French commander, General Kellermann, has been hit, perhaps by the cannonball flying close to the ground near the lower edge of the painting, and horse and rider are falling. To their right, senior officers and adjutants are wheeling their horses to see what has happened, among them the duke of Chartres on a white horse and behind him, recognizable by his profile with a long, slightly curved nose, the duke's brother, the future King Louis Philippe, who commanded a division at Valmy. Beyond them, long white lines of French regulars are marching out of the right edge of the painting to complete the ring of French infantry lining the ridge. On the slope beneath them, French artillery returns the fire of Prussian guns from the plains below, where massed forces can be seen waiting for the command to advance that was never to be given. Smoke and a red glow near the edge of the painting mark an ammunition pile that has been set on fire. Farther to the center a cannonball has just struck the line of French infantry. As bodies fall, a helmet and musket fly through the air.

The right half of the painting is dominated by the commander in chief, who is brought to his knees but in a moment will rise to achieve a success that Goethe, who was with the Prussian forces in the plains below, called a turning point of world-historical significance. The left half of the painting, by contrast, is filled with details of military activity, the numerous incidents that together make up the action of an army. A battalion of blue-coated volunteers is marching toward the regulars drawn up along the edge of the plateau, past a windmill, the wooden sides of which have already been struck by cannonballs, and which went up in flames during the afternoon. To the left of the head of the column, a powder magazine behind the French batteries has been hit. The explosion is tearing a broad gap in the ranks of the infantry; in its red glow we see men lying on the ground and horses rearing and falling, while the gunners in front of the infantry continue to serve their guns. A wounded senior officer, held up by a regular and a volunteer, as though symbolizing the power of France resting on the monarchic tradition and revolutionary innovation, gives an order to a mounted officer, who has taken off his

hat as a sign of respect. In the foreground, between two dead horses and the low wall enclosing a farm, a general is talking with a heavy-cavalry officer wearing chest armor; behind the officer a trumpeter waits and another cuirassier is cinching the bridle of his horse. The courtyard of the farmhouse in the lower left corner of the painting has been turned into a first-aid station. A surgeon feels the pulse and checks the chest of a badly wounded officer. Another blue-coated physician treats a man who is lying on his side. Other men are waiting for treatment or rest in the shelter of the wall and the house. On the opposite side of the canvas, in the lower right corner, lies a dead cuirassier. His boots have already been pulled off—a variation of the motif we have seen used earlier by Callot, Courtois, and Meynier of the endless round of waste and salvage in war.

The Battle of Valmy is a good example of academic history and battle painting of the 1820s and 1830s. It is hardly persuasive as a work of art, but Vernet not only made good use of reports by men who were at Valmy and of earlier drawings and paintings of the Cannonade, he conveys the atmosphere of a bleak fall day in northeastern France after rain has stopped and the fog is lifting, as well as something of the atmosphere of an armed force in action, seen from a vantage point in the immediate rear. Most important, so far as Louis Philippe was concerned, the painting documents and proclaims the integration of monarchic and Revolutionary France through the all-embracing force of patriotism. At Valmy the two sides did work together reasonably well, although Kellermann had only recently implored the minister of war to break up the volunteer battalions and shift their men to regular units. The demise of the royal army, the escape of Louis Philippe to England, and the birth of a new army in the months after the battle lay beyond the painting's scope.

Some art critics of the 1830s and later considered it a matter of importance to distinguish between anecdote and a general view in paintings of battle. This assumed that opposites could, nevertheless, coexist, and in *The Battle of Valmy* the distinction between them has largely disappeared. The painting is composed of numerous anecdotal scenes or vignettes within a general and impersonal framework of large units, in which hundreds of men acted as one. Some of the anecdotes are fully developed: the central incident of the unhorsing of General Kellermann or the worried surgeon tending to the half-unconscious officer behind the farmhouse. Others are mere suggestions: the two soldiers carrying a wounded comrade to shelter between the foundation piles of the windmill, where other wounded or exhausted men are already resting, and which they will soon have to leave when Prussian cannons set the windmill on fire; or the royal officer marching with a sergeant of the National Guard volunteers in symbolic symbiosis at the right edge of the painting. The work's celebration of the triumph of the Revolution before it declined into regicide and the dictatorship of the Committee of Public Safety makes it the monarchic counterpart—specifically the Orleanist counterpart—of Delacroix's idealization of the Revolution of 1830, which ended in the unexpected ascension of Louis Philippe, *Liberty Leading the People*. Delacroix painted an idea compressed into the image of contemporary Frenchmen storming over a barricade, led by a bare-breasted revolutionary Goddess of Liberty. It was only one of the ideas of the Revolution of 1830, just as the constitutional monarchy

COLOR PLATE 5. *Jean-Baptiste Mauzaisse, copy of Horace Vernet,* The Battle of Valmy, *1826/34.*
Musée Nationale du Chateau, Versailles.

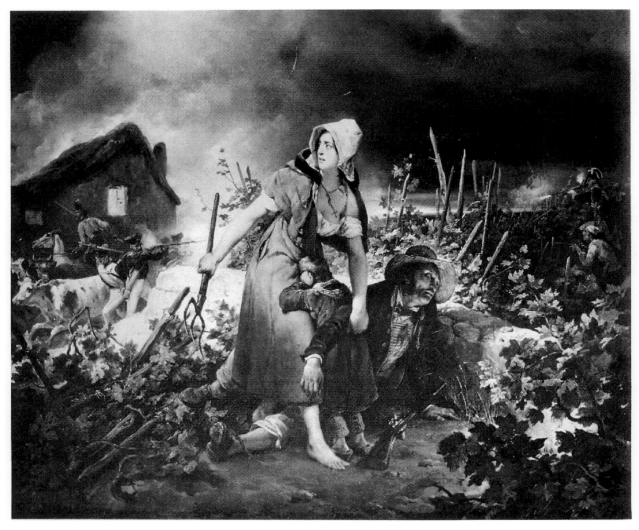

FIGURE 5.6. *Horace Vernet,* Scene of the French Campaign of 1814, *1826. Private collection.*

was only one of the ideas of the Revolution of 1789, and the interpretation of Delacroix's great romantic paean is as much a mix of the true, the wished-for, and the false as is the interpretation of Vernet's academic narrative.

In *The Battle of Valmy* Vernet succeeded in giving a differentiated picture of an army in action, but at the price of a diffused composition and a heavy reliance on narrative elements. In the same year he painted a smaller and much more concentrated work, *Scene of the French Campaign of 1814* (Fig. 5.6), in which the theme "women and children in war" appears once again. The painting is dominated by a young woman, standing over a man who has been shot and who has fallen to the ground. A small boy buries his head in the woman's lap, his hands covering his ears to block out the noise of musket fire. The little group, in a vineyard that has been crushed by people running through it, finds itself in the middle of a skirmish. On the left, some Russian soldiers and a Cossack have set fire to a small farmhouse and are driving off the

farmer's cows. They are being shot at from the right by a French dragoon and a few civilians, and one or two of the soldiers are returning their fire. They must have just hit the man on the ground, whose hunting rifle lies next to him—probably he is the farmer himself.

The woman tries to assist and protect both the man and the boy. Like the woman in Goya's etching, but unlike the women in *The Dead Soldier* and in the two German prints, she is more than a helpless victim or potential victim. The pitchfork in her right hand is as much a weapon and symbolizes her active rather than passive role as it is a symbol of work, of constructive effort, which Vernet contrasts with the destruction around her. In his concise exposition of a single incident he has also managed to depict the comprehensiveness of war. Soldiers are fighting, a civilian has been shot, property is destroyed and stolen, and women and children are shown to be as much a part of war as men.

By comparison, the interpretation of war is simplistic in the grand canvasses on which Vernet's fame largely rests. For the Gallery of Battles in the Palace of Versailles, he painted three great Napoleonic victories in the form of heroicizing anecdotes. These works, which gave full rein to the painter's Bonapartism, a sentiment that early on he knew how to combine with loyalty to his patron, the duke of Orleans, continue by means of reproductions in history textbooks to shape the image of the emperor in popular culture today. The event from which each painting derives its title is reduced to the man. Not only is the emperor the central figure in each, he and his entourage blot out the battle that is about to be fought or that has just been won. Another painting in the gallery by Philippoteaux at least shows a stylized cavalry encounter in the background; but here, too, a representation filled with pathos renounces any interest in the battle itself for the sake of presenting Napoleon as a demigod in modern uniform. That such works were not battle paintings, nor history paintings if they claimed to depict an event rather than to mythologize an individual, was repeatedly pointed out. In 1836 Alfred de Musset observed, "What is to be most criticized about [such paintings] are the titles they have been given, for these are not paintings of battles, first of all because no-one is shown fighting, and furthermore because no-one can be fighting since the emperor is present."[5] A conservative critic, Roger de Beauvoir, noted the same year:

> We cannot repeat often enough that paintings of battle must above all show men fighting. But what do we see in all the military episodes M. Vernet has chosen this year? Two pillars of smoke in the distance, and in the foreground always the eternal victor Napoleon. In M. Vernet's hands frightful combat and wars fought for glory end up like bulletins of the *Grande Armée*, which conclude with the phrase: "the emperor is well." We believe that is no way to write history. In our opinion one doesn't paint battles to show the public: look, war is a beautiful activity! One paints in order to show the public the moral characteristics of war.[6]

5. Cited in Thomas Gaehtgens, *Versailles als Nationaldenkmal* (Berlin, 1984), p. 243.
6. Ibid.

The contentious political atmosphere in France in the late 1830s and 1840s, and the unusually emphatic political program displayed in the new galleries at Versailles, may have contributed to the outspoken criticism of aspects of this art in France. Certainly there was widespread discomfort with paintings that represented war primarily as a function of the great man, even if he could be said to personify the nation. A more comprehensive critique was developed by Baudelaire. In his review of the Salon of 1845 he attacked Vernet and through him other painters who treated historical subjects in narrative fashion. Baudelaire dismissed Vernet's painting of a recent French victory in North Africa for lacking unity: "It consisted merely of a host of interesting little anecdotes; the whole vast panorama is fit for the walls of a tavern"—a criticism he would presumably have extended to *The Battle of Valmy*.[7] Baudelaire does not say whether he preferred Vernet's paintings of Napoleon at the Battles of Jena, Friedland, and Wagram, each of which was constructed around a single anecdote or incident, surrounded by supporting narrative elements; but he rejected patriotic, martial art generally. In his critique of the Salon of 1846 he returned to the attack, this time aiming at the politics as well as the aesthetics of Vernet's art.

Vernet's popularity, which cut across class lines, derived, Baudelaire thought, from the patriotism of "this eminently national artist" and from his superficiality: "Art for him is as clear as glass, and offers no problems. But he records your glory for you, and that is the great thing." Baudelaire despised Vernet's art—paintings of "nationalist nonsense" that accurately purveyed such facts as "what a gaiter or a boot battered by hard marches looks like"—but he also rejected Vernet's favorite subject—war—as not suitable for art, an odd surrender, it may be thought, for a critic who gloried in explaining to the bourgeoisie just why those matters that they regarded as forbidden or obscene were ideal subjects for the artist: "M. Horace Vernet is a soldier who busies himself with painting; I hate this art thought up to the beat of drums, these canvases daubed at the gallop, this painting fabricated by pistol-shot, just as I hate the army, armed power and anyone who clanks weapons noisily around in a peaceful place. This enormous popularity, which, moreover, will last no longer than war itself, and which will fade away as nations find other ways of amusing themselves, this popularity, I repeat, this *vox populi, vox Dei*, simply oppresses me."[8]

Thirteen years later, in his articles on the Salon of 1859, Baudelaire took up the issue of painting war once more. Vernet had died, but Baudelaire resurrected him for a sentence or two as an example of an artist who had been unable to solve a problem that the author still regarded as central to the painting of battles. A real battle, he wrote, cannot be represented in a picture, it can only be outlined schematically and topographically, tracing the movement of units over the ground in "a series of white, blue or black lines." Vernet's solution of stringing together a "series of accumulated and juxtaposed episodes" destroyed the unity of the composi-

7. Charles Baudelaire, "The Salon of 1845," *Selected Writings on Art and Literature*, trans. and ed. P. E. Charvet (London, 1992), p. 39.
8. Ibid., pp. 87–88.

tion; his paintings resemble "those bad plays where an excess of extraneous incidents prevents our seeing the main theme, the conception that was at its origin." Baudelaire now acknowledged implicitly that war might be a valid subject for "pure art," but only if it were reduced to a mere episode; yet even here he experienced difficulties. In paintings of combat he was offended by "the stand-still frozen violence, and the horrible, cold grimaces of static fury." Besides, modern uniforms were monochrome and "do not lend themselves easily to the picturesque." And once again Baudelaire objected that in this field art easily succumbed to exaggerated patriotism, although he had nothing to say about a question that other critics, like his friend Maxime Du Camp, continued to raise: Did French battle painting still glorify the general at the expense of the common soldier?[9]

Among the paintings on military themes in the salon, one nevertheless met with his approval, a modestly naturalistic study of French soldiers in the Crimean War cutting fodder for their horses. The brush strokes representing the men's red trousers made him think of poppies in a meadow, which lent "a touch of gaiety to the vast ocean of green."[10] Despite his earlier strictures, it was not the subject of war but the academic and aggressively patriotic manner of depicting it that disgusted him. With rare precision he pointed out the inadequacies of academic art in face of war, but he valued those artists who, like himself, dove to the bottom of the abyss to discover new experiences and new insights. In *The Painter of Modern Life*, probably written soon after his critique of the Salon of 1859, he praised the sketches—most now lost—that Constantin Guys sent back from the Crimean War: "I have looked through these archives of the Eastern War (battlefields strewn with the debris of death, heavy baggage trains, shipment of livestock and horses), scenes throbbing with life and interest. . . . No journal, I declare, no written record, no book could express so well this great epic of the Crimean War in all its distressing detail and sinister breadth." Further on he describes a sketch in which Guys pictured himself. The artist "seems to be scenting the terrible poetry of the battlefield, whilst his horse, sniffing the ground, picks his way between the heaps of corpses, feet upturned, faces contorted, in strange attitudes." Guys's interest in the details of military life linked him with Horace Vernet, but Vernet was a "journalist rather than a true artist," whereas Guys "succeeded, in his drawings, in distilling the bitter or heady flavour of the wine of life."[11] We can only guess what Baudelaire might have written about Goya's etchings. Although *The Disasters of War* were published four years before his death, we do not know whether he ever saw them. But his inclusion of Goya's earlier *Caprichos* among the "Beacons" in *Les Fleurs du Mal* suggests how much he would have admired those further images of "nightmares filled with the unknown."

9. Ibid., "The Salon of 1859," pp. 320–21.

10. Ibid., p. 322.

11. Ibid., pp. 409–11, 435.

6

The Retreat from Marignano

From the 1840s on, artists and craftsmen worked in the awareness that they were no longer the only creators of images. Photography became a new source of pictures of the contemporary world and, with the help of stage sets and costumed models, could re-create the past as well. Some artists saw a dangerous rival in photography. The number, variety, and popularity of the images it produced confirmed to them the necessity and power of objective, detailed depictions of reality.

In a section preceding the discussion of military art in his articles on the Salon of 1859, Baudelaire discussed the advent of photography and its impact on art. The "new industry" was a danger to art, he thought, because photography could destroy the artist's and the public's capacity to imagine and fantasize by playing on what he took to be the characteristic French preference for truth over beauty in art. Photography was valuable as an aid to memory and as a record keeper but must not become a model for art, it "should not be allowed to impinge on the sphere of the intangible and the imaginary."[1]

Baudelaire's critique is less an attack on photography than on unimaginative art, on painters who seek photographic verisimilitude, like Horace Vernet, whose pedantry and lack of imagination he castigates further on. Yet *The Battle of Valmy* pointed to a shortcoming of photography. Its large number of simultaneous, sharply detailed incidents were beyond the power of the early camera to encompass, an inability for which the practice of combining negatives into a composite

1. Charles Baudelaire, "The Salon of 1859," *Selected Writings on Art and Literature*, trans. and ed. P. E. Charvet (London, 1992), pp. 295, 297.

photograph was a feeble substitute. But painters also found it difficult to assemble many different actions into a strong composition, and it is understandable that Baudelaire advocated a reduction in the painter's focus to a single incident that might stand for the whole. Baudelaire further denied photography the ability to do more than record what already exists, although in an aside he suggested that it was foolish to believe in the exactitude of photography. That Baudelaire failed to recognize the full potential of the new process at this early stage is not surprising, but it is significant that he raised the issue of photography in relation to art and war. Of the many challenges that photography posed to art, one of the greatest was that it might finally reveal more accurately than art could the appearance of activities that until then had remained beyond the scope of many observers. Of these, war and sexual activity were probably the most important. Pornography quickly became a mainstay of photography, but war turned out to be a more difficult subject to photograph than sexual intercourse.

After the introduction of glass negatives in the early 1850s, soldiers drawn up on the parade ground and in camp proved suitable subjects for the camera; photographs of corpses in the aftermath of battle in the American Civil War and the Franco-Prussian War became famous, but combat remained almost immune to photography. Recording rapid movement from a distance continued to pose great difficulties, and combat itself became less visible as the battlefield expanded, cavalry disappeared, and infantry formations gradually opened up and became more mobile. Even in the First World War, photographs that showed actual combat rather than corpses or troops on the march, resting, or waiting in the trenches remained rare. The two-hour motion picture record of the Battle of the Somme that the British War Office produced in 1916 included no more than one minute and ten seconds of infantry combat, and even of that brief footage some was staged or taken during training. Artists who accompanied troops in the field, sketched what they saw, and afterward worked up watercolors and paintings from their notes were better able to report—let alone interpret—combat than were photographers. Even in the Second World War, photography and film, which by now had reached high levels of technical sophistication, did not displace the artist.

Photography did bring to a halt the further creative development of uniform plates of contemporary armies. They continued to be produced, but the inventiveness that distinguished the work of such superior artisans as Seele and Geissler faded and disappeared. The task of recording the changes in military fashion was accomplished too well by photography and in line drawings and woodcuts based on photographs to leave scope for the serious graphic craftsman. The depiction of uniforms worn in the past, on the other hand, retained for a time some measure of vitality. History painters necessarily made studies of individual figures in the dress of the relevant period, which might then become the basis for separate works. A number of painters developed the portrayal of soldiers of former times into a successful specialization that accompanied their larger historical efforts. Ernest Meissonier is an outstanding example. His miniatures of musketeers of Louis XIV, volunteers of the Revolution, and Napoleonic grenadiers and hussars are admiring evocations of the country's military past, which combine a romantic sense of period with the unmistakable tone of nineteenth-century

haute bourgeois culture. But the human being disappears behind the trappings of historical reconstruction.

Meissonier's German contemporary, Adolph Menzel, could not always avoid a similar outcome, but his more complex oeuvre includes paintings and graphics in which the description of dress becomes one with refined interpretations of the individual in his epoch. As a young man, Menzel illustrated Franz Kugler's *History of Frederick the Great* with 376 wood engravings, a work patterned on a popular biography of Napoleon with engravings in which Horace Vernet restated more crudely the contributions to the Napoleonic legend he had made in his paintings at Versailles and elsewhere. Menzel had nothing similar to fall back on and carried out his task in a prolonged burst of originality. He brought to it an affinity for the harshness and—in the upper reaches of society—frugal elegance of Frederician Prussia, which he backed with an unusual commitment to research. He did not lose himself in details of dress, which the engravings were in any case too small to convey clearly; instead, he developed a kind of historical impressionism that captured the movement and atmosphere of the moment within its fully realized cultural, architectural, and military context. Among the illustrations are powerful images of battle and of the cost of battle, interpreted by an artist to whom the person of the monarch and the idea of the state meant less than the attitudes and circumstances of the soldiers who fought for them. In 1843, soon after finishing his collaboration with Kugler, he began a massive catalogue of the uniforms of the army of Frederick the Great, a project on which he labored intermittently for nearly fifteen years. The 453 colored lithographs, many of which use identical figures on which the uniforms are shown and vary only in color and details of insignia and trim, were the result of a new burst of research in paintings and graphics of the time and in archives and collections of weapons and uniforms. Gradually Menzel created a body of visual information of rare comprehensiveness, highlighted with some vivid, imaginative scenes of eighteenth-century military life. But the need to differentiate endless variations of design and color finally overwhelmed even his intense interest in the material evidence of the past, and the time and energy he expended on this drudgery may perhaps have acted as a serious diversion, possibly even as a brake to his subsequent development.

Before he completed the project, he produced a separate set of thirty-two hand-colored wood engravings on the same subject, the Frederician army, in which he applied his now exceptional knowledge of eighteenth-century dress and equipment to scenes that placed Prussian soldiers in their milieu: a death's-head hussar on outpost duty in winter, wrapped in a black cloak, carbine in one hand, drawn saber in the other, astride a tough little horse shivering in the cold (Color Plate 6); or three ruffians in the vaguely Hungarian uniforms of Prussian free corps of the Seven Years' War, drinking and playing cards, while a chaplain vainly threatens them with eternal damnation. In Menzel's hand, the description of military fashion expanded into accounts of ordinary lives lived in their historical setting, and it may be said that with these graphics the historical uniform plate reached its apogee.

❀ ❀ ❀

Both Meissonier and Menzel became famous for their large history paintings—they form a smaller and less significant part of Menzel's output than of Meissonier's—and both responded to incidents of fighting that they themselves witnessed. Meissonier, who served in the National Guard in 1848, painted corpses of Parisian workers, lying on the cobblestones of the street they died to defend, *Souvenir de guerre civile*, which remains the most powerful image of the June Days, however one interprets its political message. Delacroix disliked a preliminary study, a watercolor *La Barricade, 1848*, that he saw in the artist's studio. "It is horribly realistic," he noted in his diary; "but although you cannot deny its accuracy, it does perhaps lack that indefinable quality which *makes a work of art out of an odious subject*."[2] Menzel followed the Prussian army to Bohemia in 1866 and made studies in pencil and watercolor of dying and dead soldiers, achieving a degree of pitiless objectivity that Delacroix might have found even more distasteful. When it came to painting subjects of the past, however, Meissonier's sense of immediacy faltered, whereas Menzel at his best did not seem to look backward. He effaced the difference between the past and matters he knew at firsthand.

In 1864 Meissonier completed his most impressive history painting, *1814, The Campaign in France* (Fig. 6.1), a work that shows Napoleon riding under a leaden sky, through the snow and slush of a late winter's day, followed by a group of marshals and generals, worn out, eager for peace, but driven forward by the emperor's will. Behind and beside them, long columns of troops move through the empty, seemingly endless countryside. The dreary scene is a comment on the Napoleonic experience at a time of incipient disaster, which throws into question even the emperor's earlier triumphs. Meissonier's correspondence and other statements indicate that he was of two minds about Napoleon's genius and determination and their impact on France at this late stage of his reign. He admired him, but he also admired and sympathized with the conscripts who fought the emperor's battles, without understanding the reason they were fighting and dying. Out of this ambiguity came a painting that offered not only the usual programmatic illustration of academic history painting, but also a genuine if not surprising historical interpretation: the French army's hopeless efforts in 1814 to save the Empire by keeping the Allies from reaching Paris served only one man's murderous fantasy.

Meissonier's *1814* became and has remained his best-known painting. As a work of art, however, rather than as a memorable evocation of the past and an interesting comment on it, *1814* has an obvious weakness. Is it too facetious to suggest that the painting would become incomprehensible if the expressions on the faces of the emperor and the two or three men nearest to him, occupying no more than a minute part of the canvas of little significance to the composition and color of the whole, were to change from weariness or determination to cheerfulness? The painting's raison d'être depends on the narrative difference between a frown and a smile; everything else—the lowering sky, the dirty snow—is merely supporting comment, which would fall away if a few lines of Napoleon's face were altered and the paint-

2. *The Journal of Eugène Delacroix*, trans. Lucy Norton, ed. Hubert Wellington (London, 1995), p. 94.

Husar.

Fünftes Regiment (genannt Todtenköpfe).

COLOR PLATE 6. *Adolph Menzel,* Deathhead Hussar, *no. 19 of Eduard Lange,*
Die Soldaten Friedrichs des Grossen, *1856. Private collection.*

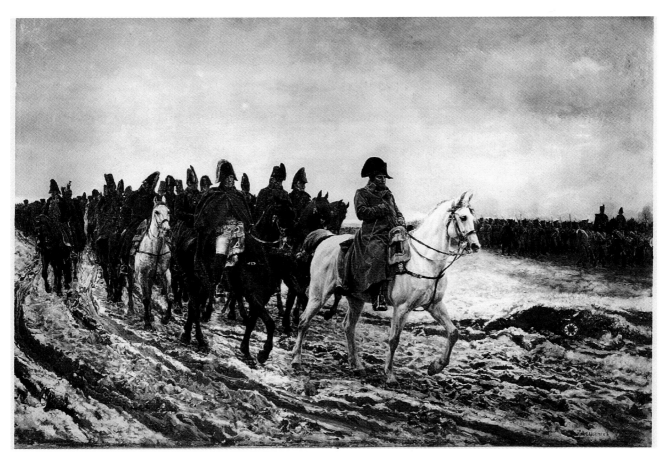

FIGURE 6.1. *Ernest Meissonier,* 1814, The Campaign in France, *1864. Louvre, Paris.*

ing's title changed to "1805, The Austerlitz Campaign." Meissonier's aesthetic resources served a purpose that was not fully integrated into their grammar and vocabulary. The work exemplifies the basic problem of history painting, a problem that only the most gifted artists could overcome—and then not always completely. Historical reconstruction limits aesthetic strength if the artist does not work through the historical issues until they become an extension of contemporary reality and an appropriate context for the artist's view of nature and mankind. When he painted *Recollection of the Civil War*, Meissonier painted not only the aftermath of a street battle, but also the men and women who had built and defended a barricade, and whose corpses now were refuse of civil war like the torn-up cobblestones on which they lie. In *1814* his sympathy for the common soldier is expressed only in his treatment of Napoleon's face. The soldiers themselves remain undifferentiated extras in the history lesson of the tragic hero self-betrayed.

In several of his paintings Menzel advanced some steps further toward the integration of art and history. In 1856 he completed his most important battle painting, *Friedrich und die Seinen bei Hochkirch*, a title usually translated as *Frederick and His Troops at Hochkirch*, although the collective noun "Seinen" implies a relationship closer than "troops" or "men"—possibly even a family bond (Fig. 6.2). In the painting, Menzel rejected both technical and programmatic con-

ventions of academic battle art. The work was destroyed during the Second World War, but even reproductions show the original's dark color scale and the uneven, often thick laying on of paint that help convey the desperate, earthy, anything but triumphant atmosphere of the October night in 1758 when an Austrian army surprised the outnumbered Prussians in their quarters and dealt Frederick—who had not believed the enemy would attack him—one of his worst defeats.

A ragged line of Prussian infantry, two and three men deep, extends from the lower left of the canvas diagonally to the middle distance. The men are facing and firing at an invisible enemy; some are silhouetted against clouds of powder smoke, which fill the upper left corner, the brightest part of the painting, and drift across a tree in front of, or in the front rank of, the firing line. Many of the soldiers are without hats and their coats are unbuttoned. Out of the darkness on the right, more men are running to help them, led by two officers who, using their drawn swords as canes, are climbing up a low rise to join the fight. From the right in the middle distance, Frederick rides past the rear of the firing line toward the viewer. A rider behind him appears to be sliding off his rearing horse; on his right a horse has fallen, its legs still kicking in the air. The king looks at the men hurrying to their comrades, but we see no gesture of command; the expression of his wide-open eyes is difficult to interpret and seems to be repeated by the staring eyes of his white horse. As Menzel's somewhat unusual title for the painting also suggests, here the king is not the distant supreme commander, but a member of the group who shares in the common effort. Evidently the painting shows only a small part of the battle, but it contains all the elements that distinguished this particular battle from others in the Seven Years' War: the army surprised at night, soldiers hurrying out of camp while others already fight, resistance emerging out of confusion. The painting of a segment becomes a concise, even symbolic statement of the whole.

Beyond its formal and technical qualities, two aspects of the painting stand out: Menzel shows only one of the two forces engaged, and his interpretation of the troops that are shown departs from the expected. By excluding the Austrians from the painting, Menzel avoided the compositional difficulties posed by two belligerents exchanging musket volleys and artillery fire across open country. This was a general problem in painting a battle, which changes in warfare intensified with each generation. More effective firearms increased the distance between troops, hand-to-hand combat became less common, and as armies grew larger the battlefield further expanded. By painting only a segment of one of the belligerents, a limitation that greatly displeased some critics when the work was first exhibited, Menzel created the basis for the realistic character of *Hochkirch* and gave it the formal and dramatic cohesion lacking in a work like Horace Vernet's panorama of the French at Valmy.

Battle paintings restricted to the actions of one of the sides were not new in the 1850s. Examples are Vernet's *Valmy* (the Prussian columns are mere streaks in the distant background) and the large picture, *The Defense of Burgos*, that François-Joseph Heim painted around 1814. We see the garrison within the walls and on the ramparts; the enemy is not visible. But this was something of an exception. In the first half of the nineteenth century the drama of close com-

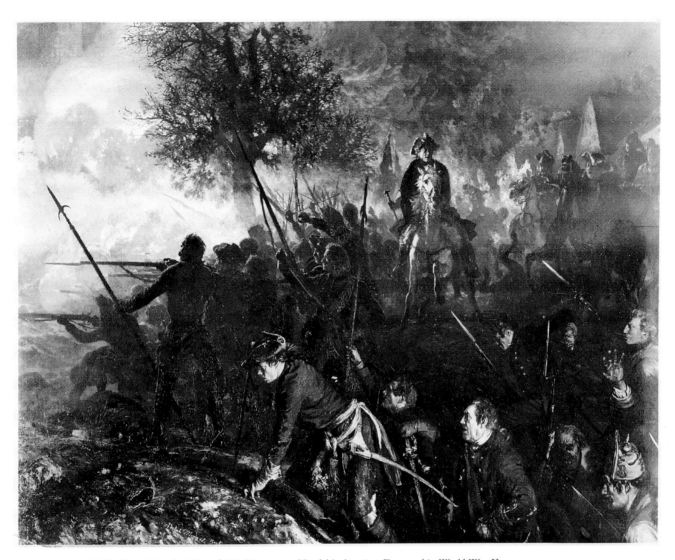

FIGURE 6.2. *Adolph Menzel,* Frederick and His Troops at Hochkirch, *1856. Destroyed in World War II.*

bat and the apotheosis of the general dominated the genre. Menzel's painting was one of the works that led to the revival of an approach that took account of the limitations of easel painting to encompass war as war was now waged. In the last decades of the century, paintings that showed a segment of the whole and suggested or implied the rest became a common type.

It has been suggested that the many French paintings after the Franco-Prussian War that showed only French troops or reduced the presence of the enemy to a minimum were a departure in battle painting, expressing both a psychological reaction of the French defeat as well as dissatisfaction with the old type of panoramic battle painting, which singled out a few leading individuals while the common soldier remained a faceless member of compact lines and columns. With his 1873 painting, *The Last Bullets,* writes one scholar, "Alphonse de Neuville established once and for all the archetype of an episode-painting, in which he introduced a com-

plete reinterpretation of a military event."[3] The painting, which shows the interior of a house defended by a few French soldiers, was followed by such works as the same artist's *Defense of the Gate of Longboyau*, in which the enemy is visible only in one small part of the canvas, beyond the gates the defenders are doing their best to keep closed; Edouard Détaille's *Defense of Champigny*, a crowded scene of French infantry organizing the defense of a chateau against the still invisible enemy; and Etienne Beaumetz's *There They Are!*, in which soldiers and civilians at the edge of the village they are preparing to defend have just spotted the Germans on the horizon.

No doubt, the shock of defeat in France, admiration for the troops, which had fought well in spite of inefficient organization and mediocre leadership, and the sense that one had to guard against further threats from the east, favored this type of battle painting. But neither the removal or marginalization of the enemy nor the paintings' episodic orientation, which directed more attention to the common soldier, were products of a specifically French experience. Artists everywhere responded to the increasing difficulty of showing both sides of a battle, and to the growing interest in the patriotic common soldier, although he might not yet everywhere be praised as the citizen in arms. Lady Butler was painting similar pictures in England in the 1870s, among them her most famous work, *The Roll Call* (Fig. 6.3). The painting shows a company of British soldiers in the Crimea assembled after a battle. Enemy troops—hardly larger than specks—are visible only in the far distance. The focus is wholly on the battered unit, which despite the losses it has suffered is pulling itself together and preparing for the next assignment. The unusual public success of the painting was owed to this concentration and to the artist's ability to paint distinct individuals—the wounded, the fatigued, the stolidly determined—who nevertheless are part of a unit that is admirably cohesive in the psychological as well as compositional sense. The works of Neuville and Détaille have something of the same character; the leading figures are soldiers who are seen individually and as part of a larger force—the company, the battalion, and by extrapolation, the nation. When Menzel painted *Hochkirch* two decades earlier, he had created a work that helped usher in a general trend.

Keeping the Austrian attackers beyond the frame of the painting allowed Menzel to concentrate attention where he wanted it, on the Prussians. But his version of Prussian soldiers in battle was unusual. It seems that no one before—certainly no German artist—had painted them in this state of disorder. The sergeant at the near end of the firing line—the spontoon in his left hand indicates his rank—stands as rigidly as he would on the parade ground, even if his hat has gone astray; but the men beyond him are not aligned in rank and file, their uniforms are thrown on, they are not firing the rapid volleys for which, rightly or wrongly, Prussian infantry was famous. Instead of dozens or hundreds of men acting in unison, they are firing individually. One man is holding his musket at a steep diagonal, others are pulling or have just pulled the trigger, and in the distance a few are raising their ramrods as they tamp down the charge.

3. François Robichon, "Der Krieg von 1870/71 und die französische Militärmalerei," in *Anton von Werner: Geschichte in Bildern*, ed. Dominik Bartmann (Munich, 1993), p. 64.

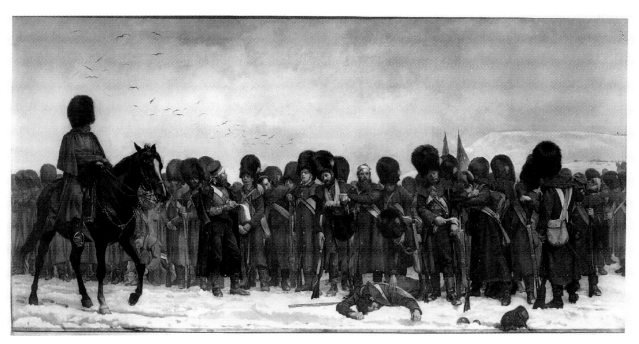

FIGURE 6.3. *Elizabeth Thompson, Lady Butler,* The Roll Call, *1874. © The Royal Collection, Her Majesty Queen Elizabeth II.*

They are fighting as well as they can in a situation of extreme peril, brought about by the overconfidence of their commander. Their self-discipline remains firm even as their drill has partly broken down. This was not the customary image of the mechanically obedient Prussian line; but Menzel not only underscores the value of the common soldier, he paints the firing line as, judging from eyewitness accounts, it actually functioned in times of crisis. In combat, writes a Prussian officer who served in the Seven Years' War, the Prussian infantry "started out to volley in sections, two or three times in good order. Then followed a general blasting away [ein allgemeines Losbrennen], and the usual rolling fire, in which everyone pulls the trigger as soon as he has loaded."[4] Nor does Menzel show the king in control of his men. Whatever actually happened that night, in the painting Frederick seems as much an observer as a general. At this moment, the accents of energy and will are on the troops.

Both the subject of the painting and Menzel's manner of presenting it challenged his public. The difficulty some Germans had, even two generations later, in accepting a view of military behavior that did not square with what was proclaimed to be the Prussian norm is suggested by a description of the painting in a monograph on Menzel that the retired director of the National Gallery in Berlin, Max Jordan, published in 1905, the year of Menzel's death. Jordan shut his eyes to the confusion of battle and the effort of individual soldiers with which Menzel filled the canvas. Instead, he saw only authority and the order that flows from it. The

4. George Heinrich von Berenhorst, quoted in Curt Jany, *Geschichte der Preussischen Armee*, 2d ed. (Osnabrück, 1967), 3:307.

painting, he wrote, shows "an infantry battalion at attention, which fires by the numbers [stramm und regelrecht] at the enemy."[5] The king, too, Jordan believes, appears in his usual posture of dominance.

It is not known what led Menzel to paint the Battle of Hochkirch. Problems of light and of composition posed by night scenes, which had already been the subject of some of his most striking illustrations for Kugler's biography, attracted him throughout his life. But Hochkirch was not the only night action in Frederick's campaigns, and it must have required a special motivation to choose a military disaster instead of one of the king's many victories, the more so since Menzel was well aware that a painter in Berlin—especially one with professional ties to the Court—might encounter difficulties if he did not present the Prussian army and its greatest icon in a favorable light. Many years later he told a colleague that when he worked on *Hochkirch* he "felt almost certain that this gigantic painting of a defeat, which at the time was by no means acceptable and welcome at court [hoffähig], could never be sold." After humiliating attempts at salesmanship he succeeded in selling the painting to Frederick William IV, although at a price he regarded as inadequate; he was further angered when the painting was hung in a side room in the royal palace, where servants washed the teacups during official receptions and dances.[6] Decades later, when Menzel himself had become an official icon in the German cultural temple, William II had the painting rehung in his study.

Since no statement by Menzel survives to explain his intentions in painting *Hochkirch*, one must consult the work itself for whatever indications it may contain. Nearly three meters high by not quite four meters wide, it is one of the two largest canvases he painted of scenes from the reign of Frederick the Great—the other, also a military theme, is the unfinished painting of Frederick addressing his generals before the Battle of Leuthen—and thus an important expression of Menzel's views of the king. But for him and for his contemporaries in Prussia, the Frederician age was not merely a matter of historical interest. In the middle of the century, a "Prussian tradition," which exploited Frederick's personality, policies, and writings for conservative ends, had become a political force. In this tradition, the Battle of Hochkirch figured as an example of persistence in adversity, of fighting even when outnumbered. Menzel conveys this message but gives it an unusual emphasis, which expands its meaning. The painting's principal figures, the figures that act, are the soldiers on the firing line. Certainly loyalty and obedience bind them to the king and to their officers, two of whom are scrambling up the little rise in the foreground to take their place in the line, but it is the soldiers' good faith, bravery, and initiative that Menzel emphasizes. The painting confirms the tradition of service and duty but demonstrates that these values may be achieved by means other than insistence on passive obedience. In the years after the Revolution of 1848, at a time when the relationship between the Crown, the old elites, and other segments of society still remained uncertain, the painting pointed to the potential strength of the common man. Menzel had already sounded this note

5. Max Jordan, *Das Werk Adolf Menzels, 1815–1905* (Munich, 1905), p. 52.
6. Gustav Kirstein, *Das Leben Adolf Menzels* (Leipzig, 1919), pp. 60–64.

in some of his illustrations to Kugler's biography of the king. It was an expression of reformist—not of revolutionary—sentiment, similar in character to the poems published under the general title *Prussian Songs* by Menzel's friend Theodor Fontane, who in these years also used incidents in Prussian history to declare that bravery and judgment were not the sole property of the men at the top.

As an expression of political belief, *Hochkirch* was denied success. The Prussian monarchy soon settled into a new authoritarian mode, in which administrative and industrial modernization coexisted with a hierarchically restrictive political system. As a work of art the painting fared better, even if it fell short of complete success. The firm and interesting composition, which succeeded in filling the canvas with a large number of people without becoming fragmented, and the freedom and assurance with which parts of the work are painted are on a high level. Perhaps that could also have been said about the use of color and the treatment of light and shade, but, as the painting has been destroyed, we cannot be sure. The work also has weaknesses, especially the large figures in the foreground, which—as has often been noted—are too obviously posed, and which are painted with a specificity of detail that conflicts with the more suggestive treatment of the men on the firing line. Beyond this, perhaps the historical and political themes weighed too heavily on the artist. Menzel could paint a Frederician battle only in his customary realistic, anti-idealist manner. The narrative and didactic element expressed in the mass of detail limited or even clashed with his overall conception and his treatment of parts of the painting. Although he painted the past as something that lived, he did not fully succeed in turning it into a subject that suited his style as perfectly as did the interiors and social scenes of his time that he interpreted in his greatest works. *Hochkirch* despite its many qualities is not among Menzel's strongest paintings, but it remains one of the most convincing and interesting images of battle painted in the nineteenth century.

In the early spring of 1900 Ferdinand Hodler completed the tripartite fresco *The Retreat of the Swiss from Marignano*, usually called simply *The Retreat from Marignano*, in the Hall of Arms of the new Swiss Museum of History in Zurich. Behind him lay four months of intense labor in the hall, years of study for the project, and years of public debate over the suitability of his design between his supporters and adherents of an academic realism, who wanted to deprive him of the commission and as a last resort tried to stop the project itself. The so-called Fresco Conflict demonstrates once again the importance that experts as well as the general public may attach to the interpretation of historical subjects in the fine arts; the fresco reveals the fact, easily lost in the turgidity of academic history painting, that historical subjects may generate significant and innovative art that transcends illustration or commemoration.

The great hall of the museum, over fifty-five yards long, was built with windowless east and west walls, the top third of each divided into three pseudogothic lunettes, beginning a little more than twenty-six feet above the floor. As the building was nearing completion, the decision was made to decorate the lunettes with frescoes. As subjects, the architect of the museum

suggested two events in Swiss history that celebrated the unity of the cantons in victory and defeat: the gathering of forces before the Battle of Murten in 1476 and, for the west wall, the retreat of the defeated Swiss after the Battle of Marignano in 1515.

A public competition in 1896 led to the unanimous choice of Hodler to paint the frescoes. When the winning cartons were exhibited, however, they mystified and caused offense to many. That a design for a fresco twenty-six feet above floor level needed to take account of the distance from the viewer and the steep angle of vision was not universally recognized, but stronger objections were raised to the stylized and symbolic character of the artist's conception. Hodler did not depict a particular incident in the battle's aftermath, but the idea of a fighting retreat as such; he had closely studied weapons and dress of the period but simplified or passed over many details. Perhaps worst, the figures in his cartons had about them an air of actors in a pageant or of priests celebrating a sacred rite, which to some members of the public made them unconvincing as men-at-arms of the country's heroic age. New meetings of the jury and of special commissions dealt with these objections, but also led to changes in design, until in the fall of 1899 the Supreme Council of the Swiss Confederation resolved the matter, which had become a major issue of cultural policy, by signing the contract with Hodler.

For the central lunette Hodler initially planned a semicircle of four monumental fighters facing outward and of a fifth carrying a wounded comrade, while behind them masses of lance carriers marched from the battlefield. The smaller flanking lunettes contained episodes drawn from accounts of the battle: on the right, a Swiss, one knee on the ground, but still swinging his two-handed sword; on the left, a standard bearer, his legs smashed by a cannonball, struggling to hand the banner to others. The themes for the flanking lunettes survived in the finished fresco, but the conception for the middle lunette went through a long process of change.

Because the jury asked Hodler to give greater clarity to the meaning of the design, he flattened the semicircle of fighting men into a loose group moving to the left, parallel to the mass of men in the background. This strengthened the theme of movement and retreat, already expressed by three of the main figures in the first design, but left the two groups insufficiently linked. In May 1898 Hodler submitted a third scheme, which made the figures in the foreground smaller but greatly increased their number (Fig. 6.4). A group of nineteen men, evidently a rear guard, moves across the level ground past a corpse, just visible at the lower edge of the fresco. Two of the men are being carried. Two men, one at the head, the other at the tail of the column, look back at the enemy beyond the edge of the picture. At the farthest right, slightly separated from the group, a halberdier turns toward unseen pursuers; the point and blade of his nearly vertical weapon, which he grasps in both hands, crosses over the slanted pikes of the men he is protecting. Above the column, more soldiers are moving from right to left along a path; and above them, on a third level, a forest of lances indicates yet another component of the retreat.

In some of the details of the men in the rearguard and in the dynamic movement of the halberdier, his knees bent and his left heel raised as he wheels toward the enemy, this was the strongest design. But it did not yet sufficiently develop the relationship between foreground

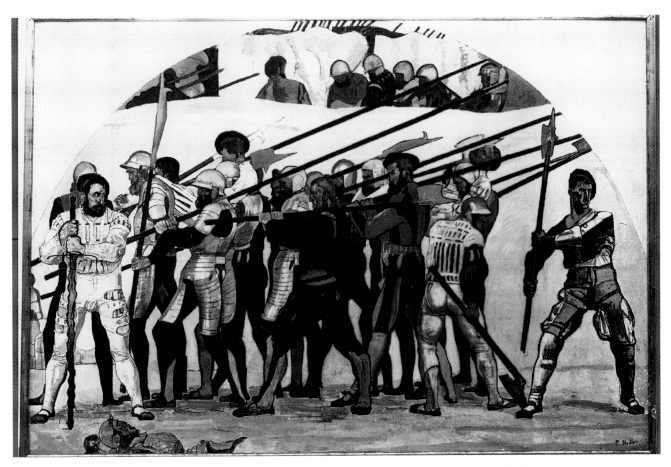

FIGURE 6.4. *Ferdinand Hodler,* The Retreat from Marignano, *study for the central fresco, 1898. Kunsthaus, Zurich.*

and background, and the monumentality of the rearguard could still be heightened. In Hodler's final version (Color Plate 7), he moved the members of the group more closely together and increased the distance between them and the halberdier. Not even their weapons now cross. His turning movement has lost some of its suppleness, his heels are on the ground and his right leg is straight; he simultaneously turns and steps out. The man at the head of the column, who had stood feet apart, almost leaning on his two-handed sword, now walks forward, and like the others in the group lowers his head in reaction to the defeat. He wears decoratively slashed yellow clothes, as do the two men at the end of the column; the bright, flat color frames the men in between, who are dressed primarily in darker red, brown, or violet, a few of whom also wear light-blue armor and helmets. The column moves as one, a group of free men not under the command of a superior. The space above them is now filled with banners and pike shafts. On the far left above the column, a soldier seen from the back and beyond him the heads of the lance carriers and their weapons suggest the armed column winding through the foothills. On the far right, behind the halberdier, two dead men, replacing the corpse at the lower edge in previous versions, lie on the undulating ground. Above them are further hills and the sky, which is divided by strips of clouds into horizontal bands.

In their final state, the three frescoes combine into a single image of war (Fig. 6.5). The two men in the flanking lunettes, persevering even in defeat, reveal the unseen battle, from which the central group, standing for the entire Swiss force, withdraws with captured banners flying. The men's slow, heavy steps suggest the harshness of combat and the reluctance with which they leave the battlefield; the variety of their clothes, armor, and weapons emphasizes rather than lessens the compactness of the group and points to the different cantons from which the men come. The little column moves toward the mortally wounded standard bearer in the left lunette, who casts an almost funereal aura of grief over the leading men, which changes to combativeness at the rear of the column. The man-at-arms in the right lunette and the halberdier and the shorter man turning to face the enemy in the central fresco are linked by their postures and the sequential position of their weapons: lowered battle-ax, upright halberd, and the two-handed sword that the kneeling man-at-arms is about to sweep in an upward arc around his body. They turn the retreat into an assertion of defiance and survival. Dominating this and other elements of the work is the juxtaposition of the column and halberdier, who is separated from it and yet part of it, a motif of great formal power and psychological conviction.

Although Hodler's manner of painting the retreat from Marignano perplexed or offended conventional taste, his reading of the event and of its significance coincided with the conventional view enshrined in Swiss history books and patriotic speeches. The battle itself was an incident in the centuries-long process of Swiss expansion to the south. The cantons in control of the Alpine passes and the main roads on both sides periodically sent armed expeditions down the valleys toward the northern Italian lakes and the Lombard plains. Other cantons might support or oppose these moves, which entangled the Swiss in the affairs of the Duchy of Milan and its neighbors and clients, and eventually in the Italian policy of France and Spain. The hiring of Swiss mercenaries, singly or in units, further complicated the political situation. When the French once again threatened the independence of Milan in 1515, the Gotthard group of cantons went to the aid of the Duchy, assisted reluctantly and inadequately by other cantons. On September 12 a French army of some 40,000 men under Francis I approached Milan, defended by 24,000 Swiss, drawn up south of the city. Some of the cantons had already accepted peace proposals by the French king, and their contingents were preparing to return to Switzerland, when on the thirteenth a small force attacked a French advance unit, apparently in order to provoke a battle, and the others came to its aid. Without adequate preparation and without unified command, the Swiss attacked in the late afternoon and continued the battle the following morning until they had to recognize that their opponents were too strong. Over 7,000 Swiss died in two days' fighting. The survivors retreated to Milan and the next day marched north to Como and the safety of the Alpine foothills.

The Battle of Marignano exemplifies the tremendous military energies that Swiss society generated in the Renaissance, but also the inability of its political institutions to channel this energy effectively beyond a certain point and the frequent failure of its military leaders to progress from tactical cohesion to operational discipline. Some political leaders and commentators drew a broader lesson from this heroic disaster: Despite its military prowess, the Swiss

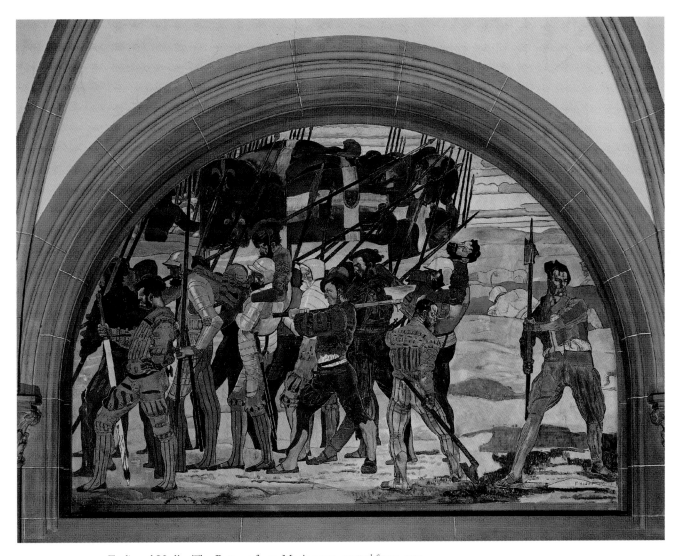

COLOR PLATE 7. *Ferdinand Hodler,* The Retreat from Marignano, *central fresco, 1900.*
Schweizerisches Landesmuseum, Zurich.

FIGURE 6.5. *Ferdinand Hodler,* The Retreat from Marignano, *fresco, 1900. Schweizerisches Landesmuseum, Zurich.*

Confederacy lacked the strength to support an expansionist policy in the center of Europe. The lost battle, followed by the discipline and courage that made the retreat a success, pointed the way to the Swiss policy of defensive neutrality, which the country gradually developed into a general principle of its political existence. Of course, history seldom works that neatly, and in fact Marignano did not put an end to Swiss incursions in Italy. The following year the Swiss switched sides and concluded an alliance with France; the sack of Novarra and the defeats of

Bicocca and Pavia were still some years in the future. But Marignano shocked the confederacy, and eventually the battle became a symbol of the various forces that turned the Swiss on a new course.

To Hodler, the link between the past of Marignano and contemporary Switzerland was far more than an abstraction. He saw it as a fact of national life, to which he wanted to give expression in his painting. "The men of that time exist today," he said about his fresco and the models he had used for it. "They are the same today, and they would still fight in the same way. I have selected them from the descendants of the robust, strong men of that time. They are still alive in the countryside and in the mountains. The stubborn, strong Swiss are the men I have selected here."[7]

The halberdiers, pikemen, lance carriers, and men armed with battle-axes and two-handed swords as representatives of Swiss strength and freedom occupied Hodler throughout his career. He studied the history of their wars and the ways artists of the time saw them, and reinterpreted them from his early work to the end of his life. After he completed *The Retreat from Marignano*, new debates and continued opposition delayed a decision on the fresco for the east wall of the Hall of Arms, and it was not until the end of 1910 that Hodler, by then internationally recognized, was given the commission. He changed the subject from the one first specified, the arrival in Bern of troops from Zurich on the eve of the Battle of Murten, to the battle itself, in which the Swiss destroyed the knights and mercenaries of Charles the Bold. After defining the project in preliminary sketches and interrupted by other work, Hodler concentrated on the new task. Between 1915 and 1917, while millions of men waged gigantic battles a short train ride to the north, Hodler made over seventy studies of the Swiss triumph four-and-a-half centuries earlier and painted two full-sized cartons for the central lunette. But he died in the spring of 1918, before he could paint the fresco.

The Retreat from Marignano interprets a historical event by finding general aspects of war in the specifics of the battle and retreat in September 1515. Above all, it succeeds both as a history painting and a painting of war because it succeeds as art. It does not repeat familiar schemes of didactic illustration but addresses issues in art that at the end of the nineteenth century were not yet fully explored: the coloristic and decorative possibilities of neo-impressionism, symbolism, the promise of the primitive, and mystical visions of the elect. The pathos of individual members of Hodler's men-at-arms may be oppressive; together, their exaggerations form a work that is a single decorative gesture. That Hodler's final conception—the group and the separate individual—emerged out of his other great serial works was an added strength, as was the subject's suitability for this way of presenting it. Hodler's historical interests and his sense of his own generation brought past and present together, as Menzel before him had joined Frederician Prussia and the Prussia of the Industrial Revolution. But the symbolism and search for timelessness in Hodler's art combined style and subject into a seamless image that Menzel's sophisticated nineteenth-century realism could not achieve.

7. Jura Brüschweiler, *Ferdinand Hodler: Selbstbildnisse als Selbstbiographie* (Bern, 1979), p. 87.

7

Machine-gun Section Advancing

One of the cultural warning signs that preceded the outbreak of the First World War was the premonition of some artists that a cataclysm was coming. Historians have traced this feeling to a commonsense awareness of the succession of international crises of the time, which were increasingly difficult to contain, and to an array of ideas and attitudes growing out of the encounter of an expanding middle class with the forces of industrialization, the politicized worker, and urban mass culture: fear of social upheaval, or a longing for it; nationalism and the spread of military values through society; generational conflicts and the rejection of traditional ideals; a feeling of disgust and often self-disgust with a materialistic, corrupt society and culture judged to be beyond reform. A few artists and some critics and prophets gloried in images of bloodletting and showed a striking readiness to adopt the rhetoric of violent sacrifice without regard for the millions of ordinary men, most of them poor and poorly educated, who were expected to fight and die so that the purification fantasies of their betters could become reality. That expectation and its expression in literature and art were themselves a signal part of the corruption the critics found so oppressive. But the variety of ideas and feelings about a coming war that acted on some artists at the time is paradigmatic of the complexities that always enter into the artist's choice of themes and guides the manner of their realization.

The reflections of the hope for war or the fear of war in European art in the years before 1914 are well known. Kandinsky and Chagall in Russia, Wyndham Lewis in England, the Italian Futurists with their bombastic glorification of revolt and destruction, de la Fresnaye in France, Meidner and Marc in Germany among

many others engaged the subject of strife and, above all, of violence in their work. More often than not, such motifs as uniforms, cannons, massed soldiers, bolts of lighting, sharp-edged shapes cutting and crashing into one another transferred the artist's effort to form and impose his ideas and style to a military plane. War became a metaphor for the struggle of the new in culture and art. But some works—Meidner's landscapes of a disintegrating world, which are filled with the artist's compassion and fear, or the reflective tragic of Marc's abstractions—express far more than their creators' efforts to develop a personal vision and capture ground for a new way of seeing and painting. The conflict over modernism in art becomes one with the insecure, threatening larger environment.

As much as they were of their time, these works expressed more than the anxieties and hopes of the generation of 1914. They also continued a new interest by some members of the avant-garde as well as artists working in traditional modes in allegories and other generalized images of war that had become evident in the preceding decades. The years between the Franco-Prussian War and the turn of the century, in which traditional battle painting achieved a last flowering and Hodler painted his symbolic reinterpretation of a historical event, also produced images of war that were not of specific battles or campaigns but of war as such. More than once they seem to have been inspired by Goya's *Disasters of War*, which were now becoming generally known. Probably most if not all of these works expressed a fear of the destructive side of modern civilization, but it would be difficult to see them as responses to an imminent crisis. Instead, they seem to convey a sense of war as an inescapable part of life, a critical or fatalistic point of view that was reinforced by the historical memory of such peaks of violence of the recent past as the Franco-Prussian, Italian, and Crimean Wars, the European echo of the American Civil War, the revolutions and uprisings of the 1840s and 1830s, and the century's formative experience with organized mass killing: the wars of the French Revolution and of the Napoleonic era.

An early and famous representative is Vasily Vereshchagin's oil of 1871–72 of a mound of skulls, *Apotheosis of War*. By means of a unitary symbol, empirically observed and re-created, the painting tries to give form to a grand but vague idea—is the artist saying this is the inevitable or this is the only result of war? Vereshchagin asked more of realism than realism could deliver, and in this sense his painting points toward new styles. More successful were new versions of the old motif of war as a horseman of the Apocalypse: a calm victor riding over corpses in Franz Stuck's *War* of 1894; a female figure, grasping torch and sword and mounted on a black beast, racing through the air above the dead and dying in le Douanier Rousseau's *War* of the same year; and vast, prehistoric men in Arnold Böcklin's two versions of *War* painted two years later. From the 1880s on, Max Klinger worked on large cycles of etchings, *Of Death*, culminating in the plate *War*, in which a reclining giant watches silently over a landscape of destruction through which an army is fleeing. In the midst of the surging mass rides a Napoleon-like figure, untouched by the panic around him, but a helpless part of the crowd nevertheless. A shorter cycle of etchings by Alphonse Legros of 1895–96, *Triumph of Death*, traces war from its

FIGURE 7.1. *Alfred Kubin,* War, *no. 9 of* Facsimiledrucke nach Kunstblättern, *1903. Private collection.*

outbreak to the aftermath of battle. In 1898 Gaston la Touche painted *War* as a segment of a battlefield in which French cuirassiers attack over dead and dying soldiers—a painting that as late as 1913 Emil Nolde copied, probably from a photograph, in his *War*. Among the simplest and most powerful personifications of war during these decades is Alfred Kubin's drawing of about 1900, *War* (Fig. 7.1), frequently reproduced and a model for many subsequent allegorical treatments. The drawing shows a naked giant, vaguely recalling an archaic Greek warrior, on his head an absurdly crested helmet with a visor that covers his face except for the eyes, in his hands a shield and battle-ax, as he moves in enormous, almost trancelike steps across a plain toward an army of tiny men, who advance to meet him, lances thrust forward, flags flying, and are about to be crushed under his broad, hooflike feet.

It has been suggested that fatalistic allegories of war began to appear in European art in the late 1880s and that they were primarily motivated by Schopenhauer's philosophy of pessimism,

which in these years gained many readers among the educated members of the general public.[1] That takes too narrow a view of cause and effect; nor is it possible to assign a birth date to the appearance in art of the fatalistic acceptance of war, a concept that in various forms, alone or together with other motifs, had been present over centuries. How great is the conceptual distance between Rubens's *The Consequences of War* and Klinger's *War*? More simply, these paintings and prints, created at a time when the last major nation-states had coalesced and scientific and technological advances accelerated, may be seen as the reactions of a few artists to an element that, all progress to the contrary, was evidently as difficult to abolish as disease or poverty. Whether it was welcomed, feared, or accepted as inevitable, war at the turn of the century was not a remote or unlikely subject.

Some artists persisted in their welcome of war even after the fighting began in 1914. Others who had had no premonition—positive or not—of what was to come were nevertheless for a time impressed by the universal sense of unity and dedication that the war seemed to create. Ernst Barlach, the opposite of a superpatriot, wrote his brother in the third week of August: "I feel that [the war] is a liberation from the constant selfish concerns of the individual; it expands and elevates people."[2] Franz Marc carried the idea further. In April 1915, at a time when he had already been in combat, he wrote his wife that the war was no different than the bad times before the war: "What we did in our thoughts then, we now do with our deeds. But why? Because we could no longer tolerate the dishonesty of Europe's ways. Better blood than these constant lies."[3]

Marc neither was a chauvinist nor deluded himself about the beauty or glory of artillery duels and infantry combat. That he could still believe—if only intermittently—that to kill and to face being killed was better than to continue existing in an ambiguous, confusing world is a sad indication of idealism gone awry and of the extent of alienation some artists and intellectuals experience in mass society. For others, neither the shortcomings of the modern world nor their personal difficulties were sufficient to justify a bloody alternative. On nearly the same day on which Marc praised war as a cure for the dishonesty of civilization, Max Beckmann wrote to his wife: "It is amusing how the much damned and bemoaned peacetime existence . . . now seems like paradise"—words that undoubtedly expressed the attitude of the great majority of men in the various armies.[4]

The war itself quickly took on characteristics and created a magnitude of suffering that few had imagined. When Marc received a postcard with a reproduction of his *Fate of the Animals* in March 1915, he could still be excited and stunned to see how much of what was now happen-

1. Siegmar Holsten, *Allegorische Darstellungen des Krieges, 1870–1918* (Munich, 1976), p. 117.

2. Ernst Barlach to Karl Barlach, August 17, 1914, in Ernst Barlach, *Die Briefe*, ed. Friedrich Dross (Munich, 1968), 1:431.

3. Franz Marc to Maria Marc, April 6, 1915, in Franz Marc, *Briefe, Aufzeichnungen und Aphorismen* (Berlin, 1920), 1:46.

4. Max Beckmann to Minna Beckmann-Tube, April 5, 1915, in Max Beckmann, *Briefe*, ed. Klaus Gallwitz, Uwe M. Schneede, and Stephan von Wiese (Munich-Zurich, 1993), 1:115.

ing he had expressed in the painting two years earlier. But what he recognized was the progression from spiritual to physical cataclysm, not the reality of technological war waged by millions. That reality became the dominant force of European society divided into opposing camps, a reality people tried to live through or escape from. And soon after the armistice had finally brought the fighting to a halt, it became clear that the war had not ended but was merely the first stage of a process of mass killing and of the social and cultural destruction of much of Europe, which was to continue until 1945 and later.

Despite their many military, political, and ideological differences, the First and Second World Wars in some respects formed parts of a whole. They were linked causally, by similar phenomena—especially the great number of soldiers who were killed or wounded—and by developments that ran from the earlier to the later war. The most important of these was the conversion of the civilian population into a major target. In the fall of 1914, in Belgium, northeastern France, and East Prussia, a few hundred civilians were inadvertent victims of the military operations or were executed as hostages in retaliation for largely imaginary war crimes committed by other civilians. Thirty years later men, women, and children by the hundreds of thousands died by design in the bombing war, and millions more were killed or starved to death in camps. Picasso's *Guernica*, painted during one of the episodes of violence that bridged the two wars, commemorated an early decision to make civilians into a strategic target. The expansion of this concept between 1939 and 1945 turned the subject of Picasso's painting from an episode of unusual barbarism into an accepted commonplace.

The First World War created a new landscape: no-man's-land between the trenches in France and the trenches themselves. The Second World War followed with its own innovations: the bombed and burned-out city, which looks different than a city destroyed by artillery or a city destroyed by infantry fighting through its streets; invasion fleets with landing craft circling before heading toward the shore; planes on a bombing run. Other aspects resembled those of earlier wars, going far back in the past, with only new weapons and equipment marking the particular moment: a company resting by the side of a road, men on outpost and sentry duty, troops rushing toward the enemy or running away.

The First World War was also the most pictured war in history until then, as the Second World War was to be in turn. The mass of images the two wars stimulated resulted from improvements in photography and the development of film, and from social and political change. The very large conscript armies of 1914 and 1939 represented societies that even under dictatorships were no longer the inert pools of military and economic manpower of the eighteenth century. Public opinion, even of the powerless in regimes that used terror as a tool of governing, was addressed, not least because the ideological justification of those in power demanded it. And in dictatorships and democracies alike, as society adapted to the expansion of war by turning itself into the new phenomenon of the homefront, the need to provide it with images of the war intensified.

Photography and film responded to this need, and the landscape and activity of the rear areas became known as never before. In the Second World War the camera even captured

meaningful images of combat, although infantry fighting remained the least explored part of war. But no country decided that the mechanically produced image made drawings and paintings redundant; between 1914 and 1918, and again between 1939 and 1945, war artists worked behind and occasionally in the combat zone, and artists who themselves were in uniform or who remained civilians chose war as their subject. The immensity of the events justified every image and every effort to record and interpret, whatever the medium. A sketch by Henry Moore and a photograph of the same subject—people sheltering in the London underground during an air raid—have equal validity. They make us see different aspects of the crowd on the concrete platform; we might prefer one image over the other but probably would not want to be without both.

In the plate *Machine-gun Section Advancing (The Somme, November 1916)* of Otto Dix's cycle of etchings, *War*, eight soldiers are climbing down a steep slope, diagonally across the plate to the lower right (Fig. 7.2). They are inside a gigantic crater, too large to have been made by one shell; only a segment of the shallow curving rim is visible. The crater is in ground over which men have been fighting for a long time. On the right, the remains of a tree, torn from its roots and its branches sheared off, leans against the steep side. Behind it a stick with a strand of wire indicates where barbed wire was once strung; other remnants can be seen near the top of the crater. A wheel from an ammunition cart, destroyed long ago, sticks out of the ground near the lower edge of the plate. The soldiers do not appear to be in immediate danger, at least they are not in the direct line of infantry fire, but since they are not keeping to a road they must be close enough to the front to be in range of field artillery and mortars. For the moment, they are mainly occupied with keeping their footing on the steep and mushy ground—mushy because the slope is covered with dead bodies; one man, supporting himself with a heavy cane, sucks on his cold pipe as he makes his way through the muck. They may be following in the wake of a counterattack that has retaken terrain lost earlier and are moving their two heavy machine guns forward to a new position. They are loaded with equipment: packs, rolled overcoats and blankets, gas masks, entrenching tools, mess kits, and canteens. Two are carrying the barrels of the machine guns, others boxes of ammunition. One man has a rifle slung across his chest, another carries a revolver; long-handled hand grenades are stuck in their belts. They are skilled workers in the factory of machine warfare, strapped in the tools of their trade. In the lower right, their leader, also burdened with a heavy pack and therefore not an officer, is striking out purposefully in a new direction, at a sharp right angle to the diagonally descending line of the men behind him. He may be Dix himself, for the etching is not only an account of trench warfare on the Western Front, it also reflects the artist's personal experience.

When we look at the etching more closely, we see that the side of the crater down which the soldiers are moving is not earth on which some corpses lie, but that it is entirely made up of them. The men are struggling down and through a mound of heads, arms, and trunks, some of which are swollen in decay; their boots sink between and into the bodies, we cannot see any-

FIGURE 7.2. *Otto Dix,* Machine-gun Section Advancing, *1924. The David and Alfred Smart Museum of Art, The University of Chicago.*

one's feet. Only the rim of the crater appears to be of earth and rock. It is not certain that the leading men have reached the bottom of the crater, their legs are cut off by the lower edge of the plate. In 1916, the date that is part of the title, no end of the killing was in sight, and the group, already outnumbered by the corpses surrounding it, still had a long way to go.

Extracting the land from no-man's-land and substituting dead bodies for it, which now replace earth and rock, is to mingle realism and symbolism, which is also how Dix treats his eight machine gunners. Their weapons and equipment are drawn with precision, but their broad, thick-lipped faces are almost interchangeable stylizations, as are their weary yet determined expressions. Only the soldier in the center opens his mouth in a scream or grimace of horror; perhaps he is echoed, but less violently, by the man on his left, who carries one of the machine

gun barrels. The sameness of the soldiers is emphasized by the massive volume of their bodies and equipment, drawn in heavy black, which contrasts with the white and gray of the corpses, and by the enveloping curves of their helmets, which Dix varies slightly in depth and width from man to man. The helmets repeat the round shapes of mess kits and gas mask canisters, of the crater itself, and of the corpses, particularly their heads, some of which bear an expression of stupefied intensity.

Dix published *War* in 1924. Ten years earlier, at the age of twenty-three, he had volunteered for service in a Saxon artillery regiment. Judging from his letters during the war and from subsequent statements, he did not welcome war, but once it had come he felt driven to experience it at close hand. He was trained as a heavy machine gunner, first saw action in France in September 1915, was soon promoted to noncommissioned officer, and fought as a leader of a machine gun section in France throughout 1916 and 1917 until his regiment was transferred to the Russian front. A photograph of his section in the Champagne in March 1916 already shows him with the ribbon of the Iron Cross second class, and he was repeatedly decorated for bravery. Early in 1918 he returned to France, again took part in heavy fighting, was wounded, volunteered for the air force, and was in pilot training when the war ended. His exposure to trench warfare at its most dangerous had been long and intensive. Among artists who were beginning to make a name for themselves in the last years before the war or, if they survived, in the 1920s, few if any could equal Dix's experience of the common soldier's routine of combat, rest, and combat again, with an occasional leave for the lucky ones—and unlike Marc or Picasso he seems to have needed the immediate contact with his subject. He recorded what he saw in numerous drawings, watercolors, and gouaches intended for himself and a few friends. After 1918 he began to address a broader public. His first paintings about war and its effects were canvasses of war wounded and cripples. Between 1922 and 1923 he painted *The Trench*, the purchase of which by the Wallraf-Richartz-Museum in Cologne and its return forced by intense political pressure became one of the important art scandals of the Weimar Republic. The following year he published the fifty etchings of *War*, making use of his wartime drawings and of numerous later sketches, supplemented by studies in a morgue and by photographs of severely wounded soldiers. Though praised by a few critics, the cycle was a commercial failure. Still ahead were the great triptych *War* and the panel *Trench Warfare*, both of 1932. In 1934, after the national socialists had already dismissed him from his teaching position at the Dresden Art Academy for painting works that were immoral and subverted the German people's martial spirit, Dix painted *Triumph of Death*, with the heroic figure of a rifleman of the First World War, and *Flanders*, the picture of a wasteland of war, in which the living and the dead become one with the muddy, churned up earth.

From the time he began to exhibit in the early 1920s, Dix's aggressive and shocking work was searched and judged for its ideological content. He was accused of defaming the German army and of being a dupe of Germany's enemies; communists and pacifists tried to claim him. In reality, he was a man neither of the right nor of the left but was fascinated by physical and moral decay, whose victims and perpetrators he found throughout society. His searing paint-

ings of war wounded show poor paraplegics begging in the street, but also equally crippled representatives of the old elites playing cards in their club. The most brutal and degrading features of trench warfare called to elements in his psychological makeup and compelled him to seek them out; the First World War was one of the major experiences of his life and became a central concern of his art.

The subjects that Dix takes up most frequently in his cycle of etchings are wounded, dying, and dead soldiers, and the landscape of war—shell holes, trenches, graves—together over half of the fifty plates. Other etchings are of troops resting or moving about; one of these is the machine gun section advancing to a new position. Several show soldiers and sailors on leave with prostitutes. Only a few are of actual combat; on one a plane bombs civilians in a Belgian town. In the etchings the soldiers are reduced to desperate and highly dangerous organisms, amoebae eating and being eaten in a primeval ooze; even images of an abandoned trench or of two shell holes carry forward the theme of encompassing horror. The cycle forces the viewer to face war's essential core of violence, which soldiers perpetrate and suffer for causes external to them. Other aspects of war are not depicted, among them some that the artist may not have seen but that nevertheless were part of his experience. The soldier who carried the Bible and a volume of Nietzsche in his pack, as Dix did, who observed and analyzed rather than merely suffered and caused suffering, does not appear in the cycle. That side of war is not a subject of the etchings, it is expressed by the fact of their existence.

In the intensity of the single-minded vision that fills these images, in their number and the variety of their themes, and in their links with Dix's paintings, which continued to return to Flanders and the Somme, the etchings stand out from the vast body of art that responded to the First World War. Nothing else is comparable to their combined range and power. But, as always, the exceptional rises out of the accustomed, and the cycle reveals commonalities with other works in the field. One is the etchings' treatment of combat. Although in France patrols and trench raids did something to counteract the widening distance between combatants in modern war, and popular art and propaganda reveled in dramatic incidents of hand-to-hand combat, the confrontation of soldiers of opposing armies was a rare motif in serious art. More common were scenes of enemies united in death and of men of one side under fire from an invisible opponent.

A major work of the latter kind is Wyndham Lewis's *A Battery Shelled* (Fig. 7.3), which he painted soon after the armistice. Almost the entire battery, seen from above, is spread out before the viewer, who is also represented by three proxies, men in uniform standing near the left edge of the painting, two overlooking the battery while the third looks out of the picture but past the viewer, as though indicating the difficulty of bridging the war and the safe world beyond the frame. Inside the perimeter of the battery, men serve the guns, carry a casualty, and search the grooved and pitted ground for unexploded shells. Shattered trees, smoke, and the trails of shells through the air hedge them in. The painting is a modern equivalent of Vernet's *Valmy*, in which the viewer also overlooks a position under fire. But the later work is marked by a degree of pathos and by the intrusion of the artist—if Lewis is indeed one of the three fig-

ures—or at least of the artist's highly personal empathetic sense of the human tragedy he is painting, which would have been inconceivable to Vernet.

There are further commonalities: the concentration on the common soldier and on the frontline officer who shared his fate; and the new significance given to the earth on which and in which he fights. In marked contrast to even a few generations earlier, paintings and prints of the First and Second World Wars with few exceptions show men who are physically engaged in fighting and in supplying and supporting the men at the front: the led, not the leaders, a point to which we will return. Nor in the art of earlier days had the surface on which troops fight been more than a part of the setting; only topographical accuracy or atmospheric qualities might raise its significance in the image. Now, driven above all by the experience and symbolic function of trench warfare, the earth becomes an actor in war art. Artists everywhere see the new landscape created by modern weapons. It is man-made but men are not present in Paul Nash's most powerful works, or the land becomes more closely linked with the soldier than ever before. Dix's vision of the earth as a damaged mother who shelters men for a time and to whom they return when they are wounded and die, and after death help create and sustain new life in the form of maggots and flowers, is only an extreme statement of a common theme.

A French poster designed by Maurice Neumont in 1917, although not finished and printed until the following year, exemplifies the ubiquity of the motif (Color Plate 8). The poster, printed in lurid red, yellow, and brown, was issued to counteract war weariness and calls for peace in the summer of 1918, which it brands as German machinations. A towering French infantryman, the classic disheveled but tenacious poilu, appears to be the speaker (one cannot see his mouth) of the poster's wordy message: "Twice I have held and conquered on the Marne. My civilian brother, the sly offensive for a 'fair peace' is assailing you in turn. As I did, you must stand firm and conquer. Guard against the hypocrisy of the Boche." The poilu stands, feet apart, between torn barbed wire, his rifle in both hands, and bars the way. On the ground before him lie a German helmet pierced by shrapnel and a German rifle and gas mask canister. He wears the regulation issue overcoat of the infantry, divided in front, and over it a sleeveless sheepskin vest, crisscrossed by the straps of his ammunition belt, gas mask, canteen, and pouch. A balaclava under his helmet leaves open only his eyes and nose. Smoke rises from the burning countryside behind him. To the right, the twin towers of a church testify both to the eternal values of God and of French culture and to German barbarism. Superimposed on the clouds formed by the smoke are the slogan "They shall not pass!" and the dates 1914 and 1918.

The poster makes apparent the great distance that separates a soundly conceived and executed commercial design and an inspired effort at understanding and communicating, even when both Neumont and Dix use related motifs. Nevertheless, the poster's standard components of pictorial propaganda receive some strength from the link between the soldier and the land. He is as hairy and shaggy as the word *poilu* implies. The skirt of his overcoat is shredded, his pants and leggings resemble branches of a tree or stalks of a plant, and his large ankle-high boots have become part of the French soil on which he stands as though he has grown from

COLOR PLATE 8. *Maurice Neumont*, They Shall Not Pass!, *1917/18. The Hoover Institution, Stanford University.*

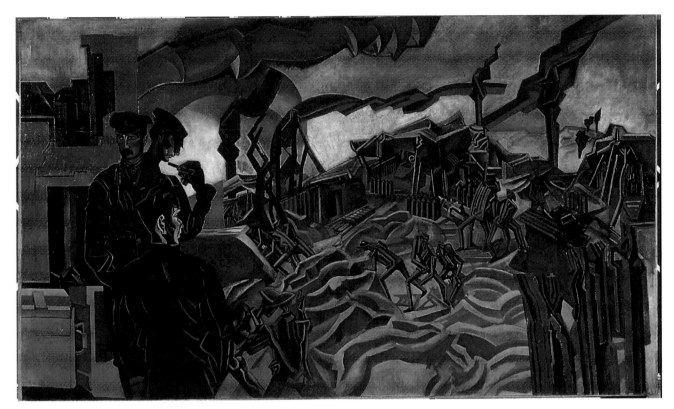

FIGURE 7.3. *Wyndham Lewis,* A Battery Shelled, *1919. Imperial War Museum, London.*

it. The design identifies the French soldier with the French earth; but behind the patriotic abstraction—which, however rhetorical, may carry great weight—lies a concrete experiential truth, created by artillery barrages and trench warfare, which drive the soldier to ground and underground.

The reality of death from above also lent itself to metaphoric treatment, at the other extreme of Dix's expansion of the literal interpretation of modern war. For the issue of September 5, 1916, of *Der Bildermann*, a German bimonthly periodical of art and literature, Ernst Barlach drew the lithograph *From a Modern Dance of Death* (Fig. 7.4). The periodical, published and coedited by Paul Cassirer, an important supporter of modernism in German art, addressed a small cultural elite, and on that account it was treated more leniently by the censors than would have been a mass-circulation journal publishing the same material. The images in the *Bildermann* included peaceful scenes of civilian life, but most addressed the war and its impact on society. A series, "The New Society," deals with shirkers and profiteers, a lithograph shows a working-class family learning that the husband and father has been killed, and another, by Käthe Kollwitz, is of a mother too poor to feed her child. The images of the war are almost all allegories, many of which, like Barlach's, stress destruction and suffering. *From a Modern Dance of Death* is a direct descendant of the allegorical images of war that had appeared at the end of the nineteenth century, but its roots go back further, to Holbein and Dürer, and beyond them to Gothic representations.

Aus einem neuzeitlichen Totentanz

FIGURE 7.4. *Ernst Barlach*, From a Modern Dance of Death, *1916. Private collection.*

A giant, clothed in the timeless robe of many of Barlach's sculptures, stands, feet far apart, over a skull and a pile of bones and other emblems of death—a scythe and an hourglass. He holds a sledgehammer in both hands and swings it over his head. His face bears a fixed, silent expression. From the horizon a swarm of dark birds, a common symbol of tragedy, rises until the sky is completely covered. In his three-dimensionality the giant is reminiscent of one of Barlach's wood sculptures, and the three curves that dominate the design—the curve of the robe stretching between the man's legs, the steep U-shaped curve of his two raised arms, and the curve of the inordinately wide sledgehammer—create a dynamic of great power.

The birds and the giant, who silently and unselectively is going about his work, are the only living creatures shown. The symbols of death at his feet seem to suggest that he is not only killing everything beneath him but also smashing death himself. In writings and drawings by combatants, shells hitting men already dead was a common theme, as though this act of extreme escalation—even the dead are being killed—best conveyed the nature of war in the machine age. Perhaps Barlach refers to this, but more probably he drew the scythe and hourglass as Gothic and Renaissance artists did, as attributes that identify the figure represented. The traditional imagery of Barlach's lithograph expands its present-day reference to a timeless statement of death from above, raining on the powerless below. It protests the cruelty and injustice of war, but beyond that also of life, and it may carry the further meaning of war as something that is inevitable, which may have helped allay the censor's concerns.

Beyond metaphors and allegories and the expansion and distortion of the literal by such artists as Dix or Beckmann, the only strong alternative available to artists in depicting war in the twentieth century appears to have been a greater degree of formal abstraction: Marc's last paintings and drawings, some of Dix's sketches during the war in which he experimented with styles that left realism far behind, the cubism of Leger, Wyndham Lewis's futurism, or a painting such as Christopher Nevinson's *Explosion* of 1916, in which nothing is shown but a brown field, the sky, and where they meet the burst of a shell.

Manuel's halberdier, Uccello's crossbowman, and the armed moles of Dix and Neumont are separated by centuries of social and political change, of technological transformation, and of repeated adjustments to the ways men become soldiers and fight. Different historical processes, not always running in tandem, led from one to the other. The development of weapons followed a relatively straightforward course, marked by the interaction of offensive and defensive innovation, which began to accelerate toward the end of the eighteenth century. The growth of bureaucratic techniques and political power also evolved along a fairly clear line. Other changes of comparable magnitude—changes in the type of government that controls and employs this power, for instance—did not coalesce into similarly apparent patterns. Here change was more fragmented, often transitory, and marked by reversals and deviations. In particular, it is difficult to draw an ascending line from the man-at-arms in a Renaissance principality or canton to the conscript in the mass army of a democratic nation-state. The formulae

that define this curve fall short of covering all the relevant elements in the relationship between individuals, the armed force in which they serve, the political power that asks or compels them to serve, and the society that expects or accepts that they do so.

The reasons men become soldiers and the ways their societies view war are at the core of the matter and do not lend themselves to generalizations that define the differences between a universalized past and present. The crossbowman at the Battle of San Romano, probably the owner of his technologically advanced weapon and adept at its use, hired himself out for the campaign. His entering the service of a prince or a city was unlikely to be affected by whatever views he might have held on public issues of the time. Manuel's survivor of the campaign against Genoa either took up arms of his own volition or was compelled to do so by the council of his canton; he lived in a society that valued military prowess and saw nothing questionable in aggressive wars. The idealized poilu of the world war poster was meant to represent specific attitudes toward the French nation and its enemies, attitudes that were held by many Frenchmen but were neither universal nor unchanging. He and the German machine gunners whose advance to Paris he blocked were the products of mass society organized into nation-states and of the policy of universal conscription—they were drafted or they volunteered knowing that they would be drafted—a policy enforced in 1914 with the same techniques by a French republic and a German empire. Almost certainly these men felt an attachment to their native land, which perhaps fed into a sense of obligation and patriotism, but by 1917 and 1918 they longed for peace and had it been possible would have stopped fighting.

In the centuries between the Renaissance and the world wars the forms of military service and of social attitudes toward war varied greatly in Europe. In France alone, from 1789 to 1914, institutions and policies swing back and forth, from a royal army of native and foreign professionals to the new National Guard, the volunteers of 1792, the *levée en masse* of 1793, followed by the regularization of conscription. After 1815 the army of long-serving professionals returns, interrupted by the volunteers of 1848, succeeded by the professional army of the Second Empire, the volunteers of 1871, and finally the elimination of substitution from conscription. During these years, living under the most diverse political systems, French society generally accepted war as an integral and justified element of national policy, even if in the last years before 1914 some groups began to distinguish between aggressive and defensive war. Nationalism and patriotism reached a peak at the beginning of the twentieth century; since then, ideologically driven disasters and the rise of the international community on the one hand and the drive for regional autonomy on the other are changing the nation-state and the feelings of its citizens toward it.

In short, not only are the processes that run from the man-at-arms to the poilu diverse, so is their outcome. Comparisons between earlier and later conditions and attitudes may be enlightening, but only if they are based on the specifics in each case, which surely are influenced by the general tendencies of the age, but will always affect and bend them in turn.

Nor can we point to a single line of development in the representation of war in art from the Renaissance to our own day. The reflections in art of the great themes of life do not come

together in orderly patterns, let alone coalesce into a clear line of development over centuries. Their strength—when they have strength—rests in the artist's specific response to a particular expression of the theme, subject and response being dependent on conditions at the time. Society and culture, economic forces, political constraints, and opportunities mold the subject and form a structure within which the interpretation evolves, a structure that some artists know how to expand. Subsequent ways of interpretation grow out of earlier ones or react against them and for a time create a developmental line. But this line broadens and fades, and under the pressure of aesthetic and external changes it is subject to sharp breaks. When the Swiss halberdier and the German Landsknecht, moving easily in and out of civilian life, are replaced by long-serving soldiers in the voluntary or forced employ of a more hierarchical system, the place of the warrior in society shifts, and with it the interpretation of war in art and the market for these interpretations. For a time, the soldier, as distinct from his commander, disappears almost entirely as a principal subject in art, to continue his existence as a figure in genre paintings and in illustrations.

Seen from a long perspective, the interactions of the artist and the subject of war appear to form entities within the larger stylistic phases in the history of art, each extending over generations. The entities are linked, but they do not necessarily point in the same direction. Even a circuitous line does not accurately characterize their relationship, since that would imply a sequential course toward a common goal. We may believe or want to believe that such a goal exists, but we cannot know what will follow today's social and political conditions and artistic conventions.

Nevertheless, the variety of images of war in art since the Renaissance is affected by considerations common to each fragment. War is a spectacle that fascinates by its violence, by its closeness to fantasies of crime and punishment, and by the finality with which it threatens its participants. Without denying the seductiveness of these elements, serious art—whether high or popular—breaks through them to reach the core of the matter. This explains the importance, repeatedly stressed in this study, of the artist recognizing what is actually involved when people are organized to go out to kill others. Personal experience with combat has little to do with it. The artist must confront the physical or emotional reality of war, or both, to achieve a serious interpretation of the subject, however the subject is ultimately represented—allegorically, in one or the other of the many approaches to literal fidelity or of distortion, or as an abstraction. The realism that matters is not on paper or canvas, but the realism in the artist's head; there it is essential, even if the effort to grasp the essence of the subject can catch hold of no more than a small segment of the whole.

Artists find it easier to recognize aspects of the reality of war at some times and under certain conditions than at others. That in the first half of the eighteenth century, to take one example, they had little of lasting value to say about this theme should not be surprising. For the time being the potential for further growth in allegory and in the apotheosis of the commander was limited, if not exhausted; the coming possibilities of history painting, with its evocation of past reality, could yet be seen only from a distance; and the common soldier, the essen-

tial actor in war, was marginalized in society and culture. As one or more of these conditions changed, the view art took of war and of the men who fought was affected, and new interests and assignments led to new insights.

In the analysis of the succession of shifting perspectives on war that art has taken in the course of centuries, the treatment of the common soldier may function as a principal regulating device. To suggest this function is not to propose a basis for value judgments. It is simply to remind us of the element that each work of art concerned with war must consider, an element that, like a fixed point, may help orient the interpretation.

Rubens's *Consequences of War*, in which each of the great protagonists—Mars, Venus, Furies, Harmony—is marked by the artist's sublime humanity, suffers nothing from relegating the pikemen and *hakebusiers* of the Thirty Years' War to the subordination of background figurines. Rubens addresses war in an intellectual and cultural vocabulary that enables him to make visible certain universals of his subject. To note that the common soldier is nearly absent from the artist's neoplatonic conceptualization of war is not to judge his work or to reject his intentions; it merely contributes to the understanding of his way of carrying them out.

The end of the eighteenth century marks a deep incision in the fluctuating course of the common soldier's appearance and disappearance in images of war. After the French Revolution he no longer fades from view. For some generations he shares the focus with those who lead him, but he gradually displaces them as the size of armies expands from a few hundred thousand men to millions, and senior commanders become managers rather than combatants. In the serious work of art senior officers almost disappear, except in such attacks on their type and class as the works of George Grosz. By the time of the First World War, with its conscript armies representing mass societies and idealized nations, the common soldier has not only become the central figure in images of war, increasingly the images are drawn or painted from perspectives that seek to be his. An ambivalence that had often marked the pictorial representation of war was resolved because the social groups that make up the overwhelming majority of soldiers now also possessed political power or significance.

As the glorification of military action loses conviction and becomes less frequent, its place is taken by a more overt recognition of the misery of war and of its human costs. The emotions that come to dominate are sadness, direct and implied criticism—which need not be political—and anger.

Certainly these had been expressed before. Goya, Seele, Callot, even the Swiss Renaissance masters—warlike though some were—knew what war did to men and society. We cannot identify the first sign in art of criticism of war and of the fate of soldiers and civilians in war, just as it would be difficult to identify the earliest appearance of other attitudes toward war, or even of any particular motif in the depiction of war. Strong similarities, perhaps assuming somewhat different form and expressed in different contexts, can be found across the centuries. But the frequency and openness of sorrow over war and of criticism of war in modern art are new.

The expansion of these feelings is owed to the expansion of war itself since the French Revolution, after a long period when wars were waged mainly by groups of specialists that were often small and somewhat isolated segments of society. As the community and society became more fully engaged—almost anyone could now be a soldier and even civilians were under threat—recent generations have repeatedly found new relevance in images of war.

Important though they are, however, the links between social and political change and changes in art do not define the scope of art. Beyond history, prints and paintings on war have always possessed the potential of serving as metaphors for other forms of strife—for conflict between individuals, between the individual and society, and within the individual. Not every artist has wanted to develop these metaphors or had the ability to do so. But some have captured in their work aspects of the violence of war and of the conditions surrounding it, and at the same time have known how to explore and reflect in these images the many-faceted conflicts of life itself.

A Note on Sources

The principal sources of this study are the paintings, frescoes, and graphics reproduced and discussed in the text. This note lists the books and articles I found particularly useful in the course of writing, some other works that require mention, and all sources of quotations.

CHAPTER ONE

The catalogue of the major exhibition of Niklaus Manuel's work in the Kunstmuseum in Bern in 1979, *Niklaus Manuel Deutsch: Maler, Dichter, Staatsmann*, includes a summary of interpretations of the drawing of the Swiss halberdier and reprints the remaining documentary evidence of Manuel's life. The catalogue is far more comprehensive and detailed than the earlier study by C. von Mandach and Hans Koegler, *Niklaus Manuel Deutsch* (Leipzig, [?1942]), which nevertheless retains its value. One of the contributors to the catalogue, Hans Christoph von Tavel, author of a monograph on the artist, has also written two important essays with discussions of Manuel's drawing that disagree with some of the conclusions in the catalogue: "Das Triumphbild als Memento," *Zeitschrift für Schweizerische Archaeologie und Kunstgeschichte* 37, no. 1 (1980), and "Niklaus Manuel als Maler und Zeichner," *Archiv des Historischen Vereins des Kanton Bern* 64/65 (1980–81). In his monograph *Le Peintre poète Nicolas Manuel et l'évolution sociale de son temps* (Geneva, 1953), Conrad André Beerli develops interesting speculations on the function of war in Swiss society during Manuel's life and on the role of death and the fear of death in Manuel's work. The *Chronicle of Lucerne* has been reprinted several times. See, for instance, the facsimile edition *Luzerner Bilderchronik*, edited by Robert Durrer and Paul Hilber (Geneva, 1932).

The seven volumes of Eugen von Frauenholz's analytic edition of documents, *Entwicklungsgeschichte des deutschen Heerwesens* (Munich, 1935–41), remain basic to any study of military policy and war in Central Europe from antiquity to the nineteenth century. On Swiss methods of warfare, I have relied above all on volume 2, part 1, of the series, *Das Heerwesen der Schweizer Eidgenossenschaft in der Zeit des freien Söldnertums* (Munich, 1936); on W. Schaufelberger, *Der alte Schweizer und sein Krieg* (Zurich, 1966); and on the Swiss General Staff history, *Schweizer Kriegsgeschichte*, edited by M. Feldmann and H. G. Wirtz, 4 volumes (Bern, 1915–33). The chapters by Emil Dürr on the interaction of local conditions, foreign policy, and war in the fifteenth and sixteenth centuries, in volume 2, pp. 7–713, are particularly impressive. The reference to contemporary reports of the Swiss dragging two heavy guns to Castellazzo is in A. Maag, *Der Schweizer Soldat in der Kriegsgeschichte*, edited by M. Feldmann (Bern, 1931), p. 130.

CHAPTER TWO

The first two volumes of Eugen von Frauenholz's *Entwicklungsgeschichte des deutschen Heerwesens*, mentioned above, offer a good documentary introduction to military organization and war of the late Middle Ages and the Renaissance, especially when they are supplemented by the descriptions and analyses of the writings on war at the time in the first volume of Max Jähns's *Geschichte der Kriegswissenschaften vornehmlich in Deutschland*, 3 volumes (Munich and Leipzig, 1889–91). Although Jähns's scholarship is outdated in nearly every case, his collection of hundreds of texts offers an unequaled general picture of medieval and Renaissance military thought.

Monographs on late medieval and Renaissance warfare that I found particularly useful are Pierre Contamine, *War in the Middle Ages* (London, 1984); C. C. Bayley, *War and Society in Renaissance Florence* (Cambridge, 1961); Michael Mallet, *Mercenaries and Their Masters* (London, 1974); and Michael Mallet and John Hale, *The Military Organization of a Renaissance State* (Cambridge, 1984). Much specific information on the various types of crossbows is contained in Ralph Payne-Gallwey's *The Crossbow* (London, 1903 [reprinted 1990]).

Arnold von Salis, *Antique und Renaissance* (Erlenbach-Zurich, 1947), includes a fine essay, "Reiterschlacht," that traces the representation of cavalry battles and battle in general from Guilio Romano's *Battle of Constantine* back to

to the Trajan frieze on the Arch of Constantine and to the mosaic of the Alexander Battle in the Casa del Fauno. The literature on Piero della Francesca has little to say about matters of interest to the present study, the literature on Paolo Uccello rather more. On the fresco of the Battle of Heraclius I found the following particularly helpful: Eve Borsook, *The Mural Painters of Tuscany, from Cimabue to Andrea del Sarto* (Oxford, 1980); Marilyn Aronberg Lavin, *Piero della Francesca* (New York, 1992); and Ronald Lightbown, *Piero della Francesca* (New York, 1992), although I do not agree with his reading of the work's military character. On Uccello I am indebted to Volker Gebhardt, *Paolo Uccellos "Schlacht von San Romano"* (Frankfurt a.M., 1991), and to Franco and Stefano Borsi, *Paolo Uccello*, translated by Elfreda Powell (New York, 1994), with its rich *catalogue raisonée*. The essay by Randolph Starn and Loren Partridge, "Representing War in the Renaissance: The Shield of Paolo Uccello," *Representations* 5 (1984), is a fascinating example of deconstructive analysis, but its approach and—ultimately—its theme are far removed from the concerns of this book. John Hale's characterization of *The Battle of San Romano* is quoted from his *Artists and Warfare in the Renaissance* (New Haven and London, 1990). Frederick Hartt's comments on Guilio Romano's *Battle of Constantine* are quoted from the first volume of his *Guilio Romano* (New Haven and London, 1958).

Dürer's woodcut *Death and the Landsknecht* with the accompanying poem is printed in *The Illustrated Bartsch*, volume 10, *Albrecht Dürer*, edited by Walter L. Strauss (New York, 1980). The reference to the peddler of Dürer's prints is to a contemporary record cited in *Albrecht Dürer, 1471–1971*, catalogue of the 1971 exhibition in the Germanische Nationalmuseum in Nuremberg.

CHAPTER THREE

I was introduced to modern scholarship of Callot by Daniel Ternois's *L'Art de Jacques Callot* (Paris, 1962), a book that integrates the history of art with cultural history and the history of ideas, and by the exhibition of Callot's work in the National Gallery of Art in Washington in 1975 with its excellent catalogue, edited by H. Diane Russell, *Jacques Callot: Prints and Related Drawings* (Washington, D.C., 1975). In the same year Pierre Marot published three valuable articles, "Jacques Callot: Sa vie, son travail, ses editions: Nouvelles recherches," in the *Gazette des Beaux Arts*, 6th series, 85 (1975), which supplement his earlier work, *Jacques Callot, d'après des documents inédits* (Nancy-Paris-Strasbourg, 1939). Diane Wolfthal gives a concise summary of the various interpretations of *The Large Miseries of War* in "Jacques Callot's *Miseries of War*," *Art Bulletin* 59, no. 2 (1977). The extensive and often very good literature on Callot has paid insufficient attention to the military aspects of the series, overlooking such facts as the different character of the troops in *The Pillage of an Inn* on the one hand, and *Destruction of a Convent* and *Plundering and Burning a Village* on the other.

For my brief discussion of seventeenth-century military painting, I have consulted above all Eri Larsen's *17th Century Flemish Painting* (Freren, 1985); a number of catalogues, among them two of exhibitions in the Wallraf-Richartz-Museum in Cologne: *I Bamboccianti*, edited by David A. Levine and Ekkehard Mai (Cologne, 1991), and *Das Kabinet des Sammlers*, edited by Ekkehard Mai (Cologne, 1993); and J. de Maere and M. Wabbes, *Illustrated Dictionary of 17th Century Flemish Painters*, 3 volumes (Brussels, 1994). In his study *The Decorations for the Pompa Introitus Ferdinandi* (Brussels, 1972), John Rupert Martin discusses *The Cardinal-Infante Ferdinand at the Battle of Nördlingen* and suggests that Jordaens added the lone visible profile in the midst of "helmeted, faceless soldiers." The monograph by Hans Gerhard Evers, *Peter Paul Rubens* (Munich, 1942), includes an interesting chapter on Rubens's interpretation of strife and war. Rubens's description of *The Consequences of War* is from *The Letters of Peter Paul Rubens*, translated and edited by Ruth Saunders Magurn (Cambridge, Mass., 1971); the quotation from Burckhardt is taken from his *Erinnerungen aus Rubens* (Vienna, 1938).

CHAPTER FOUR

The discussion of armies and war in the eighteenth century and the Napoleonic era makes use of my own work in this field: *Yorck and the Era of Prussian Reform* (Princeton, 1966), chapters 2, 3, and 5; *Clausewitz and the State*, re-

vised edition (Princeton, 1985), chapters 2, 6, and 8; "Napoleon and the Revolution in War," in *Makers of Modern Strategy*, edited by Peter Paret (Princeton, 1986); and two essays reprinted in the collection of my shorter studies in the history of military power, *Understanding War* (Princeton, 1992): "Nationalism and the Sense of Military Obligation" and "Conscription and the End of the Ancien Regime in France and Prussia."

On Benjamin West, I am indebted above all to Charles Mitchell's seminal article, "Benjamin West's *Death of General Wolfe* and the Popular History Piece," *Journal of the Warburg and Courtauld Institutes* 7 (1944): 20–33, and to the detailed analyses in Helmut von Erffa and Allen Staley, *The Paintings of Benjamin West* (New Haven and London, 1986). I have also profited from David Irwin's chapter "Trafalgar and Waterloo: The British Hero" and Werner Busch's "Über Helden diskutiert man nicht: Zum Wandel des Historienbildes im englischen 18. Jahrhundert," both in *Historienmalerei in Europa*, edited by Ekkehard Mai (Mainz, 1990). Benedict Nicolson's *Joseph Wright of Derby: Painter of Light*, 2 volumes (London and New York, 1968), is a work notable for demonstrating the compatibility of close, imaginative research with the even rarer qualities of style and wit. As always, I have found David Irwin's analysis illuminating (his brief remarks on Wright's painting *The Dead Soldier* are in *Triumph und Tod des Helden*, edited by Ekkehard Mai and Anke Repp-Eckert [Cologne, 1987]), although I would not agree that the painting is a monument to the unknown soldier. Patricia M. Burnham subjects Trumbull's *The Death of General Warren at the Battle of Bunker's Hill* to close sociological analysis in *Redefining American History Painting*, edited by Patricia M. Burnham and Lucretia Hoover Giese (Cambridge and New York, 1995). Hermann Mildenberger's biography, *Der Maler Johann Baptist Seele* (Tübingen, 1984), is a useful archival study. Paul Martin, *Der bunte Rock* (Stuttgart, 1963), includes a brief reference to Christian Gottfried Geissler's *Scene in Lübeck* and a reproduction of the etching taken from a poorly colored print that differs markedly from the reproduction in this volume. I have discussed the motif of women and infants in battle in a talk, *Witnesses to Life: Women and Infants in Some Images of War, 1789–1830*, published as a brochure by the Institute for Advanced Study (Princeton, 1996).

The sources of the quotations from Rousseau, Reynolds, and Langhorne are respectively Jean Jacques Rousseau, *Oeuvres complètes*, 3 volumes (Paris, 1964); Sir Joshua Reynolds, *Discourses on Art*, edited by Robert Lavine (New York, 1961); and *The Poems of John Langhorne*, volume 65 of *The British Poets* (Chiswick, 1822).

CHAPTER FIVE

Among important analyses of basic issues of art and war in the Napoleonic era are Elmar Stolpe, *Klassizismus und Krieg* (Frankfurt a.M., 1985), and Lorenz Eitner, *Géricault: His Life and Work* (London, 1983), with its masterly survey of the artist's cultural and professional environment. Two recent articles posit a basic shift in battle painting in the Napoleonic period. Michael Marrinan, "'Lexie': History, Text, and Authority in Napoleonic Painting," *Word and Image* 7, no. 3 (July–September 1991), analyzes the relationship between officially commissioned paintings and communiqués and other descriptions of battles. His conclusions seem to me to place rather too much weight on the actual power of words and images. See, for example, this characteristic statement: "The power of Napoleon is more than represented by [Antoine-Jean Gros's] *Eylau*; it is virtually recreated by us when we stand before the picture—text in hand—and reenact its story" (p. 191). Marrinan's article is not mentioned in "Naked History: The Rhetoric of Military Painting in Postrevolutionary France," *Art Bulletin* 75, no. 1 (March 1993), in which Susan Locke Siegfried identifies two competing types of battle painting—the "documentary mode" and the "affective mode"—that is, anecdotal incidents. I do not believe it is possible to sustain a clear distinction between these two approaches, both of which were constantly combined in the same works by such artists as Horace Vernet. Nina Athanassoglou-Kallmyer, "*Imago Belli*: Horace Vernet's *L'Atelier* as an Image of Radical Militarism under the Restoration," *Art Bulletin* 68, no. 2 (June 1986), discusses Vernet's life and work in the 1820s but does not refer to his painting of *Valmy*.

The most trenchant discussion of the historical galleries in the Palace of Versailles remains Franz Kugler's *Vorlesung über das historische Museum zu Versailles und die Darstellung historischer Ereignisse in der Malerei* (Berlin, 1846), which reflected the views of Jacob Burckhardt and in turn influenced him. The program of the galleries is outlined in Thomas W. Gaehtgens, *Versailles als Nationaldenkmal* (Berlin, 1984), and Michael Marrinan, *Painting Politics*

tics for Louis Philippe (New Haven and London, 1988). Marrinan's monograph is a useful summary of official history painting during the July monarchy and of its Napoleonic predecessors, but it greatly overrates the faithfulness to the events portrayed in the major works discussed. Note, for example, his appraisal of Gérard's *Battle of Austerlitz* on p. 165.

The catalogue of the exhibition of Goya's work in the Boston Museum of Fine Arts, *Goya and the Spirit of Enlightenment*, edited by Alfonso E. Perez Sanchez and Eleanor A. Sayre (Boston, 1989), is a good introduction to the large literature on *The Disasters of War*. The catalogue of the exhibition in the Hood Museum at Dartmouth, *Fatal Consequences: Callot, Goya, and the Horrors of War* (Hanover, N.H., 1990), includes two interesting essays by Hilliard T. Goldfarb and Reva Wolf but does not develop a systematic comparison of the two series. Reva Wolf, *Goya and the Satirical Print in England and on the Continent, 1730–1850* (Boston, 1991), explores the links between Goya's *Caprichos* and English caricatures.

Baudelaire's comments on battle painting are quoted from his *Selected Writings on Art and Literature*, translated and edited by P. E. Charvet (London, 1992); the police agent's comments on the paintings of the Battle of Eylau are cited in *French Painting, 1774–1830: The Age of Revolution* (Detroit, 1975).

CHAPTER SIX

The catalogue *Ernest Meissonier Retrospective* of the exhibition in the Musée des Beaux-Arts in Lyons, 1993, includes much biographical material together with discussions of the artist's works. In "Meissonier's *Siège de Paris* and *Ruines des Tuileries*," *Gazette des Beaux-Arts*, 6th series, 66 (November 1990), Constance Cain Hungerford refers to Meissonier's *Souvenir de guerre civile* in relation to his paintings of the Franco-Prussian War. Quotations from Baudelaire and Delacroix are, respectively, from the already mentioned edition of Baudelaire's *Selected Writings on Art and Literature* and from *The Journal of Eugène Delacroix*, translated by Lucy Norton and edited by Hubert Wellington (London, 1995).

The catalogue *Adolph Menzel* (Paris-Washington-Berlin, 1996–97), which includes my essay, "Menzel in Berlin," gives a good view of the current state of research on the artist. My discussion of Menzel also draws on the relevant sections in my book *Art as History* (Princeton, 1990). Quotations concerning Menzel's work are from Max Jordan, *Das Werk Adolf Menzels, 1815–1905* (Munich, 1905), and Gustav Kirstein, *Das Leben Adolf Menzels* (Leipzig, 1919).

The study by Peter Brieger, *Die deutsche Geschichtsmalerei des 19. Jahrhunderts* (Berlin, 1930), remains an excellent introduction to the history of history painting, especially but not exclusively in Germany. A collection of essays with a broader and more theoretical focus is the already-mentioned volume *Historienmalerei in Europa*, edited by Ekkehard Mai. Mai is also the author of a stimulating survey of war painting from the nineteenth century to 1918, "Ja das ist der Krieg!," in *Die letzten Tage der Menschheit*, catalogue of an exhibition in Berlin and London in 1994, edited by Rainer Rother (Berlin, 1994). François Robichon's "Der Krieg von 1870/71 und die französische Militärmalerei," in *Anton von Werner: Geschichte in Bildern*, edited by Dominik Bartmann (Munich, 1993), is a sophisticated, spirited analysis but errs in attributing French origins to European-wide developments. The catalogue of the exhibition of Elizabeth Butler's work in the National Army Museum in London in 1987, *Lady Butler: Battle Artist*, edited by Paul Usherwood and Jenny Spencer-Smith, is informative but insufficiently analytical.

Documents on the background and conflict over Hodler's *Retreat from Marignano* are published by C. A. Loosli in *Ferdinand Hodlers Leben, Werk, und Nachlass*, volumes 1 and 2 (Bern, 1921–22). The catalogue *Ferdinand Hodler* of the exhibition in the Nationalgalerie in Berlin in 1983, includes an excellent essay, "Historienbilder," by Lucius Grisebach. I have also profited from Ernst Schmid, *Ferdinand Hodlers "Rückzug aus Marignano"* (Zurich, 1946); Lucas Wüthrich's catalogue *Wandgemälde von Müstair bis Hodler* (Zurich, 1980); and Oscar Bätschmann, "Hodler in seinen Bildern: Selbstbildnisse und Künstlerrollen," *Zeitschrift für Schweizerische Archäologie und Kunstgeschichte* 51, no. 1 (1994). Hodler's statement about the models he chose for the fresco is quoted in Jura Brüschweiler, *Ferdinand Hodler: Selbstbildnisse als Selbstbiographie* (Bern, 1979).

CHAPTER SEVEN

The many surveys of art in and of the First World War are now superseded by Richard Cork's *A Bitter Truth: Avant-Garde Art and the Great War* (New Haven and London, 1994). No one would agree with every interpretation in this encyclopedic work, but it is a good chronological introduction, with some excellent sections on particular topics. A reduced version in a German translation, which falls short of conveying the balanced judgments of the English original, is included in the previously mentioned catalogue, *Die letzten Tage der Menschheit*, edited by Rainer Rother (Berlin, 1994), which has the advantage of addressing conventional and popular art as well. Siegmar Holsten has written a useful study of one approach to images of war, *Allegorische Darstellungen des Krieges, 1870–1918* (Munich, 1976), but the author's effort to achieve typological precision leads to some forced, partial interpretations that confuse rather than clarify. I have outlined some basic issues in the interaction of German art and the First World War in my essay "Betrachtungen über deutsche Kunst und Künstler im Ersten Weltkrieg," in *Kultur und Krieg*, edited by Wolfgang J. Mommsen (Munich, 1996), a volume that includes several other essays relevant to the subject of war and art.

The literature on Dix is gradually shedding the ideological blinkers of the left and the right that too often distorted its vision in the past. A good introduction is the catalogue of the exhibition in the Tate Gallery, *Otto Dix, 1891–1969* (London, 1992). Marxist echoes still sound through the revised edition of Dietrich Schubert's biography *Otto Dix* (Hamburg, 1991), but it is well worth reading nevertheless. Among Schubert's other essays on the artist, "Otto Dix zeichnet im Ersten Weltkrieg," in the previously mentioned volume *Kultur und Krieg*, is particularly relevant to the present work.

My discussion of Barlach's *From a Modern Dance of Death* is based primarily on the chapter "Der Bildermann" in my book *The Berlin Secession* (Cambridge, Mass., 1980) and on my forthcoming essay "Field Marshal and Beggar: Ernst Barlach in the First World War." The poster *They Shall Not Pass!* is reproduced and briefly discussed in Peter Paret, Beth Irwin Lewis, and Paul Paret, *Persuasive Images* (Princeton, 1992). The quotations from Marc, Barlach, and Beckmann are respectively from Franz Marc, *Briefe, Aufzeichnungen und Aphorismen* (Berlin, 1920); Ernst Barlach, *Die Briefe*, edited by Friedrich Dross (Munich, 1968); and Max Beckmann, *Briefe*, edited by Klaus Gallwitz, Uwe M. Schneede, and Stephan von Wiese (Munich-Zurich, 1993).

Illustrations and Credits

Original dimensions, where known, are given in centimeters.

COLOR PLATES

Color plates appear following the page number listed.

4. Christian Gottfried Geissler, *Scene in Lübeck*, colored etching, 19.3 × 16.8, ca. 1806–7. Private collection. (Photo: John Blazejewski, Princeton University), 62

5. Jean-Baptiste Mauzaisse, copy of Horace Vernet, *The Battle of Valmy*, oil, 296 × 678, 1826/34. Musée Nationale du Chateau, Versailles. (Photo: Giraudon/Art Resource N.Y.), 78

6. Adolph Menzel, *Deathhead Hussar*, no. 19 of Eduard Lange, *Die Soldaten Friedrichs des Grossen*, colored wood engraving, 2d state, 21.5 × 13.2, 1856. Private collection. (Photo: John Blazejewski, Princeton University), 86

7. Ferdinand Hodler, *The Retreat from Marignano*, central fresco, 332.5 × 490, 1900. Schweizerisches Landesmuseum, Zurich. (Photo: Schweizerisches Landesmuseum), 96

8. Maurice Neumont, *They Shall Not Pass!*, lithograph, 125.6 × 82, 1917/18. The Hoover Institution, Stanford University. (Photo: The Hoover Institution), 108

Index